D0120540

THE A–Z OF CREATIVE PHOTOGRAPHY

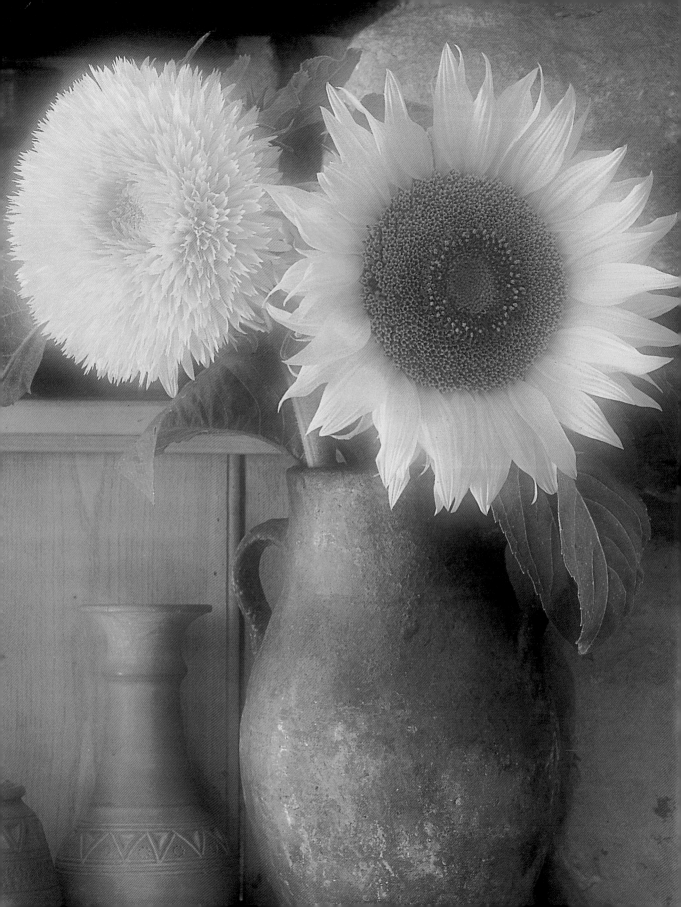

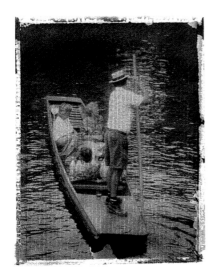

THE A–Z OF CREATIVE PHOTOGRAPHY

Over 70 Techniques Explained in Full

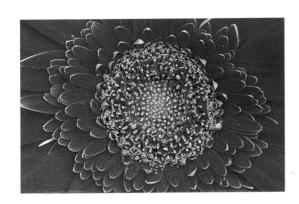

LEE FROST

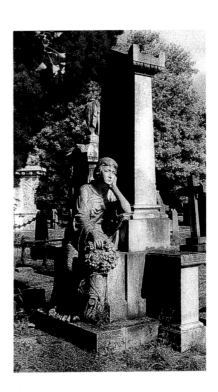

David & Charles

FOR NOAH

A DAVID & CHARLES BOOK

First published in the UK in 1996
First published in paperback in the UK in 2000
Reprinted 2003, 2004

A catalogue record for this book is
available from the British Library

ISBN 0 7153 0687 1 (Hardback)
ISBN 0 7153 1127 1 (Paperback)

Printed in China by C S Graphics Shanghai Co., Ltd
for David & Charles
Brunel House
Newton Abbot Devon

Contents

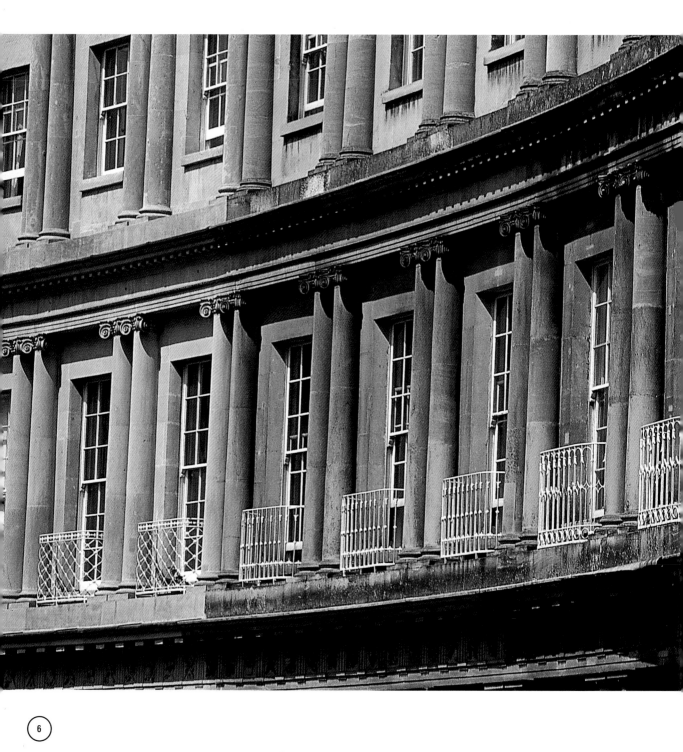

Introduction

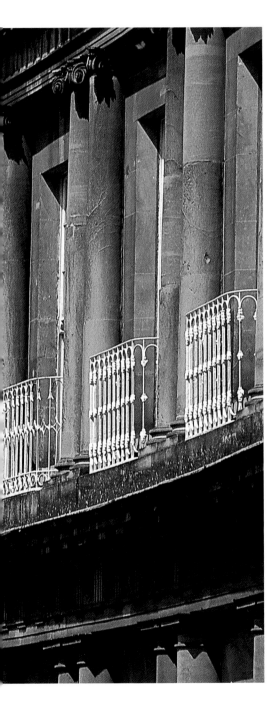

People become interested in photography for all kinds of reasons. Some use a camera to complement another hobby. Others like to document major events in their life, such as the birth of a child, holidays and family gatherings. Then there are those individuals who take pictures purely as a means of expressing their creativity and personal vision of the world, just like artists paint and architects design beautiful buildings.

This was my main motive for picking up a camera for the first time some 15 years ago. Since then, I have been experimenting with countless different techniques, not only as a means of adding my own personal 'stamp' to an image, but also because there's nothing more satisfying than trying something new and using it to create interesting pictures.

The A-Z of Creative Photography has been written to help you satisfy that very same desire. Using jargon-free text and over 200 inspirational images, it will guide you through over 50 exciting techniques, from cross-processing to candid photography, panning to panoramics, fireworks to floodlit buildings, all set out in alphabetical order so you can find exactly what you want quickly and easily.

Where possible, the advice has been presented as simple step-by-step guides or bite-sized nuggets of information, so you can dip in and out whenever you feel the urge to try something new. In-depth captions have also been provided for each image, including the equipment, film and exposure used to take it, plus any other details that will help you repeat the effect.

Most books on photography fill their pages with advice on buying and using equipment, and how to photograph a particular subject, be it landscapes, portraits or architecture. *The A-Z of Creative Photography* is different in that it looks at specific techniques and applies them to those subjects, instead of offering general advice. As a result, it is an essential reference guide for anyone interested in producing creative, innovative images, and whether you're a complete beginner or an advanced enthusiast, it's guaranteed to help you become a better photographer.

Keep shooting!

LEE FROST
March 1998

Abstract Art

Most of the pictures photographers take are of specific objects, recorded in a literal way so that the viewer can identify what has been depicted. If you photograph a building, for example, it's usually obvious what the subject is, whether you capture all or part of it. Similarly, landscape scenes are generally captured with a wide-angle lens to give a broad panoramic view. However, you don't have to work in this way, and often by taking a more abstract view of everyday subjects you will produce far more exciting results.

There are various meanings to the word 'abstract', but from a photographic point of view the most apt is basically 'having no reference to material objects or specific examples'. In other words, an abstract picture gains its appeal not from the fact that you can identify the object recorded, but from the colours, shapes, patterns and textures that make up that object. This means that literally anything can be used as the basis of an abstract picture, whether it is big or small, simple or complex, natural or man-made.

WHAT YOU NEED

Camera: Abstract photography is more dependent on your eye for a picture than on the equipment used, so any type of camera that accepts interchangeable lenses or offers variable focal length – such as a zoom compact – will be suitable.

Lenses: A range of focal lengths from 28mm wide-angle to 200mm telephoto will cover all situations, but you can produce successful images using just one lens.

HOW IT'S DONE

When you stop to take a picture it's because you have seen something that appeals to your visual senses. Unfortunately, those senses tend to work on a limited set of values, so you are very selective about what you photograph and what you ignore. You may naturally be drawn to a particular type of building, for example, but pay no attention to another, and what one photographer finds visually appealing you may not even see. As a consequence, potentially great pictures are being missed every minute of your life, simply because you didn't even know they existed in the first place.

The aim of abstract photography is to overcome familiarity so you begin to see things in a completely different way. To do this you need to tune your senses so you are more sensitive and responsive to the world around you. Once you are able to do this, it's amazing how fresh and exciting even the most familiar things can be. A car parked by the roadside is no longer just a car, but

The repeating effect of the open doorways and receding tones in this architectural scene provided the perfect ingredients for an abstract image, while the simple composition allows you to focus completely on the patterns, shapes and colours and almost ignore what the actual subject is. The shot was taken by chance in the old Mosque of Cordoba in southern Spain as the photographer wandered through the wonderful maze of passages and courtyards.
EQUIPMENT: Olympus OM4-Ti, 50mm standard lens, soft-focus filter
FILM: Agfachrome 1000RS rated at ISO1000 **EXPOSURE:** *1/60 second at f/8*

an object full of graceful curves, graphic reflections and contrasting shapes. An old wall covered in peeling posters is suddenly an eye-catching array of patterns, textures and colours.

CHOOSING LENSES

You can also use different lenses and camera angles to control exactly what appears in the final image and heighten the graphic, abstracted nature of the pictures you take.

Wide-angle lenses allow you to create dynamic compositions where disparate objects are juxtaposed in such a way that a successful image is created, an image that you didn't even see with the naked eye. The distortion wide-angle lenses introduce when used from close range is also ideal for taking your pictures a step further from reality.

Telephoto lenses are equally valuable as they allow you to isolate small parts of a subject or a scene, so the part becomes more important than the whole. This, really, is the essence of the technique – 'abstracting' a tiny part of reality to limit what the viewer sees.

LOCATION

Urban locations are the perfect place to take abstract images as there so many different shapes, colours, textures and patterns all jostling for space in a restricted area. The urban landscape is constantly changing; no street looks exactly the same for more than a few minutes as people and vehicles come and go, so there is always something different to photograph.

You can also create successful abstract images around your own home if you spend time looking and exploring: red brick captured against deep blue sky, a colourful sign against a painted door, or the play of shadows on a stone wall. The chances are that you see these things every day without giving them a second glance, but they all make perfect subject matter for appealing abstract images.

TOP TIPS

• Remember that the less realistic an image looks, the more appealing its abstract quality will be.
• If you spend time exploring everyday subjects and scenes, it's surprising how many interesting abstracts will appear.
• Use some of the other techniques described in this book to produce abstract images, such as panning (page 98), cross polarisation (page 38), grain (page 66), infrared (page 36) and zooming (page 158).

Taking a closer look at small objects is a great way of creating abstract images, simply because you are photographing things that are not normally visible to or appreciated by the naked eye. Any guesses what the subject is here? It's actually a slice of Kiwi fruit, placed on the surface of a slide viewing lightbox so the colours and patterns have been revealed by backlighting. A macro lens used at almost lifesize (1:1) reproduction was necessary to fill the frame and exclude any unwanted details.
EQUIPMENT: *Nikon F90x Prof., 105mm macro lens, tripod, slide lightbox as light source* ***FILM:*** *Fujichrome Velvia ISO50* ***EXPOSURE:*** *½ second at f/16*

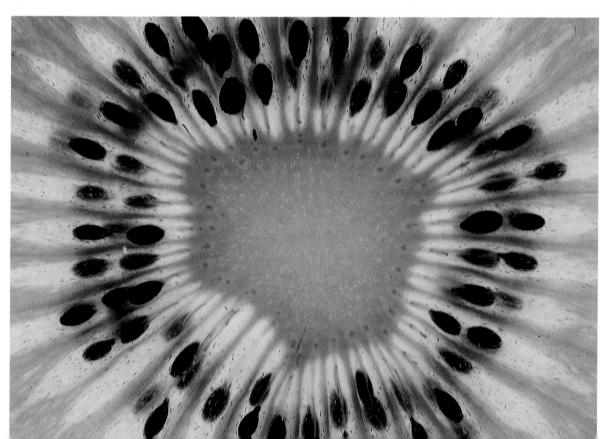

Advanced Exposure

Many of the techniques and ideas covered in this book require a clear understanding of exposure, and rely on your ability to produce perfectly exposed pictures in all manner of lighting situations.

Given the sophistication of today's cameras – especially 35mm SLRs – being able to do this is much easier now than ever before. The integral metering systems found in even the most basic models are highly sensitive, and will give an accurate reading most of the time. Modern colour negative films are also very tolerant of exposure error, to the point that you could take a picture that is up to two, even three, stops under- or overexposed and still obtain an acceptable result. This is because any error can be corrected at the printing stage, simply by printing the image a little lighter or darker.

However, while this sophistication no doubt makes photography less prone to error, you will occasionally find yourself in a situation where no amount of modern technology can solve the problem, and that's when you must take control, using your knowledge and experience to ensure a successful image is recorded. This is particularly important when using colour transparency films, as any more than half a stop of under- or overexposure will result in failure.

You can't do that, of course, unless you are aware of what is likely to fool your camera's integral metering system in the first

This picture of Pamukalle in Turkey is a classic example of a situation where a camera's integral metering system would almost certainly give an underexposed result due to the predominance of light tones. To prevent the scene being recorded as a dull grey colour instead of pure white, the photographer took a general meter reading with his camera set to aperture priority mode, then increased it by two stops using the exposure compensation facility.

EQUIPMENT: Nikon F90x Prof., 50mm standard lens **FILM:** *Fujichrome Velvia ISO50* **EXPOSURE:** *⅟₆₀ second at f/11*

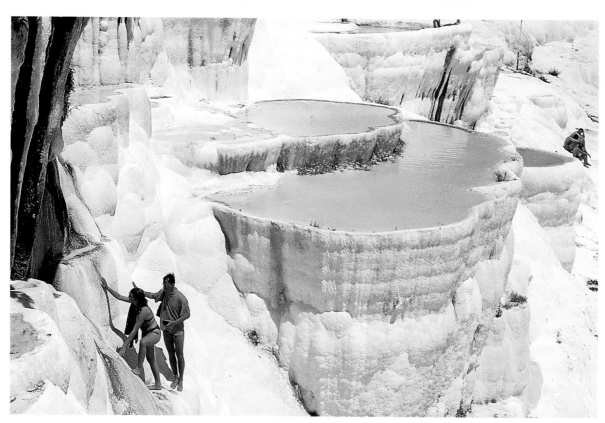

place. Equally, unless you have a basic understanding of how your camera's metering works, you will be unable to prevent exposure error. This may seem of minor importance – after all, if 95 per cent of the pictures you take are perfectly exposed, sacrificing the other 5 per cent doesn't seem like such a poor average. Unfortunately, it tends to be those 5 per cent of situations that generate the most exciting and rewarding images, so unless you know how to deal with them you could be missing out on some very important opportunities.

WHAT YOU NEED

Camera: The majority of today's 35mm SLRs offer various options when it comes to metering and exposure, so you are able to reduce the risk of error. Here is a brief outline of the most common metering 'patterns' and how they work.

Centre-weighted: This is the most common type of metering system. It works by measuring light levels across the whole of the viewfinder area, but biases the exposure towards the central 60 per cent of the image, as it is assumed that that is where the most important part of the picture will be – a simple assumption, but not always the case, of course. For general picture-taking this system can be relied on to give accurately exposed results. However, if the scene you are photographing contains a lot of light or dark tones, it is prone to cause under- or overexposure if you don't adjust the exposure set by the camera.

Multi-pattern: This system is now found in most modern SLRs, and is intended to provide greater exposure accuracy in tricky lighting. Different camera manufacturers each have their own version of it, but all work in a similar way. Light levels are measured in different zones of the viewfinder according to the design of the pattern. These readings are then analysed by the camera's on-board computer in an attempt to detect extreme levels of brightness or darkness in the scene and prevent them from causing exposure error. The more zones the pattern has, the more accurate the system tends to be.

Compared to centre-weighted metering multi-pattern is certainly an improvement, but in extreme situations it can still be fooled into setting the wrong exposure.

Spot metering: The biggest cause of exposure error in photography is extreme levels of brightness or darkness in a scene, which confuse the camera's metering system into giving too little or too much exposure. The easiest way to avoid this is by taking an exposure reading from just a small part of the scene – the most important part – so those bright or dark areas don't influence the reading you get.

Spot metering allows you to do that by measuring light levels in just a tiny part of the viewfinder – usually 1 per cent of the total image area, indicated by a small circle in the centre. When used correctly, spot metering is one of the most versatile and accurate systems available, allowing you to produce perfectly exposed pictures in the most demanding situations.

Some cameras offer 'partial' or 'selective' metering, which works on the same principle as spot metering but measures light levels in a slightly bigger area.

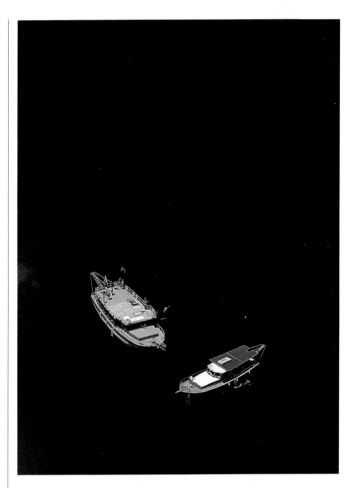

There was a high risk of overexposure being caused by this scene, due to the darkness of the sea and the fact that it occupies about 90 per cent of the frame. Because dark tones reflect little light, the camera's metering system gives too much exposure in an attempt to record them as a mid-tone. To prevent this, the photographer reduced the metered exposure by two stops using his camera's exposure compensation facility.

EQUIPMENT: *Nikon F90x Prof., 105mm lens, polarising filter*
FILM: *Fujichrome Velvia ISO50*
EXPOSURE: *⅟₃₀ second at f/16*

HOW IT'S DONE

Armed with the different types of metering outlined above, you should be able to obtain 100 per cent exposure accuracy. However, before this can be achieved, you must remember a very important factor. Basically, all types of metering pattern obtain an exposure reading in the same way – they measure the light being reflected back off your subject. Even more importantly, all camera meters are calibrated to give correct exposure when faced by subjects and scenes which reflect roughly 18 per cent

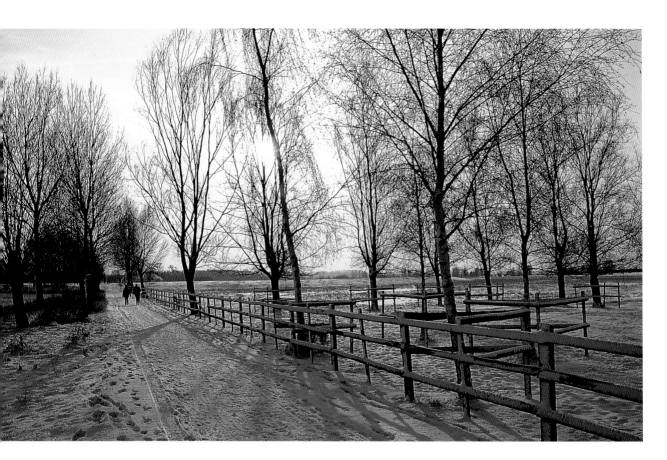

Shooting into the light always requires a careful approach, as the brightness of the sun and sky can cause severe underexposure to the rest of the scene. However, when that scene is also covered in crisp white snow, the risk of error is increased even more. To make sure he got a perfectly exposed picture, the photographer took several shots at +½, +1, +1½, +2 and +2½ stops over the metered exposure. All the resulting images were acceptable, but this one, taken at +2 stops, proved to be the best. If in doubt, bracket!

EQUIPMENT: Nikon F90x Prof., 28mm wide-angle lens, 81C warm-up filter **FILM:** *Fujichrome Velvia ISO50* **EXPOSURE:** *⅓₀ second at f/11*

of the light falling on them. Visually, this 18 per cent reflectancy can be represented by a mid-grey colour, so imagine what mid-grey looks like and fix that image in your mind.

To obtain a correct exposure using your camera's integral metering system, the subject or scene you are photographing must contain a range of tones that are similar in reflectancy to a mid-grey colour. There can be light or dark tones in the scene, but they must roughly average out to a mid-tone.

Problems occur when the tones in a scene are way off that average mid-tone value, because it means that much more or much less than 18 per cent of the light is being reflected back, but unfortunately your camera is not able to recognise the difference

and still sets an exposure as if it were an average scene.

What this means in reality is that scenes containing very light tones, such as a snow-covered landscape, or a bunch of white flowers in front of a pale background, are underexposed because your camera doesn't give enough exposure. Conversely, scenes containing very dark tones, such as a sunlit object against a shady background, are overexposed because your camera gives too much exposure.

Similarly, if part of the scene is much lighter in tone than the rest, that area will increase the overall reflectancy of the scene

Subject	Exposure adjustment
Snow scene in bright sunlight	+ 2 stops
Snow scene in cloudy weather	+ 1.5 stops
White subject filling frame	+ 2 stops
Small subject against white background	+ 2 stops
Large subject against white background	+ 1 stop
Landscape beneath bright sky	+1–3 stops
Subject strongly backlit by sun	+ 2 stops
Small subject against dark background	– 2 stops
Large subject against dark background	– 1 stop
Black subject filling frame	– 2 stops

and your camera's meter will give an underexposed picture. This is a common problem when shooting landscapes, as the sky is often much brighter than the landscape itself. So, if you do not take precautions, your pictures will be underexposed – or at least the landscape part will.

If you are faced by such conditions, the simplest way of overcoming exposure error is to take a general meter reading with your camera using the centre-weighted or multi-pattern option, then increase or reduce the exposure it sets using the exposure compensation facility. The amount by which you need to adjust the exposure obviously depends on the scene you're photographing and how light or dark it is. Also, as the accuracy of a camera's integral metering system varies so much from model to model, it's worth conducting tests to see how your own camera copes with different lighting situations. You may find that it handles some better than others, or only needs slight adjustment to produce perfect exposures.

The table below left shows a few common examples of the way in which exposure should be adjusted when using centre-weighted metering.

These amounts should only be used as a guide, and it is worth taking several pictures, each at a slightly different exposure, to ensure that at least one is perfect. For example, if you are photographing a snow scene in bright sunlight, take pictures with the following amounts of exposure increase: +1 stop, +1½ stops, +2 stops, +2½ stops, +3 stops. This technique, known as bracketing (see panel, page 14), may seem like a waste of film, but it is better to take four or five shots of the same scene and have two that are acceptable, than to take just one shot that is badly exposed.

If you are trying to prevent bright sky causing underexposure when shooting landscapes, a useful method is to tilt your camera down so that the sky is excluded from the viewfinder, take an exposure reading, set it on your camera in manual mode, and then use that exposure for the final picture once you have re-composed the scene.

What may at first seem like a tricky lighting situation can, in actual fact, be very simple and require no special exposure treatment. For this twilight picture, taken on Rannoch Moor in Scotland, the photographer took a straight TTL meter reading and made no adjustment to the exposure set by his camera. This was done because he knew that his camera would correctly expose the sky and water, recording the rest of the scene in silhouette to create a really atmospheric image.
EQUIPMENT: Nikon F90x Prof., 20mm ultra wide-angle lens, 81B warm-up filter, tripod
FILM: Fujichrome Velvia ISO50
EXPOSURE: 1 second at f/22

SPOT METERING

An alternative method is to use your camera's spot metering (or partial/selective) facility, if it has one, to measure light levels in the most important part of the scene, so that overly light or dark areas elsewhere don't affect the reading obtained and cause exposure error. If you take a spot reading from a person standing in front of a white wall, for example, the wall itself won't influence the reading at all, so the person will be correctly exposed.

This is a very accurate way of taking perfectly exposed pictures in tricky lighting, but when using spot metering you need to remember that you are still measuring reflected light, so you must meter from a mid-toned area. If you don't, and instead meter from an area that's much lighter or darker than a mid-tone, you will still get a false reading. Fortunately, it's relatively easy to find a mid-tone in most scenes. Green grass is ideal when shooting landscapes. Weathered stone and brick, roof slates, grey clothing, and anything else with a similar tonality will also give an accurate exposure reading. The key is to look for something that's of a similar colour or density to mid-grey.

Spot metering can also be used to give accurate results in very contrasty lighting, where the brightness range of a scene may be too wide for film to record fully. All you have to do is take a spot reading from the brightest highlight, another spot reading from the darkest shadows, then average them out. For example, if a highlight reading gives an exposure of $\frac{1}{500}$ second at f/11 and a shadow reading gives an exposure of $\frac{1}{30}$ second at f/11, the average of the two is $\frac{1}{125}$ second at f/11.

SUBJECTIVE EXPOSURE

Of course, while it is important to know how to take perfectly exposed pictures in all situations, the very term 'correct exposure' is open to much interpretation, and the best exposure for a picture isn't always the one that's deemed correct.

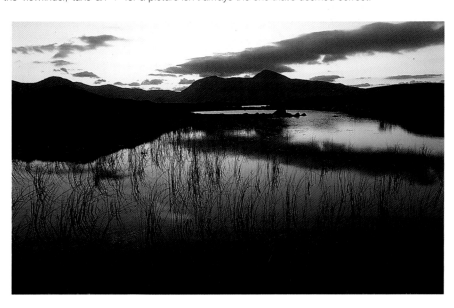

Bracketing

Perhaps the most foolproof way of avoiding exposure error is by employing a technique known as bracketing. This involves taking a photograph at the exposure set by your camera – or what you think is 'correct' – then other photographs at exposures over and under the one you begin with.

The easiest way to do this is by using your camera's exposure compensation facility, which allows you to override the metered exposure. Most SLRs have this feature, and on modern models you can often increase or reduce the exposure by up to five stops in ⅓, ½ or full stop increments, simply by pressing a button or turning a dial. Some cameras even have an auto-bracketing facility which, when activated, automatically shoots a sequence of three pictures, each at a different exposure.

The extent by which you bracket depends on how tricky the exposure situation is, and the type of film you're using. As mentioned earlier, colour negative film is very tolerant to exposure error, so it would be a waste of film to bracket in increments of less than a full stop. With colour transparency film, however, greater exposure accuracy is required, so it's common to bracket in ⅓ or ½ stop increments.

More often than not, a simple bracket of three pictures – one at the metered exposure, one over it and one under it in ⅓, ½ or full stop increments – should suffice. But if you know that there is a risk of overexposure – when shooting a scene full of dark tones, for example – you would only need to bracket exposures under the metered exposure, not over it. Similarly, if there's a risk of underexposure, as is the case with snowy scenes and bright backgrounds, there would be no point in reducing the exposure any further, so you could simply bracket your shots over the metered exposure.

Bracketing is undoubtedly a useful technique, but should only be used when necessary, otherwise you could find yourself getting through a lot of film very quickly.

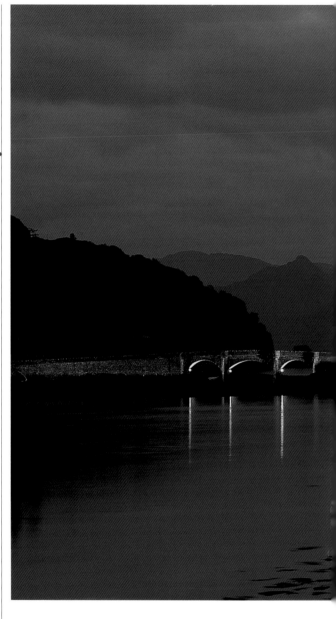

For example, you now know how to prevent a bright background causing underexposure in a picture. But in some situations it would be foolish to do that – such as when you want to create a silhouette (see page 118).

So, once you have mastered the techniques and tricks of advanced exposure, don't be afraid to ignore them from time to time, or at least to adapt the principles to suit your own needs. In the end, the aim of exposure is to ensure that sufficient light reaches the film in your camera to produce the type of image you want, and only you know that.

TOP TIPS

• In tricky lighting you can avoid exposure error by taking a meter reading from an 18 per cent grey card held in front of your subject. These cards are available from most camera stores and often come in sets of two or three different sizes, so you can always keep one in your gadget bag for use on location as and when you need it.

• It's a good idea to make notes of the exposure you use to take pictures in tricky lighting. You can then compare those notes with the pictures you obtain, and if any are ruined by exposure error make sure you don't suffer the same problem again.

• Intentionally underexposing colour transparency film by ⅓ to ½ stop can increase colour saturation.

• When using colour transparency film it's normal practice to expose for the highlights and leave the shadows to their own devices, but with negative film you should expose to record detail in the shadows, as the highlights can be 'burned-In' at the printing stage.

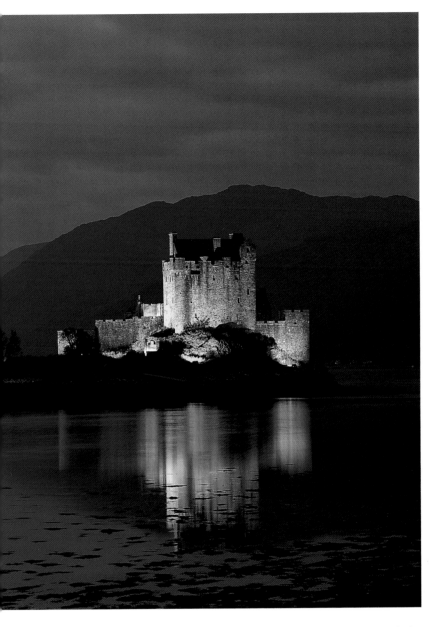

In this shot of Eilean Donan Castle in the Scottish Highlands, the floodlit castle was not only the key feature, but also the brightest part of the scene. Taking a general meter reading would have overexposed the castle as the surrounding scenery, lit only by the last traces of daylight reflected from the sky, was much darker. To avoid exposure error, a handheld spot meter was used to meter direct from the main castle building. The exposure reading obtained – 20 seconds at f/16 – was then bracketed, with the photographer taking pictures at exposures of 10, 15, 20, 30, 40 and 60 seconds at f/16. (See page 58 for more details on techniques for photographing floodlit buildings.)

EQUIPMENT: Pentax 67, 165mm telephoto lens, tripod, cable release, handheld Pentax Digital Spotmeter *FILM:* Fujichrome Velvia ISO50 *EXPOSURE:* 30 seconds at f/16

Using a handheld meter

In many situations, a much quicker and easier method of obtaining an accurate exposure reading is to use a handheld meter, which, as well as measuring reflected light like your camera, also allows you to take incident light readings of the light falling onto a subject or scene. The main advantage of this method is that incident light readings are not influenced by light or dark areas in a scene, so they give accurate results no matter what. The vast majority of experienced photographers use a handheld meter.

To take an incident light reading, hold the meter in front of your subject and point the white metering dome – the 'invercone' – back towards your camera so it measures the light falling onto your subject. If you were shooting a portrait by windowlight (see page 152), for example, you would simply hold the meter a few centimetres in front of your subject's face, point it back to the camera position, press the meter button and obtain an exposure reading. Even if there's a very bright window behind your subject, the reading obtained will still be accurate because the meter is only measuring the light actually falling onto your subject's face, whereas if you took a meter reading with your camera, the brightness of the window would cause underexposure.

If it isn't possible to get up close to your subject – when shooting landscapes, for example – hold the meter up with the invercone pointing behind you, so the light falling on the scene is also falling on the meter.

The only time an incident reading is not suitable is when the light you need to measure isn't within reach. If you are shooting a landscape, for instance, and a distant part of the scene is lit by a pool of sunlight, you need to expose for that area of the scene. An incident reading will measure light levels around you, which will be much lower than in the distance, so in situations like this you need to take a spot meter reading from the sunlit area. Many handheld meters can be fitted with spot attachments for this very purpose.

Architectural Details

The usual approach to architectural photography is to capture whole buildings on film. However, if you take a closer look at each individual building, you'll discover lots of interesting details and aspects of its design that make eye-catching subjects in their own right.

On old buildings ornate carved stonework details, such as figures, faces, columns and cornices, are common, while on newer buildings interesting patterns can be found in the bold, geometric design and repeated features; think of the hundreds of identical windows on a towering office block, or the dynamic pattern created by external steel frames or concrete panels. These smaller details tend to be missed as we rush around without paying much attention to our surroundings, but if you take the time to study the buildings in your neighbourhood you'll discover a wealth of subjects waiting to be photographed.

WHAT YOU NEED

Camera: Any type of camera that accepts interchangeable lenses is ideal for photographing architectural details.

Lenses: As most architectural details are either small or some distance away, telephoto lenses are usually required to isolate them and fill the frame. An 80–200mm or 70–210mm telezoom should be powerful enough.

Accessories: Often you will be looking up at buildings, and this is much easier to do for prolonged periods if the camera is mounted on a tripod; as well as reducing the risk of camera shake, a tripod will aid precise composition.

Filters can also be used – a polariser to deepen blue sky and increase colour saturation, plus an 81B or 81C warm-up to enhance the natural warmth of stonework.

This simple picture of an Orthodox church on the Greek island of Spetse owes its appeal to the bold colours and deep blue sky, which together have produced an eye-catching abstract image. To maximise colour saturation and deepen the blue sky, a polarising filter was used, and the scene was captured during early morning, when the sunlight was clear and crisp, but not too harsh.
EQUIPMENT: Olympus OM4-Ti, 135mm telephoto lens, polarising filter
FILM: Fujichrome Velvia ISO50
EXPOSURE: ⅟₆₀ second at f/8

Film: Use slow-speed film (ISO50–100) to maximise image quality and record every detail with razor-sharpness.

HOW IT'S DONE

The key to success when photographing architectural details is to eliminate all extraneous information so that only the key subject matter is recorded. This means choosing your viewpoint and lens carefully and spending a little time fine-tuning the composition. If any distracting details can be seen creeping into the viewfinder, such as the edge of a street sign, or an annoying blemish on the building, crop it out. Zoom lenses are ideal in this respect because you can make tiny adjustments to focal length, enabling you to compose the picture with great precision.

LOCATION

It's also important to spend time exploring the building and seeking out the best details. Look for patterns emerging, such as the identical windows and columns in old Georgian buildings, or the glass and steel construction of modern office blocks. See what happens when you change viewpoint. A row of columns or buttresses, for example, will look far more interesting when photographed from the side rather than head-on because you'll emphasise the pattern aspect more effectively. Telephoto lenses are ideal for highlighting patterns in a building because they compress perspective and make the repeated features seem closer together.

The stark contrast between old and new also makes for interesting pictures. You could capture the reflection of an old church in the windows of a modern office block, or photograph an ageing building being overshadowed by an enormous skyscraper – again using a telephoto lens to emphasise the effect. On a smaller scale, architectural features such as letterboxes, windows, doors, door knockers and house numbers make great subjects.

TIME

The best time of day to photograph architectural details depends on the type of building. Old stone buildings, such as cottages, churches, castles and cathedrals, tend to look stunning during late afternoon and early evening, when the mellow stonework is bathed in warm sunlight – you can emphasise this using an 81B or 81C warm-up filter.

Modern buildings suit bright, sunny weather as it shows their bold, angular design to advantage, and often allows you to capture reflections of the sky in the windows to produce interesting abstract images. Use a polariser to deepen the blue sky and reduce glare on the windows. Modern office blocks also

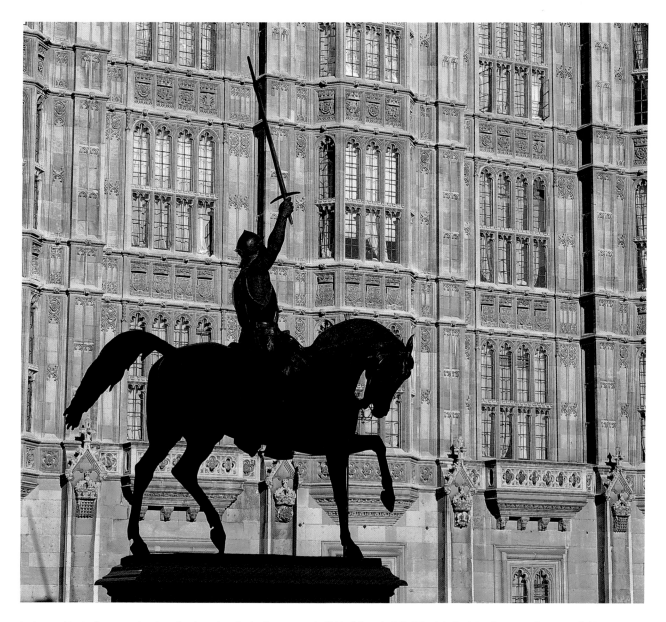

look good just after sunset, when the façade reflects the warm colours in the sky.

TOP TIPS

• Spend time exploring a building for interesting details – the best ones aren't always the most obvious.
• You needn't visit exotic or grand buildings to find eye-catching details – the buildings along your own street can be just as rewarding to photograph.
• The quality of light plays a major role in the success or failure of a picture, so always try to take pictures in the best light.

Old buildings look their best during late afternoon, when warm light from the low sun makes the stonework glow like gold. In this picture of the Houses of Parliament in London, the photographer added extra interest by including the statue in the foreground. A telephoto lens was also used to compress perspective so that the building loomed dramatically in the background. Correct exposure was obtained by taking a meter reading directly off the building with a handheld spot meter. Because little sunlight was falling on the statue, it has recorded as a near-silhouette, simplifying the image for maximum impact.

EQUIPMENT: Pentax 67, 165mm telephoto lens, 81C warm-up filter, tripod **FILM:** *Fujichrome Velvia ISO50* **EXPOSURE:** *⅛ second at f/16*

Autumn Glory

Autumn is a season of dramatic change. After weeks of warm weather and bright sunshine, the countryside begins to wind down in preparation for winter, creating a stunning palette of vibrant, rustic colours.

Deciduous trees shimmer yellow, bronze and red as their leaves die and eventually fall to the ground. Banks of bracken glow russet and gold in the evening sunlight, and the once lush green landscape is transformed into a beautiful patchwork quilt of rich, earthy tones.

All these aspects of autumn create endless opportunities to take stunning pictures, which is why, to many photographers, autumn is the most rewarding time of the year.

WHAT YOU NEED

Camera: As you will be taking pictures in tricky lighting and perhaps using filters, a 35mm SLR is ideal as it gives you control over exposure and offers through-the-lens viewing.

Lenses: Focal lengths from 28–200mm will cover everything from sweeping scenics to detail shots. A macro lens or zoom with a macro mode will also be handy for close-ups of small details such as natural patterns and textures and autumn leaves.

Accessories: A tripod will keep your camera steady when shooting in low light, or when using small apertures for close-up shots which usually result in slow shutter speeds. A polarising filter is also a must for saturating the amazing autumn colours and deepening blue sky, plus an 81B or 81C warm-up filter to enhance the natural light and colour in a scene.

Film: For general use, load up with slow-speed film (ISO50–100) which gives vibrant colours, fine grain and superb sharpness.

HOW IT'S DONE

Your own garden is a good place to start; look for carpets of fallen leaves on the ground and move in close to fill the frame with their beautiful colours. Berries, fungi, spiders' webs covered with dew and autumn flowers make ideal close-up subjects.

Successful pictures can also be taken in your local park; trees full of

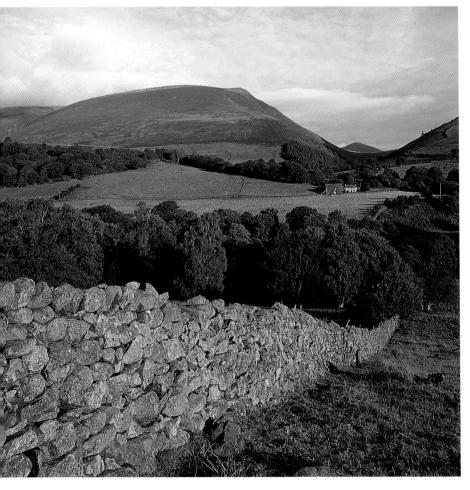

When the photographer first reached this location, thick cloud was drifting across the sky and there was no sign of the early morning sun. Within 30 minutes, however, the clouds parted and suddenly golden sunlight began to rake across the scene, adding a beautiful warm glow to the rustic autumn colours. An 81B warm-up filter was used to enhance the light, and the old stone wall was used as foreground interest to lead the eye through the scene to the cottage in the distance.

EQUIPMENT: Pentax 67, 55mm wide-angle lens, 81B warm-up filter, tripod and cable release **FILM:** *Fujichrome Velvia ISO50*
EXPOSURE: *½ second at f/22*

This woodland scene was photographed on a dull, overcast day when the light was soft and almost shadowless. As there had been heavy rainfall during the morning, a polarising filter was used to reduce glare on the wet foliage so that colour saturation was maximised.
EQUIPMENT: *Pentax 67, 55mm wide-angle lens, tripod, cable release, polarising filter* **FILM:** *Fujichrome Velvia ISO50*
EXPOSURE: *1 second at f/16*

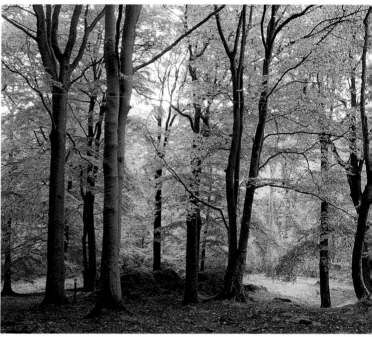

fiery autumn colours look stunning against the blue sky, especially if you use a polarising filter to saturate the colours even more. You can also take candid pictures of people walking their dogs, the park keeper sweeping up leaves on a misty morning, and young children enjoying the novelty of burying themselves in the fallen leaves.

If you visit only one location this autumn, however, make it your local woodland or forest – nowhere else will you find so many different subjects in such a small area. Early in the morning, the autumn woodland is often covered in mist, with the trees fading away in the distance. As the sun rises and rays of golden light break through, you can take beautiful pictures with light 'exploding' from behind the trees.

If you leave the exposure to your camera's integral metering system, the trees will record as striking silhouettes (see page 118), while a warm-up filter can be used to enhance the warm light. You can also produce evocative images by increasing the suggested exposure using your camera's exposure compensation facility. As you give more exposure – up to two or three stops more than the meter sets – the background will brighten and more detail will be revealed in the tree itself, with shadows rushing towards the camera.

TIME

The rustic autumn colours in woodland are best photographed on an overcast day, when the light is very soft and there are no dense shadows or bright highlights to cause problems. Light levels will be very low because little daylight can penetrate the thick canopy, so a tripod will be essential to prevent camera shake. It's also a good idea to use a polarising filter to reduce glare on the damp foliage so the colours look pure and rich.

For autumnal landscapes, early morning and late afternoon tend to be the most rewarding times of day. With the sun low in the sky, long shadows reveal texture and depth, and the light has a beautiful warmth to it; the closer you are to sunrise and sunset, the warmer the light tends to be.

TOP TIPS
• The optimum time to photograph woodland before the leaves begin to fall only lasts a few days.
• Create autumn still-life pictures by collecting things that are associated with the season, such as leaves, berries and fungi.
• The weather can change very quickly during autumn, so be prepared to brave the elements – it may be raining when you set out, but within minutes the sun may break through.

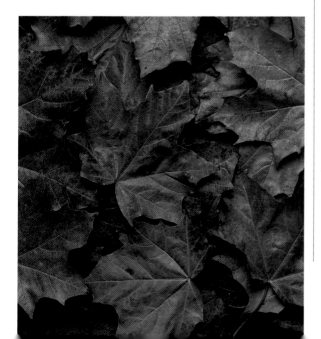

Fallen leaves are probably the easiest autumnal subject to photograph because you can find them literally everywhere. For this picture the photographer collected the leaves in his garden, then took them inside and photographed them in his studio, using a single flash unit fitted with a large softbox to mimic diffuse daylight. The result is a simple but striking image which relies on interesting shapes and warm colours for its appeal.
EQUIPMENT: *Pentax 67, 135mm macro lens, tripod, studio flash and softbox* **FILM:** *Fujichrome Velvia ISO50* **EXPOSURE:** *1/30 second at f/16*

Backlighting

The vast majority of pictures are taken with the main light source – usually the sun – positioned behind the camera so the subject or scene is lit from the front. However, while working in this way is undoubtedly easy, it rarely produces exciting results. This is because when an object is lit head on, shadows fall away from the camera so the image tends to look rather flat and lacks any impression of depth.

Shooting with the main light source on one side of the camera will make a big difference, as shadows become an integral part of the composition, revealing texture and form in your subject. But an even better approach is to shoot 'into the light', in other words, pointing your camera towards the main light source so your subject is backlit. This technique, usually referred to as 'contre-jour' (literally meaning 'against the day') is one of the most exciting photographic techniques available, and can be applied to a wide range of subjects, from portraits to landscapes, both indoors and out.

WHAT YOU NEED

Camera: Contre-jour photography requires precise exposure control, so any camera with a sophisticated metering system will be suitable.

Lenses: Choose focal length to suit the situation – anything from extreme wide-angle to long telephoto can be used.

Accessories: A handheld light meter will help you ensure correct exposure in all situations, though it isn't essential. Contre-jour pictures can also be improved with filters. 81-series warm-up filters are ideal for enhancing warm sunlight,

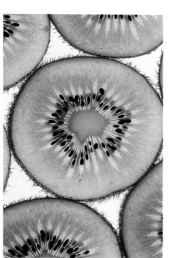

These slices of kiwi fruit were carefully placed on the surface of a slide viewing lightbox, so that the backlighting revealed their beautiful colour and patterns. The same approach can be used to shoot close-ups of leaves and other translucent objects, and because the light source is constant, you can see exactly what kind of result you are going to get. To prevent underexposure due to the brightness of the background, the exposure set by the camera was increased by one stop.
EQUIPMENT: Nikon F90x Prof., 105mm macro lens, tripod
FILM: Fujichrome Velvia ISO50
EXPOSURE: 1/8 second at f/11

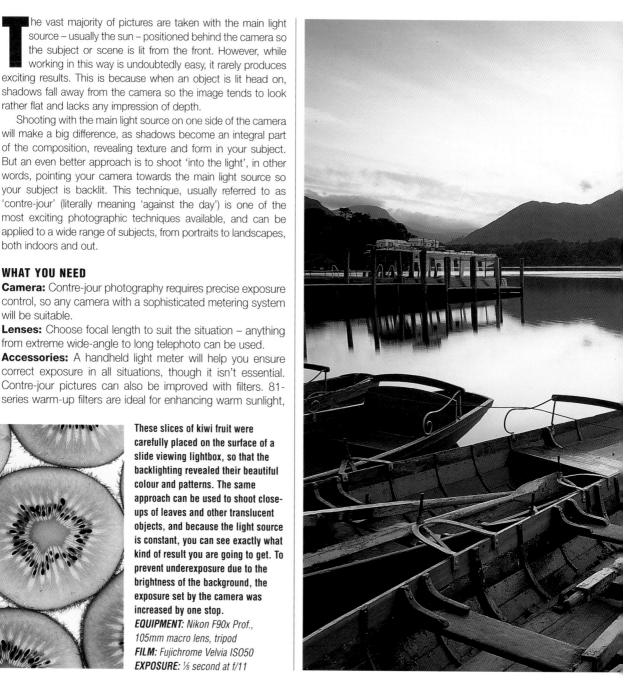

while cooler filters suit contre-jour shots taken in frosty or misty weather. If you want to record foreground detail, a graduated filter will be required to tone down the sky.

Film: Any type or speed of film can be used, though for all the pictures shown here, slow-speed film (ISO50–100) was chosen for optimum image quality.

HOW IT'S DONE

The first thing you need to remember when shooting into the light is that contrast – the difference in brightness between the highlights and shadows – is going to be much higher than normal. This does vary enormously – contrast is much lower on a misty morning than it is during mid-afternoon on a bright and

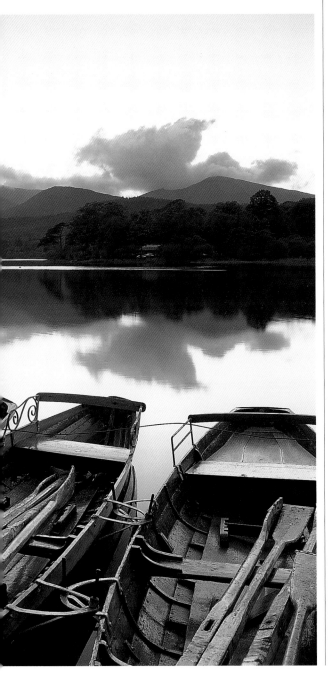

LEFT **This tranquil lake scene is a perfect example of contre-jour photography. Taken shortly after sunset, its appeal is derived mainly from the beautiful colours in the dusk sky, and the vivid reflections in the water which provide a beautiful background to the moored boats. Had the picture been taken before sunset, contrast would have been too great and the mood of the scene lost, so the photographer waited until the perfect moment. To determine the exposure required, a meter reading was taken from the brightest part of the scene – the sky – and another from the boats in the foreground. The average of the two readings was then used as a starting point, and the exposure bracketed over and under it for additional shots.**
EQUIPMENT: *Pentax 67, 55mm wide-angle lens, tripod, 81C warm-up filter* **FILM:** *Fujichrome Velvia ISO50* **EXPOSURE:** *½ second at f/16*

BELOW **Daylight flooding in through the doorway of an old barn has been used here to backlight the young boy. As the difference in brightness between the interior and exterior of the barn was very high, the exposure had to be chosen carefully to record just enough detail in the shadows, without the brighter background completely burning out. This was achieved by taking a spot meter reading off the grass just outside the barn, then increasing it by one stop. The exposure was also bracketed to be sure at least one frame was acceptable.**
EQUIPMENT: *Olympus OM4-Ti, 50mm standard lens* **FILM:** *Fujichrome RD100, ISO100* **EXPOSURE:** *⅟₆₀ second at f/8*

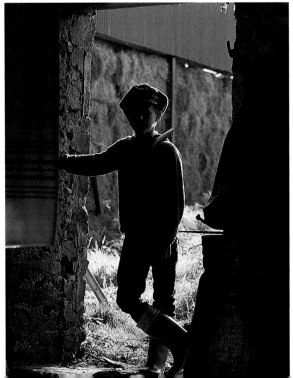

sunny day. Nevertheless, in all situations the background or light source is always going to be much brighter than the rest of the scene, so you need to take great care when determining the exposure.

EXPOSURE

If you rely on your camera's integral metering system, more often than not it will set an exposure that is correct for the bright background, while the much darker foreground records as a silhouette. This in itself can produce stunning results (see page 118), but there are other options available when your subject is backlit, so you need to make a conscious decision about the type of effect you wish to record.

You may decide to record some level of detail in the foreground: when capturing a landscape on a stormy day, for instance, with the sun breaking through the dark, cloudy sky, or at dawn on a misty morning with the sun rising above the horizon. To get this type of shot right you should basically ignore the fact that the background – that is, the sun and sky – is really bright, and concentrate on ensuring that you expose the foreground correctly.

The simplest way to do this is by tilting your camera down so the sky is excluded from the viewfinder and the meter measures light levels in the foreground. All you have to do then is make sure the exposure set doesn't change when you re-compose the shot by setting the camera to manual mode.

Another method is to use your camera's spot or partial metering facility – if it has one – to take an exposure reading from a mid-tone in the scene (see page 13) so that the bright background doesn't influence it. Choose something of a neutral tone, such as green grass, stone, tree bark or slate. This method is ideal in situations where the bright background occupies the whole frame, for example in woodland.

The most foolproof way of ensuring correct exposure, however, is to use a handheld meter and take an incident reading of the light falling on to your main subject, as this is not influenced by excessive brightness behind it (see page 15).

By exposing for the foreground, of course, you're going to overexpose the much brighter background so it burns out. In some situations this can produce evocative 'high-key' images. In woodland, for example, if you expose for the shadows, light will seem to 'explode' around the trees like a halo. This effect can be enhanced using a soft-focus filter so the bright highlights merge into the shadows to add a wonderful glow.

Unfortunately, when shooting contre-jour landscapes the dramatic effect will be lost if the sky is overexposed. To prevent this, you must use a graduated ('grad') filter to darken the sky down and ensure that detail records. This is particularly important when shooting in stormy weather as it is the dark, dramatic sky that will give the shot its impact. The same applies when shooting a sunrise or sunset – if the sun and sky burn out, the atmosphere of the scene will be destroyed.

FILTRATION

Most photographers use a grey 'grad' because it doesn't alter the sky's natural colour. Usually a two-stop (0.6) density grad should darken the sky enough, but in bright conditions you may need a three-stop (0.9) density grad.

When using a grad, you must take an exposure reading without the filter in place and set it on your camera in manual

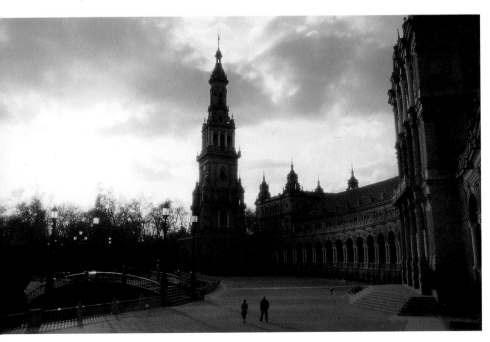

Stormy weather provides ideal conditions for contre-jour photography, and this scene, captured at the Plaza de Espana in Seville, Spain, shows the type of results you can expect. A straight TTL meter reading would probably have resulted in the buildings being reduced to a silhouette due to the brightness of the sky fooling the camera's metering system, so to prevent this the photographer took a spot reading from the paved area in the foreground – where the couple can be seen walking. Knowing this would cause the sky to overexpose, orange 85B and soft-focus filters were used to enhance the romantic feel of the backlit image.
EQUIPMENT: Olympus OM4-Ti, 28mm wide-angle lens, 85B and soft-focus filters **FILM:** *Fujichrome Velvia ISO50* **EXPOSURE:** *¹⁄₃₀ second at f/11*

mode. Once you have determined the exposure, carefully align the filter by sliding it down into its holder until it covers the correct area. If you press the stopdown preview button on your camera or lens this may help you to align it correctly.

In situations where a graduated filter is not required, you can produce different effects by increasing the exposure so the relationship between highlights and shadows is varied. If you start by taking a general meter reading to record the foreground as a silhouette, take additional pictures with the exposure increased by +0.5, +1, +1.5, +2, +2.5 and +3 stops over the initial exposure. This can be done with your camera's exposure compensation facility, and with every increase in exposure the background will become progressively lighter while more detail is revealed in the shadows.

AVOIDING FLARE

One of the biggest problems encountered when shooting into the sun is flare, which reduces contrast, washes out colours and can produce light patterns across your pictures. Flare is caused by non-image-forming light getting into the lens, and is usually a result of a bright light source, such as the sun, being inside or just outside the camera's viewfinder when a picture is taken.

The easiest way to avoid flare is by fitting a hood to your lens so that the front element is protected from stray light glancing across it. Equally important is that you keep your lenses, or any filters on them, spotlessly clean, as dust or greasy finger marks will increase the risk of flare considerably – especially when shooting directly into the sun.

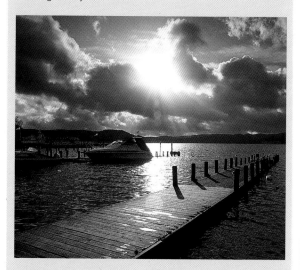

This dramatic picture shows how shooting into the sun can cause flare – you can see a trail of ghostly patches running down from the sun towards the wooden jetty. Although the effect is not too obvious, the image would have been even more successful without it.

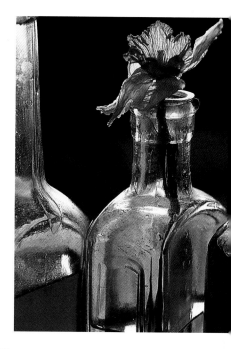

Backlighting can turn everyday objects into appealing images – like these old bottles, which were arranged on a tabletop so that the light coming through a nearby window illuminated them from behind. The background is the wall next to the window, which came out almost black because very little light was falling onto it.
EQUIPMENT: *Olympus OM1n, 50mm standard lens, tripod*
FILM: *Fujichrome RF50, ISO50*
EXPOSURE: *⅟₁₅ second at f/5.6*

INDOOR BACKLIGHTING

Backlighting can also be used indoors in a more controlled way, to create silhouettes of solid objects or to reveal the beautiful colours in translucent objects. If you place a row of bottles on a windowsill at sunset, for example, the warm colours in the sky will pass through the glass to produce a beautiful effect. Similarly, if you light a bottle of white wine from behind using a flash unit, its delicate colour will be revealed.

The easiest way to backlight objects like this is by using a studio flash unit fitted with a large 'softbox' attachment, which diffuses the light and produces an even, white background. However, a similar effect can also be produced by placing a sheet of opal perspex material behind your subject, then firing a flashgun through it.

Alternatively, you can use a slide viewing lightbox if you have one. The light source inside is usually daylight-balanced so it will not produce a colour cast on normal daylight film, and the white viewing panel makes an ideal background on which to position small translucent objects.

TOP TIPS

• Remember that you can produce completely different effects by varying the exposure when shooting into the light.
• If you shoot backlit portraits, brighten up your subject's face using a burst of fill-in flash (see page 52).
• Early morning and late afternoon are the best times to take contre-jour pictures outdoors, as the sun is low in the sky making it easier to include in your pictures.
• See the sections on photographing sunsets (page 138) and shooting silhouettes (118) for more backlighting ideas.

Black and White for Beginners

Newcomers to photography tend to assume that if you want to sample the joys of black and white film, then you must first set yourself up with a darkroom and all the necessary equipment in order to make the most of this fascinating medium.

However, while having access to such facilities is undoubtedly useful, as some of the later sections in this book will show, it's by no means essential if your main aim is simply to start shooting black and white pictures. In fact, you can do this without any more equipment than you already own, or without the need to become involved in processing and printing your own work.

Intrigued? Then read on and all will be revealed.

WHAT YOU NEED

There are currently two different types of film available which allow you to produce high quality black and white images quickly and easily.

Ilford XP2: This is a black and white negative film with a nominal speed rating of ISO400 which is used like any other film. The main difference is that it's processed in the C-41 chemistry normally used for colour negative film, so after exposing a roll in your camera you can simply take it along to any high street lab where it's processed and a set of black and white prints are made on colour printing paper.

Ilford XP2 is renowned for its superb image quality. Grain is very fine considering the speed, and it has the ability to record fine detail with amazing clarity. Like any other negative film it's also highly tolerant to exposure error, so even if you under- or overexpose a shot by one or two stops, you will still end up with an acceptable print.

Agfa Scala: If you prefer shooting slides rather than prints, this film should be ideal for your needs. It's a black and white slide film with a speed rating of ISO200, and was launched by Agfa a few years ago to replace Agfa Dia Direct.

Scala is a great improvement over its predecessor, offering much more speed (Dia-Direct had a nominal rating of ISO12!), and producing sharp, almost grain-free images with lots of punch and an excellent tonal range.

Part of the fun of black and white photography comes after a film has been processed and you can get to work in the darkroom on your prints. But Scala bypasses this and allows you to produce successful pictures just as quickly as you would with colour slide film.

HOW IT'S DONE

You can use both Ilford XP2 and Agfa Scala in the same way that you would use any other black and white film. Both are suitable for any subject, be it portraits, landscapes, still-lifes or architecture, and when used with care are capable of producing high quality images.

Agfa Scala is quite a contrasty film, but when used carefully is capable of high quality results. The main thing you need to remember is that like any slide (transparency) film, it must be exposed with great accuracy, as any exposure error cannot be rectified later. The fine grain and 'punchy' nature of the film have been used to good effect in this portrait. The subject was lit with a single studio flash unit fitted with a softbox and placed at 90° to create bold sidelighting.
EQUIPMENT: *Olympus OM4-Ti, 85mm lens* **FILM:** *Agfa Scala rated at ISO200* **EXPOSURE:** *1/60 second at f/16*

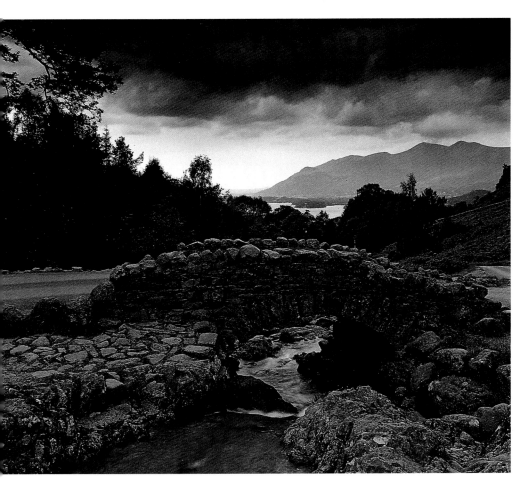

This dark, dramatic landscape was shot on Ilford XP2 in 120 roll-film format and is reproduced direct from a lab-made print. As no darkroom manipulation of the image was possible, the photographer used a grey graduated filter to darken the sky; this would normally be done by 'burning in' the sky area during printing.
EQUIPMENT: Pentax 67, 55mm wide-angle lens, 2-stop (0.6) grey graduated filter, tripod and cable release
FILM: Ilford XP2 rated at ISO400
EXPOSURE: ⅛ second at f/16

The main drawback with Ilford XP2 is that the prints have a tendency to come back from the lab with a colour cast – usually blue or sepia (brown) – because the negatives are printed on colour paper. This colour cast can often look very effective, not unlike a conventional black and white print that has been toned (see page 140), but if you want purely black and white prints, ask the lab – they can usually make sure any colour cast is avoided.

Once the film has been developed, enlargements can be made from any of the negatives onto colour printing paper by your local lab. Alternatively, file away the negatives and if at some point in the future you create your own darkroom, you can enlarge them onto black and white printing paper like any other black and white negative.

As for Scala, a special process is required which only Agfa and one or two professional processing labs provide, so after use you must return the film to the manufacturer or to a suitable lab for processing.

Should you require prints from your black and white Scala slides, these can be made on colour reversal paper, such as Ilford Ilfochrome Classic, in the same way that you would make prints from colour slides. You can also obtain pseudo-toned effects by asking the lab to dial in filtration such as sepia or blue at the printing stage.

TOP TIPS

- To produce successful black and white pictures you need to think slightly differently, and look at your subject in terms of its textures and form rather than colour.
- Some colours look very similar in black and white – red and green record as the same shade of grey, for example. To avoid this, use coloured filters – red, orange, yellow, green and blue are the most common. They work by lightening their own colour and darkening their complementary colour. So, a red filter will lighten red but darken green, while a green filter will lighten green and darken red.
- Coloured filters can also boost contrast to give your black and white pictures more impact. An orange filter makes blue sky look much darker so that white clouds stand out, for instance.
- Both Ilford XP2 and Agfa Scala are available in 35mm and 120 roll-film formats.

Candid Camera

While some people feel completely at ease when posing for pictures, the majority of us feel uncomfortable if a camera is pointed in our direction, and tend to put on a false expression or silly pose. The idea of candid photography is to avoid this by photographing people when they are unaware of the camera's presence, so you can capture them as they really are.

If you get it right the results can be incredibly revealing. No more stiff, starchy poses and forced smiles, but photographs that really capture the energy and humour that many people have. Family and friends will love the pictures you take of them at parties and special occasions, but because the idea of candid

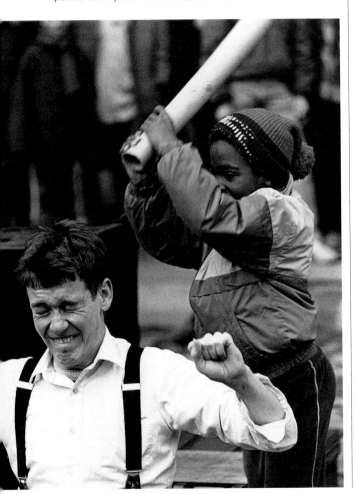

photography is that you remain unseen by your subject, you can also use the technique to capture the trials and tribulations of life on the streets, as strangers go about their everyday business, unaware that somewhere out there an eagle-eyed photographer is waiting to take their picture.

WHAT YOU NEED

Camera: The 35mm SLR is by far the best tool to have for candid photography. It's small, lightweight, quick and easy to use, and allows you to fit a wide range of lenses and accessories. Modern compact cameras with a zoom lens can also be used with success.

Lenses: Telephotos are generally used for candid photography as they allow you to bring distant subjects close and fill the frame without the person knowing. Telephoto lenses also give limited depth-of-field at wide apertures – f/4, f/5.6 – so you can throw distracting backgrounds out of focus. A 200mm telephoto or 70–210mm telezoom should be adequate in most situations.

Wide-angle lenses can also be useful for close-range candid shots taken in crowd situations. Because the angle-of-view of a 28mm or 24mm lens is so great, your subject probably won't even know they're being photographed, even if they see you with a camera pointing in their general direction.

Film: In most outdoor situations, ISO100 film will be fast enough, allowing you to use fast shutter speeds with your lens set to a wide aperture. Indoors or outdoors in low light, use faster film – ISO400 should make a good starting point.

HOW IT'S DONE
Location

Anywhere that you find people out and about doing things, involved in activities or simply enjoying themselves will provide ample opportunities to shoot interesting candid pictures. Town and city streets are an obvious place to start. The hustle and bustle of life provides a never-ending flow of subject matter:

Street entertainers make ideal candid subjects – not least because they're used to having a camera pointed in their direction and tend to take little or no notice. This picture was taken in London's Covent Garden, a haven for buskers and entertainers where any photographer could spend a fruitful afternoon capturing the activity on film. Anticipating what was about to happen, the photographer waited until the young boy was about to strike his victim with a cardboard tube and managed to capture the painful expression on his face.
EQUIPMENT: Olympus OM2n, 135mm telephoto lens **FILM:** *Ilford HP5 rated at ISO1600 and push-processed by two stops* **EXPOSURE:** *$\frac{1}{250}$ second at f/5.6*

mothers struggling with small children, buskers entertaining shoppers, people arguing, pavement artists, workmen – the list goes on and on.

Markets and car boot sales are also ideal haunts for the eagle-eyed candid photographer. There are lots of places where you can hide yourself away, and because everyone is busy with more important tasks, such as doing their shopping, there's less chance of you being spotted. The same applies with street parties, festivals, country fairs and carnivals.

Holidays can also be a good source of candid moments. When people take their clothes off they often shed their inhibitions as well, so the beach is a perfect hunting ground. Watch out for old couples snoozing in their deckchairs, young couples in fond embrace, kids paddling in the sea or burying dad in the sand.

Focusing

The key to success is being alert, and quick off the mark. Opportunities come and go in the blink of an eye, so you have to learn to concentrate on your subject completely and anticipate the moment, waiting for an interesting expression, and then acting on it without delay.

To be able to do that you have to learn to use your camera instinctively. You won't shoot successful candids if you're worrying about whether or not the right exposure has been set, or fiddling around with buttons and dials, so you need to make using your camera second nature. That way, when you come across an interesting subject you can raise the camera, focus and take a picture in a second or two, before anyone realises what you're doing.

This is best achieved by setting your camera to an automatic exposure mode. Program is the quickest, but aperture priority is better because it allows you to control depth-of-field; the usual approach with candid photography is to set a wide aperture such as f/4 or f/5.6 so the background is thrown out of focus and all attention is directed on your unsuspecting subject.

If you use an autofocus SLR, accurate focusing won't pose any problems, providing you keep the AF target area in the viewfinder over your subject. If not, practise your fast-focusing skills until you become more confident, or learn how to estimate distance so that in tricky candid situations you can pre-focus on an object that's as far away from the camera as your subject.

Finally, to be successful at candid photography you need to learn how to blend in with your surroundings. So avoid wearing bright, conspicuous clothes, and don't carry your equipment in a bag that's obviously designed for photography. In fact, if you just carry one camera and lens, you won't need a bag at all.

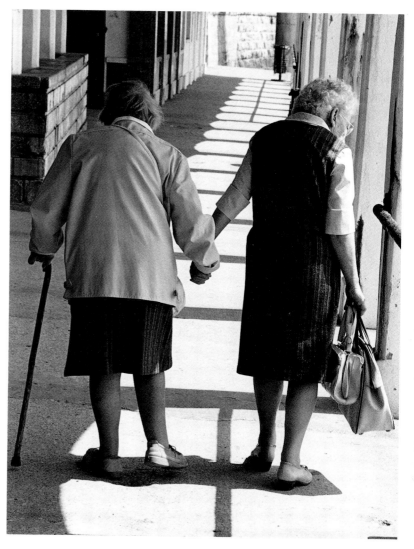

To produce successful candid pictures your subjects need not be looking directly at the camera. These two elderly ladies walking hand-in-hand made a rather touching sight, so the photographer waited until they had walked past him before grabbing a quick picture.
*EQUIPMENT: Olympus OM1n, 85mm telephoto lens **FILM:** Ilford HP5 rated at ISO400 **EXPOSURE:** 1/125 second at f/5.6*

TOP TIPS

• Keep a camera with you at all times so that you never miss any good candid opportunities.

• Always try to remain as inconspicuous as possible so there's less chance of you being spotted.

• If you are spotted, and your subject confronts you, politely explain what you were doing, and why. Not everyone likes the idea of being photographed.

Character Portraits

The aim of portraiture is not only to capture a physical likeness of your subject on film, but some aspect of their personality too, so that when other people look at that picture they learn a little about the person depicted in it.

The easiest way to do this is by photographing people when they are unaware of the camera and don't have the opportunity to 'put up a front', as explained in Candid Camera (see page 26). Another method is to include your subject's surroundings in the picture, a technique explored later in this book in Environmental Portraits (see page 48).

In more formal situations where it's just you and your subject, capturing their character on film can be more difficult, mainly because most people tend to feel uneasy when posing for portraits. You therefore need to use your skills both as a photographer and as a communicator to make your subject feel relaxed, and to draw out their personality, so you end up with natural, revealing portraits.

WHAT YOU NEED

Camera: Any type or format of camera can be used for portraiture. The most important factor is that you are able to operate it quickly without thought so that you don't miss any revealing expressions, which tend to come and go very quickly.

Lens: A short telephoto lens with a focal length from 85–135mm is considered the best choice for portraiture. The main reason for this is that short telephotos slightly compress perspective and flatter facial features. They also allow you to work from a comfortable distance and fill the frame with your subject's head and shoulders. By shooting at a wide aperture such as f/4, depth-of-field will be limited so distracting background detail is thrown well out of focus, making your subject the most prominent feature in the picture.

Film: Both colour and black and white film can be used to produce successful character portraits. Many photographers insist that black and white is better, as the lack of colour places more emphasis on the subject, but, as you can see from the portraits shown, colour can be just as effective when used sympathetically. In terms of speed, ISO50–100 film is ideal when you want sharp, grain-free images, but faster films can also be employed to create grainy portraits.

Accessories: A tripod can be useful for portraiture, as it gives the sitter a reference point and means you can take pictures without being hidden away behind your camera. When shooting outdoors, an 81B warm-up filter is ideal for flattering your subject's skin tones by warming up the image slightly.

HOW IT'S DONE

If you want to capture a person's character on film they must feel completely relaxed and comfortable in front of the camera. This can be achieved in a number of ways.

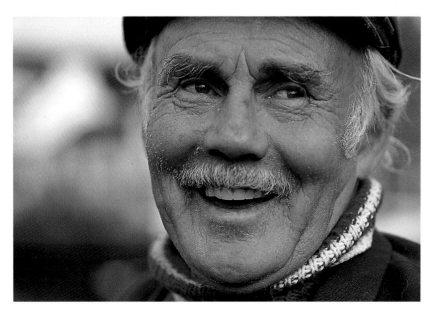

This interesting old gentleman was noticed sitting by the harbour in a small Scottish town. Realising he would make a perfect subject, the photographer approached him and, after a little while, during which the gentleman recalled his life as a fisherman in the area, asked if he could take a few pictures. By this time another local had wandered along, so while the subject was chatting to him the photographer started taking pictures, capturing a range of different expressions and shooting off a whole roll of film in the space of a few minutes. No prompting from the photographer was required – the expression is completely natural, and the subject was so engrossed in his conversation that he didn't even appear to know the camera was there. Shooting at a wide aperture ensured that the background was thrown out of focus.
EQUIPMENT: Olympus OM4-Ti, 85mm telephoto lens FILM: Fujichrome RDP100 ISO100
EXPOSURE: ⅟₂₅₀ second at f/4

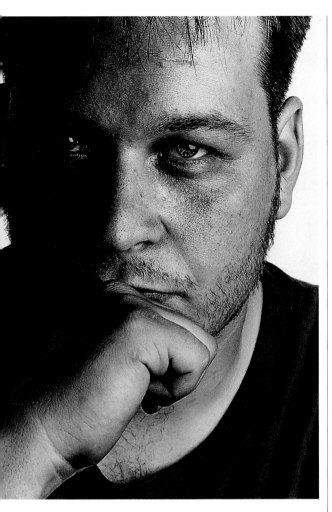

The studio is a much more formal environment for portraiture, so even greater care is required. In this bold black and white portrait, the subject is a friend of the photographer, so any problems with him feeling uneasy in front of the camera were quickly overcome due to their relationship and mutual respect for one another. The subject was lit using a single flash unit fitted with a softbox and placed to the right of the camera, while two more lights were used to illuminate the white paper background.

EQUIPMENT: *Pentax 67, 165mm telephoto lens (equivalent to 85mm in 35mm format), three studio flash units, softbox, tripod* **FILM:** *Ilford FP4 Plus rated at ISO125* **EXPOSURE:** *⅛₀ second at f/16*

more you know about a person, the more control you will have over the situation and the portraits you take.

Third, plan everything beforehand so you can keep the shoot short and sweet. Decide on a location, have a few ideas for pictures in your head and set up your equipment so you can get to work straightaway. Posing for portraits can quickly become rather tiresome, so unless you get a few good shots in the bag within the first 20 minutes, it's unlikely you ever will.

If you are working indoors in a studio environment, keep the lighting simple so you don't have to take complicated exposure readings. A single flash unit fitted with a softbox is ideal for portraits of men, and when placed at 45 – 90° to your subject will produce bold illumination that shows off their sculptured features and reveals the texture in their skin. If you are photographing a woman or a girl, use softer, more even illumination so there are no harsh shadows. Two flash heads and softboxes positioned on either side of the camera are ideal.

Alternatively, pose your subject next to a window and use the light flooding in (see page 152).

Outdoors, the soft light of a bright but slightly overcast day is ideal for portraiture as contrast is low so there are no harsh shadows and bright highlights to contend with. If you are forced to work in bright sunlight, pose your subject in the shade where the light is soft and shadowless, or position them so that the sun is behind them, and use a reflector to bounce light into their face.

The most effective portraits tend to be the simplest, because the less equipment you have to worry about, the more you can concentrate on your subject. If you remember that, you won't go far wrong.

TOP TIPS

• Taking a picture is the easiest and least important part of portraiture – communicating with your subject and putting them at ease is far more crucial if you want to produce natural, revealing images.

• Always give the impression that you're confident and in control, even if you're as nervous as your sitter inside; if they sense you don't know what you're doing, you'll never put them at ease.

• The best expressions tend to come and go in a split second, so always make sure you're ready to capture them.

• Be prepared to shoot plenty of film in order to produce one successful portrait.

First, talk to your subject. Get them chatting about something of mutual interest, so they feel less nervous. Within a few minutes they will forget about the camera, and you can grab pictures whenever an interesting expression appears.

Second, never ask your subject to smile or say 'cheese'. A real smile comes from within, and the only way you can make a person do that is by giving them something to smile about – by telling a joke, or talking about a humorous topic, for example. Often, of course, you won't want your subject to smile. If you look at the work of successful portrait photographers you will often see that their subjects have a more thoughtful, serious expression, and this tends to be far more revealing.

Again, the way your subject responds to the camera depends on how they feel, so if you want a serious portrait, talk about a serious subject, or discuss something that you know will generate the right kind of response. Perhaps the person you are photographing has strong views on politics or the environment, or maybe they are going through a difficult time in their life. The

Close-Ups

Most pictures are taken with the camera held at eye-level and depict subjects or scenes that are clearly visible to the naked eye. However, if you go beyond these obvious subjects and begin to take a closer look at the things around you, you will discover a whole new world of photographic opportunities.

It's a known fact, for example, that well over 95 per cent of life on earth is microscopic, so no matter how many pictures you take during your career as a photographer, you will only ever scratch the surface of what's on offer. But to produce interesting close-up images, you needn't go to such lengths, because with simple equipment and a little patience, you can record an endless range of much more accessible subjects, and the techniques involved can be as simple or as complicated as you like.

WHAT YOU NEED

Camera: A 35mm SLR is the most suitable type of camera for close-up photography, as it can be fitted with a wide range of readily available accessories, the most popular of which are as follows.

Macro zooms: Many zoom lenses have a close-focusing ability which usually gives a reproduction ratio up to 1:4 (one-quarter lifesize). This means that you can fill the viewfinder of your SLR with a subject that's around 100mm long, such as flowers, small mammals and a variety of household objects.

This flower was photographed at almost lifesize magnification to highlight the vibrant colour of the petals against the detailed yellow centre. The camera was carefully positioned directly over the flower, and the lens aperture set to f/22 to maximise depth-of-field. The flower was also lit with a small electronic flashgun held next to the lens to give crisp, even illumination.

EQUIPMENT: Nikon F90x Prof., 105mm macro lens, tripod, cable release, flashgun **FILM:** Fujichrome Velvia ISO50 **EXPOSURE:** 1/60 second at f/22

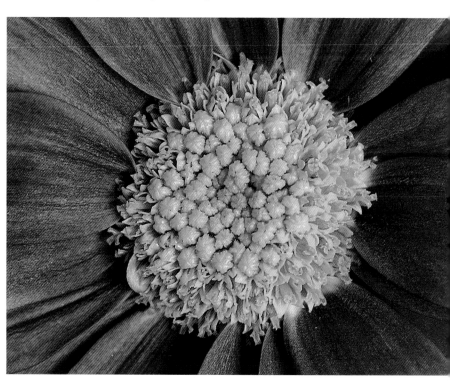

Supplementary close-up lenses: These inexpensive attachments are an ideal introduction to the world of close-up photography. They fit to the front of your lens in the same way as filters, and reduce its minimum focusing distance so that you can get closer to your subject.

The power of close-up lenses is measured in dioptres – the most common are +1, +2, +3 and +4. The bigger the number, the greater the magnification. A +4 dioptre lens used on a 50mm standard lens with the focus set to 1 metre will give a reproduction ratio of 1:4 (one-quarter lifesize).

More than one close-up lens can be used in combination in order to give increased power, but in doing so you will reduce image sharpness. You should also use close-up lenses with prime (fixed focal length) lenses rather than zooms – the 50mm standard lens is ideal.

Reversing ring: This handy accessory allows you to mount a lens on your camera back to front, so you can work at much closer focusing distances. The advantage of reversing rings is that they don't affect the optical quality of your lens. The main drawback is that you lose all linkage between the camera and lens, so the metering system and aperture stopdown no longer work. Reversing rings are ideal if you're on a tight budget. They

can also be used with bellows or extension tubes to provide extra power for macro pictures.

Macro lenses: For convenience, nothing beats a purpose-made macro lens that's designed to give optimum image quality at close-focusing distances.

The focal length tends to be either 50/55mm or 90/100/105mm, although there are one or two 180mm macro lenses available as well. All types are useful, but the longer focal lengths are more suited to nature photography because they allow you to shoot from further away, reducing the risk of scaring timid subjects such as butterflies. The 90–105mm macro lenses are also ideal for portrait photography.

Most macro lenses offer a reproduction ratio of 1:2 (half lifesize), although some of the longer focal lengths are capable of 1:1 (lifesize) reproduction.

Extension tubes: These simple, metal rings fit between the lens and camera body and increase the distance between the lens and film plane so greater image magnification is obtained. The tubes normally come as a set of three and can be used individually or in combination to obtain different reproduction ratios. The more expensive makes also allow automatic aperture stopdown and TTL metering to be used.

When the length of extension matches the focal length of the lens, the reproduction ratio obtained is 1:1 – that is, lifesize. So, to obtain lifesize reproduction with a 50mm standard lens, you need to use a 50mm extension tube.

Bellows: These work in the same way as extension tubes, but the concertina design allows you to control the reproduction ratio much more accurately. They also allow more extension to be used – often up to 150mm, which would give a reproduction ratio of 3x lifesize with a 50mm standard lens. This means that you can fill the viewfinder of your 35mm SLR with tiny subjects, and as no additional lenses are required, other than the one that you fit to the end, the image quality is superb.

Focusing

The most important thing you need to be aware of is that depth-of-field is limited at close-focusing distances, so it may be impossible to record all of your subject in sharp focus. To maximise what little depth-of-field there is – the closer you are to your subject the less there will be – always use the smallest lens aperture possible, usually f/16 or f/22. You should also focus carefully on the most important part of your subject so at least that area will be sharp.

Unfortunately, as a direct result of selecting a small lens aperture, you will often find that a slow shutter speed is required to give correct exposure, even in bright sunlight. This is partly due to the exposure increase required when you use bellows, extension tubes or a macro·lens.

A tripod is essential to prevent camera shake, although you should use one anyway for close-up photography as it will aid accurate focusing. It is also advisable to use a cable release to trip the camera's shutter, and to use the mirror-lock facility (if your camera has one) to lock up the reflex mirror inside the camera, thus reducing vibrations when a picture is taken.

HOW IT'S DONE

Armed with any of the items mentioned earlier, you can produce eye-catching close-ups of literally anything. If you're fond of natural history then flowers, plants, butterflies and insects are ideal, but even simple household objects can look fascinating when viewed in close-up – try taking pictures of the bristle on a toothbrush, for example.

Patterns and textures can also be revealed by close-up equipment that you may not be able to see or appreciate with the naked eye. Lichens on rocks, the veins in a leaf, the lines on the underside of a mushroom, or the scales on a pineapple are just a few examples of the kind of things you can photograph.

Simple close-up pictures can be taken of all kinds of subjects. Here a blade of grass coated in droplets of dew was noticed while the photographer explored his garden for interesting specimens, and recorded using a 105mm macro lens in the soft light of a dull day. A painted door behind the grass created a perfect background, its neutral colours helping to emphasise the main subject perfectly. A moderate aperture of f/8 was chosen to ensure that the background was thrown well out of focus. As this meant depth-of-field would be very limited, careful focusing on the grass was necessary.

EQUIPMENT: Nikon F90x Prof., 105mm macro lens, tripod, cable release
FILM: Fujichrome Velvia ISO50 ***EXPOSURE:*** *¹⁄₁₅ second at f/8*

This picture shows the delicate petals of a sunflower, which were photographed in natural window light using a macro lens at lifesize magnification. Although a small aperture is normally used to maximise depth-of-field, here the photographer decided to set a wider aperture – f/5.6 – so that only the tips of the petals were recorded in sharp focus.
EQUIPMENT: Nikon F90x Prof., 105mm macro lens, tripod, cable release **FILM:** *Fujichrome Velvia ISO50* **EXPOSURE:** *⅟₆₀ second at f/5.6*

Of course, while a tripod will keep your camera steady, you will still end up with blurred pictures if your subject moves. This problem can be partly overcome by erecting a windbreak to shield your subject if you're taking pictures outdoors in windy weather, but a much better method is to use electronic flash.

Lighting

The main benefit of using flash for close-up photography is that it allows you to set a much faster shutter speed – the correct sync speed on most SLRs is at least ⅟₆₀ second. In addition, the brief burst of light will freeze any subject movement, and because you're providing lots of light you can still work at small lens apertures to maximise depth-of-field.

You can actually buy a special type of flashgun for close-up photography known as a 'ring flash'. This comprises a circular flash tube which fits around the end of your camera lens so the subject is flooded with even light. However, most close-up photographers simply use one or two small, low-powered flashguns which are either held next to the camera, or fitted on a special bracket which positions them close to the lens. Mounting the flashgun on the camera's hotshoe is usually unsuitable for close-up photography as your subject won't be evenly lit, and a shadow may be cast by the lens.

If you use a dedicated flashgun and connect it to your camera with a dedicated sync lead, you may find that it's possible to take perfectly exposed close-up shots with no trouble whatsoever. However, normal flashguns are not really designed to be used at such small flash-to-subject distances, so overexposure may occur, especially if the flashgun is quite powerful.

An easy way of overcoming this problem is to buy an inexpensive low-powered manual flash unit, which always fires on the same power output. Flashguns with a guide number (GN) of 12 to 20 are the most suitable. You can use the following formula to calculate the aperture required to give correct exposure.

Correct aperture = Guide number (in metres at ISO100) / Flash-to-subject distance (m) x (magnification + 1)

For example, if your flashgun has a guide number of 12 (metres at ISO100), the flash-to-subject distance is 50cm, and the magnification is 0.5x (a reproduction ratio of 1:2, or half lifesize), the aperture required = 12/0.5 x (0.5+1) = 12/0.75 = f/16.

Using the formula to calculate the correct aperture at different flash-to-subject distances and image magnifications, you can produce a handy table which, when taped to the back of your flashgun, can be referred to whenever you use it.

REPRODUCTION RATIOS

Two common terms used by close-up photographers are 'reproduction ratio' and 'magnification'. They basically refer to the size of your subject on a frame of film compared to its size in real life, and help to express the power of close-up equipment.

If you photograph a subject measuring 2cm in real life so it measures 1cm on a 35mm slide or negative, the reproduction ratio is 1:2, or half lifesize, and the magnification 0.5x. If the same subject measures 0.5cm on a frame of film, the ratio is 1:4, or one-quarter lifesize, and the magnification 0.25x; if it measures 2cm the ratio is 1:1, or lifesize, and the magnification 1x.

EXPOSURE COMPENSATION

Depending upon the type of equipment you're using to shoot close-ups and macro pictures, the exposure may or may not need to be increased.

Supplementary close-up lenses and reversing rings require no exposure increase because they don't cause a light loss, but bellows, extension tubes and macro lenses do because they work by increasing the lens-to-film distance, so the amount of light reaching the film is reduced.

Cameras with TTL (through-the-lens) metering will, in theory, account for any light loss because they are measuring light levels reaching the film. However, while this can be relied upon with macro lenses, accurate exposures may not be obtained when using bellows and extension tubes so it's worth taking an exposure reading without them in place, then increasing the exposure accordingly to compensate for any light loss. Alternatively, use a handheld meter to take an exposure reading, then increase it as required.

The table below gives the recommended exposure increase for various common reproduction ratios.

Reproduction ratio	Magnification	Exposure factor	Exposure increase (in stops)
1:10	0.1x	x1.2	⅓
1:5	0.2x	x1.4	½
1:2.5	0.4x	x2	1
1:2	0.5x	x2.3	1⅓
1:1.4	0.7x	x2.9	1½
1:1	1x	x4	2
1.2:1	1.2x	x4.8	2⅓
1.4:1	1.4x	x5.8	2½
1.8:1	1.8x	x7.8	3
2:1	2x	x9	3⅓
2.4:1	2.4x	x11.6	3½
3:1	3x	x16	4

There are two factors to remember. First, the formula is correct for ISO100 film, so if you use ISO50 film you need to set the lens aperture one stop wider – f/11 instead of f/16, for example. Similarly, if you use ISO200 film, you must select the next smallest aperture – f/22 instead of f/16.

Second, if you're using a macro lens, bellows or extension tubes, remember also that you need to increase the exposure to compensate for any light loss. When using flash, this should be done by setting a wider aperture as it's the lens aperture which affects flash exposure, not the shutter speed (see Exposure Compensation panel).

TOP TIPS

• Be very quiet when photographing live subjects such as butterflies. Avoid making any sudden movements or casting your own shadow over them as this spoils the lighting.

• Choose the background to your close-ups carefully. Anything plain, such as green foliage, is ideal. Carry a few pieces of card in your gadget bag, so they can be slipped behind your subject to create a backdrop.

• Use white reflectors to fill in shadows and provide more evenly lit results when shooting close-ups in available light.

• A small, low-powered flashgun is ideal for close-up photography. The light is quite harsh but, because the source is very big in relation to the size of your subject, it will give soft, flattering illumination.

Noticing a proliferation of ladybirds in his garden, the photographer pushed a blade of grass into the soft soil then set up his equipment, focused on the tip of the blade of grass and hoped that before too long a ladybird would use it as a perch! Within a few minutes this inquisitive creature arrived, and as soon as it reached the top of the grass the picture was taken. A wide lens aperture – f/4 – was used to limit depth-of-field so only the ladybird was recorded in sharp focus while everything else faded to a blur.

EQUIPMENT: *Nikon F90x Prof., 105mm macro lens, tripod, cable release*
FILM: *Fujichrome Velvia ISO50* **EXPOSURE:** *⅟₆₀ second at f/4*

Colourful Creations

For most of us, colour is a vital part of every picture we take. We live in a colourful world, after all, so it's natural to try and record this so our work captures a true representation of the things we see.

Colour can do far more than simply make something look real, however. It has symbolic powers, and an ability to evoke a certain response. When used creatively, colour can also dominate a picture, and become more important than the subject matter itself.

When using colour in this way, the key is to think of it in a more abstract sense, rather than for what it really is. A vibrant yellow car photographed against a blue garage door can create a powerful image, for example, but that power isn't generated by the car and the door, but by the juxtaposition of the contrasting colours in the scene. Similarly, a field of golden corn may not make a particularly interesting subject, but if there happens to be a bright red poppy growing in the middle of it, suddenly you have the making of a successful image.

WHAT YOU NEED

Camera: An eye for a picture and the ability to juxtapose colours in an effective way is far more important than the type of camera you use with this technique, so anything from a simple compact to a sophisticated SLR can be used.

Lenses: Choose whichever focal length you need to make the most of the colours in a scene. In some situations a wide-angle lens will be required, while in others a telephoto lens will be more suitable for picking out interesting areas of colour.

Accessories: Use a polarising filter to reduce glare on non-metallic surfaces and increase colour saturation, or colour filters such as red, orange and blue to add an overall cast to your shots.

Film: Some films are better than others at making colours look as bright as possible. To date, Fujichrome Velvia is considered the best choice in this respect.

HOW IT'S DONE
Location

Colour can be found literally anywhere – all you have to do is train yourself to find it. This means trying to overcome familiarity and looking at things in terms of their photographic merit rather than what they really are.

For instance, you probably see colourful road signs dozens of times every single day, but how many times have you thought of them as potential subjects? Probably never. But, when approached in a creative way, even something as simple as this can make an excellent abstract image – try shooting a bright red sign against the blue sky, or a painted door.

These colourful peppers were bought and arranged specifically for the picture. To fill the frame with colour the photographer used a 105mm macro lens from close range, while a single studio flash unit fitted with a large softbox produced diffuse, even illumination and revealed the vibrant colours of the peppers. Shooting on Fujichrome Velvia slide film also helped to maximise colour saturation.
*EQUIPMENT: Nikon F90x Prof., 105mm macro lens, tripod, studio flash and softbox **FILM:** Fujichrome Velvia ISO50 **EXPOSURE:** 1/60 second at f/11*

– the countryside can be an excellent source of colourful pictures. Fields of vibrant yellow oil-seed rape swaying in the breeze look stunning when captured against the deep blue sky, as do beds of spring flowers such as tulips, especially if you use a telephoto lens to home in on the areas of colour. A bright red telephone or postbox can also add impact to a green landscape, as can a red lifebuoy on the side of a pier.

Composition

If you don't find any suitable subjects in town or country, make your own by arranging colourful objects together. A trip to your local supermarket will reveal all sorts of colourful fruit and vegetables, even packaging, while vibrant flowers can be purchased from your local florist.

Whatever your subject is, think carefully about how you can make the most of its colour. Keep the composition simple so that the colour becomes the main point of interest and all extraneous details are excluded. With a small subject like a flower this

Vibrant slabs of colour can be found in the landscape – like this field of yellow oil-seed rape. The picture was taken in bright sunlight, with a polarising filter to increase colour saturation and deepen the blue sky. Use of a wide-angle lens allowed the photographer to make the yellow flowers dominate the foreground, and the ratio of 2:1 between the landscape and sky has produced a simple, graphic composition.
EQUIPMENT: *Olympus OM4-Ti, 28mm wide-angle lens, polarising filter*
FILM: *Fujichrome Velvia ISO50* **EXPOSURE:** *1/30 second at f/11*

may involve moving in really close with a macro lens, while on a larger scale you may need to adjust your viewpoint or change lenses to capture one area of colour against another. Telephoto lenses are ideal for doing this as they compress perspective to make the elements in a scene appear closer together, while a wide-angle lens used from a low angle will allow you to capture colourful subjects against the sky.

Once you're happy with the composition, think about how you can maximise colour saturation. Bright, sunny weather makes colour look much stronger than dull, overcast conditions, but in the summer you may find that the light is too harsh around midday, and early morning or late afternoon give better results.

Urban areas are undoubtedly the best hunting ground for colourful subjects as there's so much going on, and the 'landscape' is forever changing as traffic moves through the congested streets, posters are billed on walls, buildings are given a fresh coat of paint, and so on. So why not spend a day scouring your neighbourhood for interesting subjects? Look for one strong colour against another – such as a car parked opposite a painted wall, or vivid green ivy growing around a colourful door. The brightly coloured panels of industrial buildings also make effective backdrops to other colours. Once you start looking at things in terms of their colour content it's surprising how many interesting subjects you'll find.

Of course, you need not limit your search to towns and cities

TOP TIPS
• Slight underexposure – ½ or ⅓ stop – will also make colours look more intense when shooting slide film.
• You can make the colours in a slide look more intense by copying the slide onto another roll of slide film (see page 44).
• For maximum impact, juxtapose colours in a picture that contrast with each other, such as yellow and blue.
• Red is the most dominant colour of all, and will dominate a picture even when it only occupies a tiny area.

Red is the most noticeable colour, and has the ability to dominate a picture even when it only occupies a tiny area. If you accidentally include a red object in a shot this can have disastrous consequences, but when used creatively it can make all the difference to a picture. If you place your finger over the red sports car in this picture, for instance, the scene appears empty and uninteresting, but take your finger away and the small splash of colour screams out for attention.
EQUIPMENT: *Nikon F90x Prof., 20mm wide-angle lens, polarising filter*
FILM: *Fujichrome Velvia ISO50* **EXPOSURE:** *1/60 second at f/8*

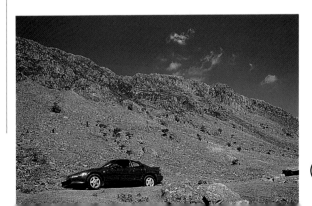

Colour Infrared

olour infrared film was designed mainly for aerial surveillance work, but creative photographers soon discovered that it could also be used to produce unusual images. The beauty of this film is that it is sensitive mainly to light at the infrared end of the spectrum, so it records the world in a completely different way to how the human eye sees it.

WHAT YOU NEED

Camera: Colour infrared film is best suited to 35mm SLRs which give some degree of control over exposure and focusing.

Lenses: Any lens can be used, though wide-angle focal lengths are recommended as they give extensive depth-of-field.

Film: Only one brand of colour infrared film is available – Kodak Ektachrome EIR – which comes in 35mm rolls.

Accessories: Colour infrared film must be used with a coloured filter. Kodak recommend a deep yellow, but red, orange, green and sepia all give interesting results – see pictures below.

HOW TO USE IT

There are a few important factors you need to understand about colour infrared film if you are to get the most out of it.

Loading

Whereas black and white infrared film (see page 88) must be loaded in complete darkness to avoid fogging, colour infrared film is not quite as sensitive and can be loaded in subdued light. If you are outdoors in sunny weather, shield your camera with a jacket while loading the film, step inside a building or load in the shade.

ISO rating

Colour infrared film is not DX-coded, so set your camera's film speed setting to ISO200. You can then take TTL meter readings with a coloured filter fitted to your lens and your camera's metering system will automatically compensate for any light loss incurred by the filter.

Exposure

Even if you follow the advice given above, taking a correctly exposed picture with colour infrared film can still be tricky. This is because the way it responds depends on how much infrared radiation there is in the atmosphere, a factor that is influenced by weather conditions, the time of year and so on, but which can't be measured using a conventional light meter. Additionally, colour infrared film is very contrasty, so if you don't get the exposure exactly right, highlights will burn out and shadows block up.

The easiest way around this problem is to bracket your exposures over and under the suggested exposure by at least a stop, in half-stop increments. So, if your meter sets an exposure of $\frac{1}{60}$ second at f/16, take one shot at this exposure and others at the following: $\frac{1}{60}$ second at f/11.5, $\frac{1}{60}$ second at f/11, $\frac{1}{60}$ second at f/16.5, and $\frac{1}{60}$ second at f/22. That way, at least one of the frames should be acceptable. This may seem a waste of film, but it's far better to get a handful of perfect shots from a roll than none at all.

Original scene on Fuji Velvia.

Kodak Ektachrome EIR with yellow filter.

Kodak Ektachrome EIR with orange filter.

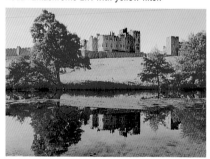

Kodak Ektachrome EIR with red filter.

This set of pictures shows the strange way in which colour infrared film records the world compared to conventional film, and how by using different filters you can vary the effect even further.

EQUIPMENT: *Olympus OM4-Ti, 28mm wide-angle lens, various coloured filters*
FILM: *Kodak Ektachrome Colour Infrared rated at ISO200* **EXPOSURE:** *Various*

Focusing

Infrared radiation focuses on a slightly different point to light in the visible spectrum, so you need to take care when using colour infrared film. The easiest way to ensure perfectly focused images is by using a wide-angle lens and the smallest lens aperture you can get away with – f/11, f/16, f/22. Doing so will give increased depth-of-field and prevent your pictures coming out less than sharp due to inaccuracy in focusing.

Processing

The old type of colour infrared film had to be processed using an old E-4 system which only one or two labs in the UK offered. Fortunately, this film has now been replaced with a new E-6 compatible version, so it can be processed at your local lab along with ordinary colour slide film.

Just one word of warning – when you take any exposed colour infrared film for processing, be sure to tell the lab exactly what it is. There are three reasons for doing this.

Firstly, the vast majority of processing labs have never processed colour infrared film before, so they may not realise that the film cassette must remain in its lightproof tub and will promptly remove it in broad daylight. If this happens, the film will be ruined.

Secondly, this lack of knowledge of infrared film may result in you being told that it can't be mixed with other E-6 films during processing. This was true of the older E-4 version, but the new EIR film is E-6 compatible. If you have any trouble, take the film box or instructions along to the lab, as both state this fact.

Thirdly, many commercial labs use infrared viewing equipment in the darkroom, which doesn't harm conventional E-6 slide film but will fog EIR and ruin all your pictures.

The easiest way to overcome these problems is by asking. It's also a good idea to stick a label on each film tub saying 'Colour infrared film for E-6 process. Handle in complete darkness'.

TOP TIPS

• Remember to bracket exposures at least a stop over and under the initial meter reading using your camera's exposure compensation facility.

• For the best results, use colour infrared film in bright, sunny weather when there's plenty of infrared radiation about.

• The infrared effects of this film are best seen in foliage – which goes magenta or bright red, depending on the filter used – so look for scenes that will suit it. Gardens and landscapes are ideal, especially during spring and summer.

• Try using colour infrared for portraiture – you will get some very strange, but highly effective, results.

The amazing colours in this scene were created by photographing it on Kodak EIR colour infrared film, with a yellow Cokin filter on the lens. The sky colour is far more intense than it was in real life, while the wonderful red of the foliage and grass is a typical characteristic of this film.
EQUIPMENT: Nikon F90x Prof., 28mm wide-angle lens, yellow filter
FILM: Kodak EIR colour infrared rated at ISO400
EXPOSURE: ¹/₁₂₅ second at f/16

Cross Polarisation

As well as being an invaluable accessory for general photography (see page 110), the polarising filter can also be used to create interesting special-effect images. If you place a polarising filter on your camera lens as normal, but also place a second polariser on a light source and use it to backlight a transparent plastic object, such as items from a child's geometry set or part of a clear polythene bag, any stress patterns in those objects will be revealed as vivid colours, producing eye-catching abstract images.

WHAT YOU NEED

Camera: A 35mm SLR is the ideal camera for this technique because it gives you direct viewing through the lens so you can judge the effect with precision, though medium-format models can also be used.

Lenses: This depends on how big, or small, the object you choose to photograph is. Small objects tend to produce the most interesting results, so a lens that allows close focusing will be required. The close-up setting on a zoom lens or a pukka macro lens may be sufficient. If you have neither, purchase an inexpensive supplementary close-up lens – +3 dioptres should give enough power – and fit it to a standard 50mm lens or to a short telephoto.

This is the type of effect you can expect from cross polarisation. To produce the image, the photographer used a slide viewing lightbox as a light source and laid the plastic objects on top of a sheet of polariser gel. The exposure set by his camera in aperture priority mode gave a very accurate result.
EQUIPMENT: Nikon F90x Prof., 105mm macro lens, polarising filter, polariser gel, lightbox, tripod, cable release
FILM: Fujichrome Velvia ISO50
EXPOSURE: ½ second at f/11

Accessories: A normal polarising filter to fit on the camera lens, plus a second polariser. You could use another polarising filter, but sheets of polarising gel, available from large photo stores, are much more convenient (see below left).

Light source: Ideally you need a constant light source rather than electronic flash, so you can see the effect clearly. A slide projector can be used, but a lightbox used for viewing slides is much more convenient as you can simply lay the objects to be photographed on it and obtain even illumination.

HOW IT'S DONE

The easiest way to produce cross-polarised effects is by using a lightbox and a sheet of polariser gel. Follow these steps:

1 Lay the polariser gel on the surface of the lightbox, then arrange your objects on top of it. Switch the lightbox on so the objects are backlit.

2 Mount your camera on a tripod, set it up over the lightbox and compose the picture. Place a polarising filter on the lens.

3 While looking through your camera's viewfinder, slowly rotate the polariser on the lens and watch how the colours in the plastic objects change. When you're happy with the effect, stop rotating the polariser.

This simple arrangement was used to produce the main image.

4 Set your camera to aperture priority exposure mode and then stop the lens down to f/8 or f/11 in order to provide you with sufficient depth-of-field. Now trip your camera's shutter release to take the picture.

If you are using a slide projector instead of a lightbox as your light source, position it on the floor with the lens pointing upwards, then fix a sheet of translucent perspex 20–30cm above the lens. You can then lay a sheet of polariser gel on the perspex and place your plastic objects on the gel.

Alternatively, instead of using a polariser gel, place a second polarising filter on the projector lens and follow steps 2–4 above. This doesn't work quite as well as using polariser gel, but it is better than nothing.

TOP TIPS
• Although your camera's integral metering system may produce well exposed results, it's always a good idea to bracket exposures a stop over and under the metered exposure.
• Use a slow-speed colour transparency film such as Fujichrome Velvia in order to maximise the vibrant colours produced by cross polarisation.
• Try the technique with any clear plastic objects – strips of torn polythene bag can work very well, along with the tops from plastic boxes.
• Don't be afraid to leave small gaps between the objects when using a sheet of polariser gel. Any gaps will record as solid black, enhancing the colours in the plastic objects.

Cross-Processing

Every so often a new photographic technique is devised, either intentionally or by accident, which instantly becomes very popular. In the last decade, the most exciting one has to be cross-processing.

This simple technique basically involves processing colour film in the wrong chemicals – either to process colour slide film in the C-41 chemistry normally used for print film so you get negatives instead of slides, or to process colour negative film in E-6 slide film chemistry to get colour slides instead of negatives.

In theory this sounds rather silly – a bit like putting your favourite silk shirt in a 37°C (100°F) boil wash – but in practice it can produce all sorts of amazing results. Colours often record nothing like they were in reality, contrast is increased, and overall it provides the perfect way of turning conventional subjects into imaginative images.

Any brand or speed of colour film can be cross-processed, though each one will react differently and some work better than others, so you're advised to experiment with a selection to see which you prefer. Cross-processing also provides the perfect excuse to use all those outdated or obscure rolls of film you've probably had for ages and couldn't think of a use for.

HOW IT'S DONE
Exposure

The trickiest part of the technique is getting the exposure correct, as the recommended ISO rating of a film becomes more or less redundant. This isn't such a problem if you process slide film in C-41 chemistry because, like normal colour negative film, it has wide exposure latitude and one or two stops of exposure error can be corrected at the printing stage. However, if you process print film in E-6 chemicals to produce slides, its exposure latitude is limited like conventional slide film, so you need to get it right.

The easiest way to achieve this is by bracketing the exposures, noting the exposure used for each shot and then comparing those notes with the final results to see which one works the best. You may find that a particular brand of film gives the best results when overexposed by two stops over the suggested meter reading, for example, so when you use that same brand again you can simply overexpose every frame by two stops to produce well exposed pictures.

Alternatively, rate it at a different ISO to account for the exposure adjustment required. If you find that an ISO100 film gives the best results when overexposed by two stops, for instance, re-rate it at ISO25 so as to give two stops overexposure for the whole roll automatically. So, for every stop of overexposure required you simply need to halve the ISO rating, while for every stop of underexposure required you need to double it.

Many photographers also push-process colour print film when they are cross-processing it. Doing this provides extra speed as well as increasing contrast even more and enhancing grain. Deciding

These portraits show how cross-processing colour slide film in C-41 chemicals totally transforms the way the film records colours and tones. Left: the model photographed using slide film processed normally. Right: the same film cross-processed. As cross-processing colour slide film produces negatives, you can also change the colours at the printing stage to give the effect you want.
EQUIPMENT: *Olympus OM4-Ti, 85mm lens, two studio flash units fitted with softboxes*
FILM: *Fujichrome Velvia ISO50 for both*
EXPOSURE: *1/60 second at f/11*

whether or not this is necessary will depend on your first set of results.

In terms of subjects, cross-processing is mainly used by fashion and portrait photographers as it works particularly well on pictures of people, making skin tones look very light and bleached, and changing the colour of their clothes to produce unusual images.

Lighting

Electronic flash is the preferred choice of lighting as it gives clean, crisp and consistent results. Cross-processing boosts contrast considerably, so for this reason most photographers diffuse the flash in order to moderate its contrast, by using a softbox or brolly attachment. One softbox plus a large reflector, or two flash heads fitted with softboxes will produce soft, relatively shadowless illumination.

Alternatively, experiment with more directional lighting so that the contrast is higher, and exaggerate the shadows so they come out deep black while your subject's skin tones record as a light, textureless tone.

Further effects can be produced by using brightly coloured backgrounds such as blue, green or red, or over-lighting a white background so it comes out pure white. Asking your subject to wear brightly coloured clothes or make-up will also add to the vivid and surreal colour rendition of cross-processed film.

Cross-processing can work outdoors, but the results are less predictable and they tend not to be so bizarre. Bright, sunny weather tends to work best with graphic or abstract subjects that have strong shapes and colours; buildings and monuments against blue sky are generally perfect examples.

HOW TO PROCESS

Although cross-processing film is fairly straightforward, it renders the chemicals unusable for normal processing and you may find that most high-street commercial labs won't accept film for cross-processing. Fortunately, because of a rise in its popularity, most professional labs will. All you have to do is place a sticky label on the cassette with instructions so the processors know what to do with the film; failure to do this will mean that the film is processed normally and the effect lost.

Alternatively, if you're used to working with colour-processing kits there's no reason why you can't cross-process at home – at least that way you're guaranteed the film will be put through the right (wrong) chemicals!

TOP TIPS

• Remember to keep notes of the exposures used for each shot until you're familiar with different types of film and how they respond to cross-processing.

• Experimentation is the key to success – try different types of

This shot shows how cross-processing increases contrast and intensifies colours to produce stark, eye-catching images. The blue of the subject's shirt and eyes stand out boldly against the crisp white background. Vivid colours tend to work best.
EQUIPMENT: Olympus OM4-Ti, 85mm lens, two studio flash heads fitted with softboxes **FILM:** *Fujichrome RDP100 slide film rated at its normal speed of ISO100 then cross-processed in C-41 chemicals.*
EXPOSURE: 1/60 second at f/16

film and then you can see which ones give the best results.

• Controlled lighting is required for consistent results, electronic flash being ideal.

• Keep the lighting relatively soft by using softboxes or reflectors to avoid harsh shadows.

Depth-of-Field

epth-of-field is the area of acceptable sharp focus that extends in front of and behind the point you focus on, and is something that needs to be considered every time you take a picture. Most photographers have a basic understanding of depth-of-field, but if you wish to master many of the techniques covered in this book, knowing how to control and use it creatively is vitally important.

WHAT YOU NEED

Camera: Some cameras give you more control over depth-of-field than others. The majority of traditional manual focus SLRs have a depth-of-field preview button which allows you to assess which parts of the picture are likely to be in sharp focus. For some reason, however, these features have been omitted from many modern autofocus SLRs. Compact cameras also lack any kind of depth-of-field control.

Lenses: Manual focus lenses tend to have a clear depth-of-field scale on the barrel, and this will show the nearest and furthest points of sharp focus at a given aperture and focusing distance. This feature is also found on many autofocus lenses, although by no means on all.

If you use a telephoto lens set to its widest aperture – the longer the focal length, the better – depth-of-field will be limited to such an extent that the only part of the scene which records in sharp focus is the point you focus on. This technique, known as differential focusing, is ideal for throwing the foreground and background out of focus so that all attention is concentrated on a single element.
EQUIPMENT: Olympus OM4-Ti, 200mm telephoto lens
FILM: Fujichrome Velvia ISO50 *EXPOSURE:* ½₅₀ second at f/4

HOW IT'S DONE

There are three factors which determine depth-of-field:

Lens aperture setting

Small apertures such as f/11 and f/16 give more depth-of-field than wider apertures such as f/2.8 and f/4. As you increase the aperture size on the lens – by setting a smaller f/number – depth-of-field is progressively reduced, and vice versa. This applies for any given focal length.

Lens focal length

As focal length increases, depth-of-field is reduced at any given lens aperture, and vice versa. So a 28mm wide-angle lens which is set to f/16 will give far more depth-of-field than a 200mm lens set to f/16.

Focusing distance

The further the point of focus is from the camera, the greater depth-of-field there will be at any given aperture setting or focal length. So, for example, a 50mm lens set to f/16 will give more depth-of-field if it is focused on a point 10m away than it will when focused on a point 1m away.

Taking these factors into account, if you want maximum depth-of-field, use a wide-angle lens set to a small aperture such as f/11 or f/16, while for minimal depth-of-field use a telephoto lens set to a wide aperture such as f/2.8 or f/4.

Of course, knowing which factors affect depth-of-field is one thing, but unless you are able to assess it with some degree of accuracy you will never be able to make the most of it.

If you're going to take a picture with your lens set to its widest aperture, the image you see through the camera's viewfinder will be exactly what you get on the final picture, as all lenses are set to maximum aperture.

If you're using a smaller lens aperture you can roughly assess depth-of-field by using the depth-of-field preview facility on your camera or lens. This stops the lens down to the aperture it's set to so you can gauge which parts of the scene will be in and out of focus. The only problem is that at small apertures, such as f/11, f/16 and f/22, the viewfinder image will go very dark when you use the depth-of-field preview, making it difficult to see very much at all.

In these situations, a better method is to use the depth-of-field scale on the lens barrel to check the nearest and furthest points of sharp focus. The scale is marked on either side of the red focusing index on the lens (see right).

To use the scale, decide which aperture you want to use, then

Being able to maximise depth-of-field is vitally important when shooting wide-angle landscapes. In this scene, everything from the boat in the immediate foreground to the hills in the background has been recorded in sharp focus by setting the lens to its smallest aperture and using the hyperfocal focusing technique.
EQUIPMENT: *Pentax 67, 55mm wide-angle lens, tripod*
FILM: *Fujichrome Velvia ISO50*
EXPOSURE: *½ second at f/22*

background comes out blurred because there wasn't enough depth-of-field available, the picture will be ruined. Similarly, if there is too much depth-of-field in a picture, distracting elements may become too prominent, detracting from your main subject; this is a particularly common fault when shooting portraits against a detailed background. However, if you think carefully about the lens and aperture used, you should be able to prevent it from happening.

TOP TIPS

• Get into the habit of checking the depth-of-field scale on your lens before taking a picture, so you have

focus the lens. Next, look at the scale to see which focusing distances fall opposite the relevant f/number. These represent the nearest and furthest points of sharp focus at that aperture.

By assessing depth-of-field using the scale you may decide that too much of the scene will be in sharp focus, in which case a wider aperture can be set to reduce depth-of-field. A more likely scenario, however, is that you won't have enough depth-of-field, even with your lens set to its smallest aperture, to record the whole scene in sharp focus. This is especially common when using wide-angle lenses to shoot landscapes.

If this is the case, there is a simple technique you can use, known as hyperfocal focusing, which will maximise depth-of-field. To use it, focus your lens on infinity, then check the depth-of-field scale to see what the nearest point of sharp focus will be at the aperture set. This is the hyperfocal distance. Next, focus the lens on that distance. By doing so, depth-of-field will extend from half the hyperfocal distance to infinity.

By mastering these techniques and thinking carefully about depth-of-field when taking a picture, you can use it creatively to produce exactly the effect you have in mind. If you photograph a landscape, for example, and the immediate foreground or distant

a clear idea of what is likely to be in and out of focus.
• Some SLRs in the Canon EOS range have a depth-of-field mode. This feature allows you to pinpoint the area you wish to record in sharp focus. The camera then selects an aperture and focusing distance which will ensure that sufficient depth-of-field is provided.
• Depth-of-field extends roughly twice as far behind the point of focus as it does in front, so a 'Heath Robinson' way of maximising depth-of-field is to set your lens to its smallest aperture and focus roughly one-third into the scene.

This photograph of the barrel on a 28mm wide-angle lens shows how the depth-of-field scale can be used to assess depth-of-field. With the lens set to f/16 and focused at just under 2m, you can see that depth-of-field will extend from less than 1m out to infinity.

Duplicating Slides

Making copies from your 35mm slides serves several purposes. First, it means you can safeguard the valuable originals by never letting them out of your sight. You may have only one copy of a special shot, but would like to enter it into competitions, or send it out for possible publication, for example. Whenever a slide is sent on to someone else there's a risk it can be lost in the post or damaged, but if you only send duplicates it doesn't matter too much if this happens.

Second, you may really like a picture, but feel it would be better if you changed the composition slightly, perhaps added a filter effect such as soft-focus, or copied the image onto fast, grainy film. Colour originals can also be copied onto black and white film, or onto colour negative film so you can have prints made cheaply.

Finally, duplicating allows you to let your imagination run riot, because you can create all kinds of unusual effects by combining images on the same piece of film to create slide sandwiches.

WHAT YOU NEED

The easiest way to make duplicated copies from 35mm slides is by using a 35mm SLR together with one of the following pieces of equipment.

Simple slide copier: These inexpensive accessories comprise a metal tube with its own lens and a fixed aperture of f/16. It fits to your camera body via a separate mount and has a slide holder on the front with a perspex diffuser panel. Some models are designed for making only full-frame (1:1) duplicates, but others have a zoom facility which lets you crop the original and copy part of it. Image quality is acceptable, but don't expect the 'dupe' to be as sharp as the original.

Macro lens: If you have a macro lens which gives 1:1 (lifesize) reproduction it's just about possible to make full-frame dupes from 35mm originals, though they're easier to use when fitted with a small extension tube so you can obtain more than lifesize reproduction. Macro lenses are also ideal for making 35mm dupes from larger format originals, and image quality is much better than from a simple slide copier.

Bellows unit: The extensive magnification that bellows provide – usually up to 3x lifesize – makes them ideal for slide duplicating. Most bellows manufacturers also make a slide holder which fits to the end for this very purpose. Because you can vary the magnification with great precision, it's possible to change the composition of the original, or simply enlarge and copy a small part of it to emphasise grain.

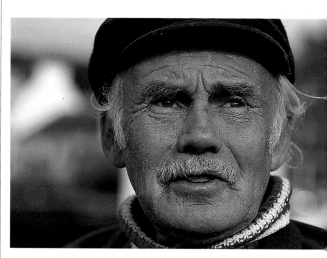

The set of pictures right shows how using different types of film can have a major influence on the quality of the final duplicate slide compared to the original. Viewed in isolation you could say that each image is acceptable. However, when viewed together it's surprising just how much each one differs. The two dupes were produced using an Olympus OM4-Ti and Jessop zoom slide copier, as shown above.

The original portrait, shot on Fujichrome RDP100 with an 85mm f/2 lens in bright but overcast weather conditions. If you look closely, you will see that the portrait contains a lot of fine detail, particularly in the subject's skin, and the colours are relatively muted.

Purpose-made slide duplicator: If you need to make a lot of slide dupes, it may be worth investing in a purpose-built unit such as the Bowens Illumitran. Though relatively expensive compared to the other equipment you can use, these units make the duping process much easier. They feature a built-in light source, an automatic exposure control and even a facility which allows you to pre-fog conventional slide film in order to lower the contrast of the duplicates so that an accurate match with the original is obtained.

Film: Although it's perfectly feasible to make duplicate slides using conventional colour slide film, the results are often disappointing. This is because duplicating increases image contrast, so colours appear much harsher on the dupe, while highlights tend to burn out and shadows become very dense. Colour casts are also common, so it's difficult to obtain an accurate match with the original.

If these factors aren't important, then go ahead and use normal colour slide film, ideally choosing a low-contrast brand. Kodachrome 25 and 64 are good choices, along with other slow-speed Kodak slide films from the Panther and Elite ranges. Alternatively, if you want to increase contrast and make the colours in the duplicate really vibrant, use a punchier film such as Fujichrome Velvia. This film is ideal for making colourful copies of abstract images. Photographs taken in dull, flat lighting can also be enhanced by duping onto conventional film, as the increase in contrast will add impact.

Where an accurate match with the original is important you should use purpose-made slide duplicating film, which is designed specifically for copying and has a low-contrast emulsion. There are three brands available in 35mm format – Kodak Ektachrome 5071 and Fujichrome CDU for use with tungsten light, and Kodak Ektachrome SE SO-366 for use with electronic flash. All give excellent results, but you must use colour-compensating filters with them to ensure that an accurate colour match is obtained. The recommended filtration is printed on the film box. However, if you buy a large number of rolls from the same batch, it's worth shooting a test roll at different filtrations to find out which one gives the most lifelike results – it isn't always the recommended filtration.

Light source: To make duplicate copies, the original slide must be backlit so that the image is clearly revealed. The easiest and most consistent way of doing this is by using electronic flash. However, you can also do it using a slide viewing lightbox, a tungsten lamp, or even natural daylight.

HOW IT'S DONE

The approach you take to duplicating slides will depend on the type of equipment you have at your disposal.

With a slide copier, clean the slide, then place it in the holder at the end of the tube. If you're using a zoom copier to make selective dupes, fine-tune the composition and check that the image is focused.

As the aperture of the copier is very small – f/16 or f/22 – the image you see through your camera's viewfinder will be quite dark, making focusing and composition tricky. Overcome this by holding the copier close to a window, or aiming it towards a bright light such as a desktop reading lamp or a slide viewing lightbox.

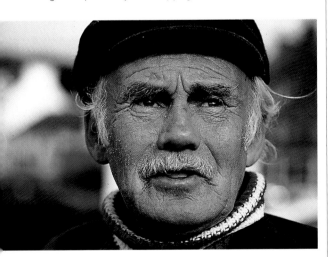

Duping the image on to Fujichrome Velvia using electronic flash as a light source has increased contrast by a very obvious amount, making the image much harsher and the subject's skin tones warmer. This is the type of result you can expect when duping onto conventional slide film, though Velvia is known to be a high contrast film and was chosen here to illustrate an extreme case.

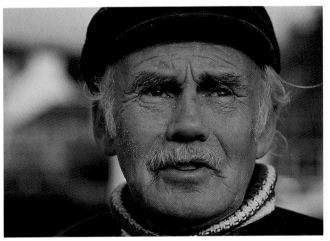

Using Kodak Ektachrome SO SE-366 duplicating film with the recommended filtration and electronic flash has produced a much more accurate rendition of the original image. The subject's skin tones are slightly warmer, which indicates that the filtration needed adjustment to produce an accurate colour match, but the difference is not excessive and this duplicated image is perfectly acceptable.

Lighting

The next step is to sort out your light source. Electronic flash is the best choice as it's reliable, consistent and the colour of the light is completely neutral. Daylight is not a good light source because its colour changes throughout the day, and this can have a strong influence on the colour balance of your dupes.

Dedicated flashguns are the easiest to use. All you need to do is position the gun approximately one metre behind the copier so that the flash is pointing towards the camera, connect the gun to the camera with a dedicated sync lead, set your camera to program or aperture priority mode and fire away. Because dedicated guns automatically cut out when sufficient light has been generated, you should obtain perfectly exposed duplicates without doing anything else.

If you don't have a dedicated flashgun, you will need to take several test pictures to discover how far the gun needs to be from the slide copier to give correctly exposed results.

If you don't have any flashgun at all, then a different source will be required. One option is to point the slide copier towards a window so the slide in it is backlit by daylight. This is a very simple approach, but as mentioned earlier, daylight changes colour so it isn't a reliable source if you need an accurate colour match.

Another option is to use a tungsten lamp such as a reading light. If you intend making the dupes on normal colour slide film, a blue 80A or 80B filter should be used to balance the tungsten light so your dupes don't come out with a strong orange colour cast. Alternatively, use either tungsten-balanced slide film such as

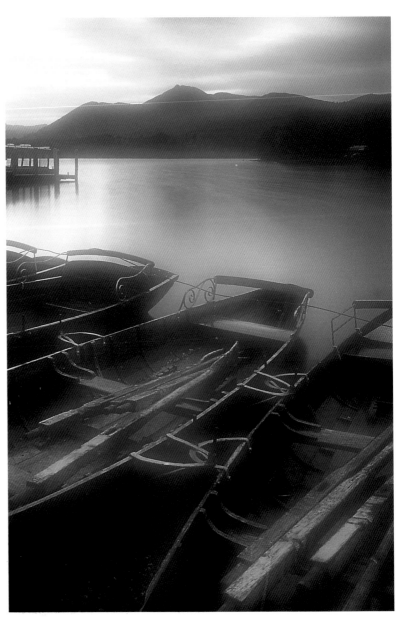

Though perfectly acceptable, the photographer felt he could use the original image shown above as the basis for more creative techniques, so he decided to dupe it and at the same time experiment with different filter effects. To do this, the original 6x7cm colour slide was placed on a lightbox, then the camera was set up over it on a tripod and the dupes produced using a 105mm macro lens. For this variation (right), blue 80B and soft-focus filters were fitted to the lens and the dupe was made onto Fujichrome Velvia slide film to boost contrast.

Fujichrome 64T, or Kodak Ektachrome 5071 duplicating film, which is designed for use with a tungsten light source.

A lightbox normally used for viewing slides can also be used as a light source – all you have to do is mount your camera on a tripod and position the slide copier so that it is pointing towards the lightbox. An advantage of this approach is that most lightboxes use a daylight-balanced tube, so you can use it with conventional daylight-balanced slide film and produce dupes that don't suffer from a colour cast.

Again, the results won't be as consistent as flash, but if you're using a macro lens to make the dupes from 35mm or larger format slides it is much simpler because you can place the original slide on the lightbox, then set up your camera over it.

When using any light source other than flash, it's advisable to bracket exposures to be sure you get a successful dupe. If the original image contains a lot of light tones, such as snow for example, there's a high risk of underexposure, just as there would be if you were shooting a snow scene.

Also, when using purpose-made duplicating film remember to add the required filtration. This can be done by placing the filter behind the slide copier or in the holder if there is an extra slot. The sets of colour compensation (CC) gels used for colour printing are ideal for this process and can be purchased from most camera dealers.

Although duping onto conventional colour slide film is normally to be avoided, sometimes it can be used to your advantage. Here, for example, the graphic nature of this street scene has been enhanced considerably by the increased contrast and colour saturation caused by copying the original image onto Fujichrome Velvia slide film.

Exposure

Practice is the key to success. Note down the exposures you use and how far away the light source is, then compare them with the first set of results. If the dupes are badly exposed, you should be able to identify the reason why, then adapt your approach and make sure the same thing doesn't happen again. Having said that, modern equipment is so sophisticated that there's no real reason why you shouldn't obtain perfect results from your very first roll of film.

TOP TIPS

• If you want to make quick, easy dupes, use a simple slide duplicator and a dedicated flashgun.
• Purpose-made duplicating films are the best choice if you want consistent dupes that closely match the originals.
• Once you've mastered the art of making 35mm dupes, why not go a step further and make 12.5x10cm (5x4in) large-format dupes from 35mm originals using an enlarger (see page 80)?

Environmental Portraits

The main aim of portraiture is to try and capture the character of your subject – or at least some aspect of it. More often than not this is done by moving in close to the subject and concentrating on their head and shoulders to produce a tightly composed portrait that includes little or no extraneous detail.

However, while this approach can result in very revealing photographs, equally it can be limiting. For example, if you photograph an old man whose face is wrinkled and weather-worn, you may well achieve an interesting character portrait, but if you only show his head and shoulders, the picture will reveal no clues about why his skin is wrinkled and worn. Is it because he has spent his life outdoors working the land? Perhaps he's a fisherman? Who knows.

An easy way to avoid this dilemma and produce portraits that tell a much more interesting story is by standing back and including your subject's surroundings – their natural environment – in the picture as well. A portrait of a boat builder surrounded by the tools of his trade will be far more effective than a simple head and shoulder study. Similarly, a keen gardener captured in his potting shed or greenhouse surrounded by garden implements and clutter will speak volumes about that person.

Photographing your subject in a familiar environment has another advantage – it will almost certainly help them feel more relaxed and at home in front of a camera than they would in the stuffy confines of a studio. This, in turn, should result in more natural, revealing images.

WHAT YOU NEED

Camera: Any type or format of camera can be used for environmental portraits.

Lenses: As the idea of this technique is to include your subject's surroundings in the picture, shorter focal lengths are normally chosen, instead of telephotos. If the location offers restricted space, such as a small room, then a 28mm or 35mm wide-angle will be ideal, while a 50mm standard lens can be used where there is more space to move around.

Film: Match your choice of film to the situation. Slow-speed colour or black and white film is a good choice outdoors, but if you're shooting indoors in available light you should use faster film – ISO400, for example – to provide faster shutter speeds so a tripod isn't required.

Accessories: You will need a tripod if light levels are low and you're using slow-speed film. An electronic flashgun can also be handy for adding extra light – you could bounce the flash off a wall or ceiling to provide attractive illumination, rather than firing it direct at your subject.

HOW IT'S DONE

Before taking any pictures, have a good look at the location and decide on the best position. In cramped situations you may simply have to make the best of what you have, but if there's plenty of space to move around in, look at all the possibilities.

Often it's a good idea to compose the picture without your subject, so you can spend a little time fine-tuning the viewpoint, deciding what to exclude and include, and perhaps moving the odd item around to make sure that there are no distracting features in the scene. You can then introduce your subject to the picture, knowing immediately where you want them to pose.

As with all portraits, try to keep the background as simple as possible, and avoid having objects 'growing' out of your subject's head or body as they will look very odd. If you are using a wide-angle lens it's also important to keep your subject away from the edges of the frame, otherwise they may be distorted – especially if you have to tilt the camera to get the shot you want.

Once your subject is introduced to the picture, help them get into position. Most people feel awkward standing for pictures, so suggest that they sit or lean on something. Giving them something to hold which relates to the environment can also help to put them at ease, and prevent their hands hanging limply – body language in a portrait is as important as facial expression.

Finally, while wide lens apertures are normally used for conventional portraiture to throw the background out of focus and isolate your main subject, with environmental portraiture the background and surroundings are an important part of the picture, so they should be rendered in sharp focus. To ensure this happens, set your lens to a small aperture – f/11 or f/16.

This enthusiastic gardener was photographed in his garden, among his plants and flowers. The shed on the left side of the picture is actually the location of the other portrait, so you can imagine how little space there was inside. To make this image a little different, the photographer used infrared film (see page 88), which turned the foliage in the garden white and added a surreal effect. Posing the subject on the opposite side of the frame to the shed helped to balance the composition, and a small aperture was used to maximise depth-of-field.
EQUIPMENT: Olympus OM4–Ti, 28mm wide-angle lens, red filter
FILM: Kodak High Speed mono infrared film rated at ISO400
EXPOSURE: 1/60 second at f/16

TOP TIPS

• Most people have some aspect of their working or personal life that would make a good subject for environmental portraiture, so it is a good idea to chat to them about their hobbies and interests before taking any pictures.
• When you're out and about, look for situations that could make interesting environmental portraits – old village shops with their shelves crammed full of tins and packets make perfect locations, as do building sites, allotments, scrapyards, and so on.
• Take your camera to work and shoot environmental portraits of your colleagues. Whether you work in an office or on a production line, it's possible to produce revealing pictures.

For this portrait, the same subject was photographed in his potting shed, surrounded by the implements and clutter he uses on a daily basis to grow vegetables and keep livestock. Space was severely limited, so the photographer had to use an ultra wide-angle lens to include as much of the interior as possible. The picture was taken from the doorway to the shed, using available window light for illumination. The subject was also asked to hold some of the eggs he had just collected from his chicken pens to add interest to the portrait.
EQUIPMENT: Pentax 67, 45mm ultra wide-angle lens, tripod, cable release **FILM:** Fujichrome Velvia ISO50 **EXPOSURE:** 1/8 second at f/11

Fairgrounds

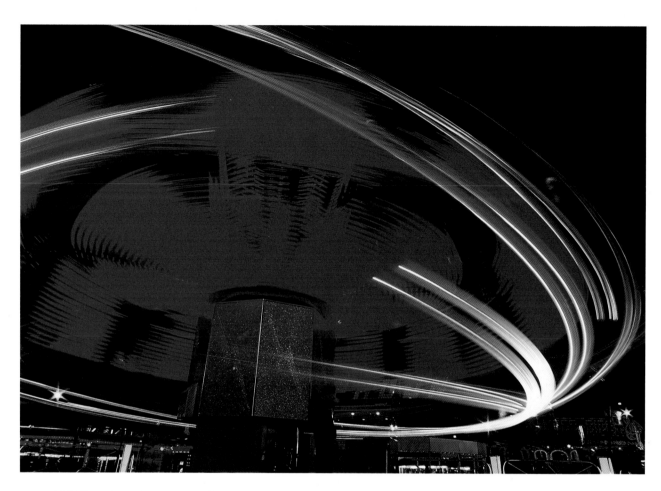

Throughout the summer and autumn, travelling fairs visit most towns and cities around the country and with them come a wide range of photogenic subjects. Bright lights, white-knuckle rides, games and food stalls all provide excellent photo opportunities, and in the space of a single evening it's possible to take lots of interesting pictures like those shown here.

WHAT YOU NEED

Camera: Any type of camera that will allow long exposures and different lenses to be used. Most photographers use a 35mm SLR, but a zoom compact with a night mode will also be suitable.
Lenses: As most subjects will almost certainly be at relatively close range, focal lengths from 28–200mm should cover all

Fairground rides may not look particularly interesting to the naked eye, but if you use a long exposure to photograph them in motion, it's surprising what you end up with. Here the spinning lights have recorded as a mass of colourful streaks, and by shooting from close range with a wide-angle lens the photographer has produced a dramatic composition.
*EQUIPMENT: Olympus OM2, 28mm wide-angle lens, tripod and cable release **FILM:** Fujichrome Velvia ISO50 **EXPOSURE:** 32 seconds at f/16*

eventualities, with wide-angle lenses being particularly useful.
Flashgun: Although it isn't essential, an electronic flashgun can be used to produce interesting 'slow-sync' effects (see page 126 for details of this technique).
Accessories: For most pictures long exposures will be

This aerial view of a fairground was taken from a bridge overlooking the location, well away from the crowds. A tripod was used to keep the camera steady, and the photographer left the exposure to his camera's integral metering system, shooting in aperture priority mode.
EQUIPMENT: Olympus OM4-Ti, 28mm wide-angle lens, tripod and cable release FILM: Fujichrome Velvia ISO50 EXPOSURE: 20 seconds at f/16

required, which means a tripod is essential for keeping your camera steady. Also use a cable release to trip the shutter.

Film: Use slow-speed film – ISO50–100 – for pictures taken with your camera on a tripod. It's also worth carrying one or two rolls of fast film – ISO400+ – so you can take handheld candid shots of people enjoying the fun of the fair.

HOW IT'S DONE

Most fairgrounds come to life in the evening, when thousands of colourful lights are used to illuminate the rides and stalls. The best time to take pictures is around dusk, when there's still some colour in the sky and a little ambient (natural) light around. This helps to keep contrast within a more manageable level, and will make your pictures look more interesting.

For shots of spinning rides, such as the big wheel and Waltzer, use long exposures so the lights record as colourful streaks. This is best done by mounting your camera on a tripod, composing the shot, then waiting for the ride to start moving. Once it reaches its maximum speed, trip your camera's shutter to take the picture.

Determining the correct exposure can be tricky, so most photographers rely on their camera's integral metering system – just set your camera to aperture priority mode, stop the lens down to f/11 or f/16 and fire away. A wide-angle lens is ideal for this type of subject as it will allow you to move in close to produce a dynamic composition, especially if you have to look upwards to the ride so that it's set against the sky.

Try to avoid including bright static lights in the picture, such as floodlighting around the perimeter of the funfair, as they will create white hotspots and could cause flare.

The same technique can also be used for pictures of the whole funfair. Look for a high vantage point so you've got a clear view. By using a long exposure the moving rides will record as colourful streaks, while crowds of people walking around will blur to create a highly effective image.

If you want to photograph people enjoying the thrills and spills of the funfair, flash can be a useful ally as it will freeze any movement, despite the low light levels. Combine this with a long exposure and exciting results are guaranteed. The technique, known as slow-sync flash, is explained in more detail on page 126, but the basic idea behind it is to use flash to freeze your subject – such as children on the dodgem cars – and a slow shutter speed so the colourful lights in the background record as blurred streaks to add impact to the picture.

TOP TIPS

• When using a tripod, try to find a clear area where it's unlikely to get knocked by people passing by.

• Take the minimum amount of equipment with you and keep a close eye on it – there will always be someone happy to relieve you of it if you aren't careful. Hang your gadget bag over the tripod when taking a picture, and always keep the bag closed so the contents aren't on display.

• Be prepared to take lots of pictures and expect a few failures. Fairground photography can be unpredictable, but if you don't get what you want on your first visit, you can always return the next evening.

• Once all colour drains from the sky, you should avoid including it in your pictures – large expanses of blackness tend to look rather boring.

A burst of flash was used to freeze the passing dodgem car, while a slow shutter speed ensured the lights in the background also recorded. The colourful streaks were created by panning the camera as the picture was taken, in order to add a sense of excitement and action.
EQUIPMENT: Olympus OM4-Ti, 28mm wide-angle lens, Vivitar 283 flashgun
FILM: Fujichrome Velvia ISO50
EXPOSURE: ¼ second at f/5.6

Fill-in Flash

ost photographers only ever use their portable flashgun when taking pictures indoors – at parties, special events, for portraits or to brighten up room interiors. However, it's equally useful outdoors for a technique known as fill-in.

Fill-in flash is mainly used when shooting portraits in bright sunlight. In such conditions, daylight alone is very harsh and casts ugly black shadows across your subject's face. The contrasty light also tends to make skin tones look pale and bleached, which is not exactly flattering. You can prevent this by posing your subject with the sun on their back, then bouncing light onto their face with a reflector, but using fill-in is a much easier method.

WHAT YOU NEED

Camera: A growing number of modern 35mm SLRs and most compact cameras have a small, low-powered built-in flashgun which on some models has an automatic fill-in mode. If your camera has this facility, you may find that it produces well-balanced results. If not, you will need a portable flashgun that can be fitted to the camera's hotshoe or connected to the camera with a sync lead and held to one side.

Flashgun: Any type of portable flashgun can be used for fill-in and you don't need a great deal of power to achieve successful results. Automatic guns are the easiest to control.

HOW IT'S DONE

The way you obtain fill-in flash will depend on the type of flashgun you use. Here's a simple guide to using the two most popular designs – automatic and dedicated.

With an automatic flashgun

1 Take a meter reading with your camera set to aperture priority mode, so you select the aperture and the camera sets the shutter speed automatically. Make sure that the shutter speed set isn't faster than the correct flash sync speed for your camera. You can set a slower shutter speed, but not a faster shutter speed. Check your owner's manual if you are unsure what this is – it is usually $\frac{1}{60}$, $\frac{1}{90}$ or $\frac{1}{125}$ second, though on some models it may be $\frac{1}{250}$ second.

2 The key to fill-in flash is 'fooling' your flashgun into delivering less light than it would do normally, so that you get the desired effect without the flash dominating the shot and making your pictures look washed out. Some flashguns have a power output control so you can set it to $\frac{1}{2}$, $\frac{1}{4}$, $\frac{1}{8}$, even $\frac{1}{16}$ power, but if your

This set of pictures shows how different flash-to-daylight ratios produce different results. All the flash pictures were taken using a simple Vivitar 283 automatic flashgun on a Nikon F90x Prof. 35mm SLR. To achieve different ratios, the auto aperture settings on the flashgun were used as explained on these pages.

No flash.

A flash-to-daylight ratio of 1:1.

A flash-to-daylight ratio of 1:2.

A flash-to-daylight ratio of 1:4.

flashgun doesn't have this feature you will need to employ a simple trick.

The easiest way to do this with an automatic flashgun is by setting it to a different auto aperture setting than the aperture you've set on the lens. A flash-to-daylight ratio of 1:4 tends to give the best fill-in effect for general use, and this means you need the flash to deliver only ¼ the amount of light you would normally require. To achieve this, select the auto aperture on your flashgun that's two stops wider than the aperture you've set on the lens. For example, if the exposure set on your camera is ⅟₆₀ second at f/11, select the f/5.6 auto aperture on the flashgun. If you're shooting on ⅟₆₀ second at f/8, then set the flashgun to f/4 and so on.

By doing this, the flashgun will deliver enough light for the aperture you've set it to, but you're actually taking a picture at a smaller aperture, so the flash part of the exposure is underexposed.

3 In really harsh sunlight a flash-to-daylight ratio of 1:2 may be more suitable. To obtain this, set your flashgun to an aperture one stop wider than you've set on the lens. So, if you're shooting on ⅟₆₀ second at f/11, for example, set the flashgun to f/8. Alternatively, if you only need a very weak burst of flash, a ratio of 1:8 can be used. This is achieved by setting the auto aperture on your flashgun three stops wider than the aperture set on the lens.

4 If the auto aperture you require isn't available on your flashgun, adjust the daylight exposure so that you can get what you need. For example, if your flashgun only has auto aperture settings of f/5.6 and f/8, to achieve a flash-to-daylight ratio of 1:4 you must set the lens to either f/11 (and the flash to f/5.6) or f/16 (and the flash to f/8).

With a fully dedicated flashgun

Fooling a dedicated flashgun into giving less light is trickier because no matter which exposure mode you set your camera to, the flash is still fully automatic and most flashgun models offer no means of overriding the output to prevent it firing on full power. Here's one way.

1 Take a meter reading with your camera in manual exposure mode and set the required aperture/shutter speed combination to give a correctly exposed daylight shot. Let's say this is ⅟₆₀ second at f/5.6.

2 The only way of fooling the flashgun into delivering less light than it would do normally is by adjusting the film-speed setting on your camera. By doing this you can achieve different flash-to-daylight ratios, but because your camera is set to manual exposure mode, the daylight exposure set will remain the same.

3 To produce a ratio of 1:4 you will need to quadruple the film speed. So, if you're using ISO100 film, set the camera to ISO400, or if you're using ISO50 film, set the film speed to ISO200, and so on. In order to produce a flash-to-daylight ratio of 1:2 with ISO100 film, set the camera to ISO200, and ISO100 if you're shooting on ISO50 film.

Fill-in flash can also be used to illuminate your subject when taking pictures outdoors in low light. This portrait, for example, was shot a few minutes after sunset, and a burst of fill-in flash meant the photographer could light the subject but also record detail in the sky behind her.
EQUIPMENT: *Mamiya C330 TLR, 80mm lens, Metz flashgun*
FILM: *Fujichrome RDP100 ISO100* **EXPOSURE:** *⅟₁₅ second at f/8*

This may seem rather complicated, but once you have tried it a few times, the steps involved will become second nature. Also, if you own a modern dedicated flashgun made by the same manufacturer as your camera – such as a Nikon SB26 for Nikon autofocus SLRs, or a Canon Speedlite 430EZ with Canon EOS SLRs – you may find that fill-in flash is much easier because these flashguns have more features and give the user much more control. Read through the flashgun instruction manual if you're unsure.

TOP TIPS

• Fill-in flash can be used to add sparkle to portraits taken on a dull day.

• Fill-in flash doesn't have to be reserved just for portraiture – it's also a handy technique to use when you need to brighten up any close-range subject.

• Once you've mastered the art of fill-in flash, why not experiment with other interesting flash techniques, such as slow-sync (see page 126) or filtered flash (see page 54).

Filtered Flash

As well as using coloured filters on your camera lens in order to add an overall colour cast to the pictures you take, they can also be used on your flashgun to colour the light that is being produced.

The main difference with this technique is that only the parts of the scene lit by the flash will be affected by the colour of the filter, so you can produce unusual images where the background looks natural but the foreground is coloured.

Taking the idea a step further, you could use two coloured filters – one on the lens and another on the flashgun. If you do this using complementary filters, such as an orange 85B and a blue 80B, any areas lit by the flash will record naturally because the two filters cancel each other out, while any areas not lit by the flash will take on the colour of the filter on the lens.

By experimenting with this idea it's possible to produce all kinds of unusual effects. If you use a blue 80B filter on the flashgun and an orange 85B on the lens, for example, the background will take on an orange cast. Conversely, if you use the orange filter on the flashgun and the blue filter on the lens, the background will come out blue but the foreground will be unaffected.

The same idea can be used with tungsten-balanced film. If you expose this film in daylight, your pictures will have a strong blue colour cast because it's designed for use in much warmer tungsten light. However, you can get rid of the blue cast by using an orange 85A or 85B filter. So, if you use that filter on your flashgun, any areas of the scene lit by flash will come out natural, while everything else still has the blue cast of the tungsten-balanced film.

These techniques can be used for all kinds of subjects. Fashion photographers often use tungsten-balanced film and filtered flash when working with models outdoors, while using filtered flash to light the foreground of a scene is ideal for scenic

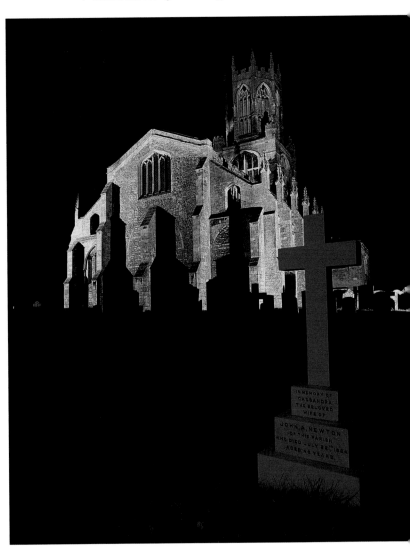

Here's a typical example of how filtered flash can be used. After composing the scene through a wide-angle lens so the cross dominated the foreground, the photographer took a meter reading to determine correct exposure for the floodlit church in the background. He then tripped the camera's shutter and held it open with a cable release to expose the scene. While the shutter was open, a flashgun with a red filter over the tube was aimed at the cross and fired by pressing the test button.
EQUIPMENT: Pentax 67, 45mm wide-angle lens, tripod and cable release, red filter, Vivitar 283 flashgun **FILM:** *Fujichrome Velvia ISO50*
EXPOSURE: *45 seconds at f/16*

photography at sunset or at night; thus you could illuminate driftwood on a beach at sunset, or gravestones in a churchyard against the floodlit church.

WHAT YOU NEED
Camera: A 35mm SLR is the best type of camera for this effect as it gives you control over the exposure.
Lenses: Any focal length can be used, but when working with flash you will need to be relatively close to your subject, so shorter focal lengths up to 135mm are the most suitable.
Filters: Any coloured filters, depending on the type of effect you want to produce.
Flashgun: An automatic or dedicated flashgun will make it easier to obtain well exposed results, especially when using filters on both the flashgun and the lens.

HOW IT'S DONE
To give you an idea of how this technique is carried out, here's a step-by-step guide to using a coloured filter over a flashgun to illuminate the foreground on a night scene – like the one shown on page 54.

1 Mount your camera and lens on a tripod and compose the scene. Set a small aperture such as f/11 or f/16 so there's sufficient depth-of-field to record the whole scene in sharp focus.
2 Take a meter reading to determine the exposure required for the most important part of the scene, such as a floodlit building, and set it on your camera. At night this may mean you need to use your camera's B (bulb) setting, but you could set the camera to aperture priority and let it set the exposure time automatically.
3 Fix the coloured filter over your flashgun using tape or elastic bands. This will reduce the amount of light being emitted by the flash. However, if you are using an automatic or dedicated flashgun this should be taken into account automatically to give correct exposure.
4 Connect the flashgun to your camera with a sync lead so that it fires automatically when you trip the shutter release. If you are using a dedicated flashgun, use a dedicated sync lead, but make sure the camera doesn't automatically set the correct sync speed as this will be too brief to record the existing light. Alternatively, if you are taking pictures at night with long exposures, you can fire the flashgun manually while the camera's shutter is open by pressing the test button, instead of connecting it to the camera.
5 Point the flashgun towards whatever you want it to light and trip the shutter release to take a picture.
6 If a single burst of flash is unlikely to cover a wider area, you can point it to different areas and fire it more than once by pressing the test button.

A similar procedure applies when using filters on both the flashgun and camera lens. However, when doing this you need to think carefully to avoid exposure error, as both filters will cause a light loss.

If you are using an automatic or dedicated flashgun, the correct exposure will be determined automatically so you can just fire away. If you are using a manual flashgun, however, you will need to adjust the exposure in order to account for the light loss which is caused by the filters.

To do this, check the scale on the back of your flashgun to determine the correct lens aperture required for the camera-to-subject distance you are working at. Let's say this is f/11. Now adjust the aperture to account for the light loss caused by the filter you will be using over the flashgun. If this is two stops, set the lens aperture to f/5.6. If it's one stop, set the lens to f/8.

With the correct lens aperture set for the filtered flash, use your camera in aperture priority mode to take the final picture. By doing this, the camera will automatically set the shutter speed required to expose the ambient light correctly, and account for the light loss incurred due to the coloured filter on the lens.

TOP TIPS
• At first glance these techniques may seem rather complicated. However, modern dedicated flashguns are highly sophisticated and should be able to produce perfectly exposed pictures with no adjustment.
• Experimentation is the key to success. Try using different coloured filters on the camera and lens.
• Cokin produce a range of filters that have been designed for these techniques. Known as 'Colourbacks' they come in a range of colours, with one filter for the lens and another complementary filter for the flashgun.

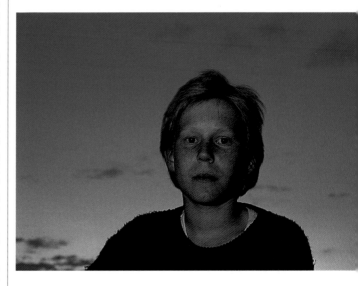

For this portrait, taken at dusk, the photographer placed an orange 85B filter over the flashgun and a blue 80B filter over the lens. This meant that the subject in the foreground recorded naturally because the two filters cancelled each other out, while the sky took on the blue colour of the filter on the lens.
EQUIPMENT: *Olympus OM1n, 50mm standard lens, Vivitar 283 flashgun, 85B and 80B filters* ***FILM:*** *Fujichrome RFP50*
EXPOSURE: *1/15 second at f/8*

Firework Photography

Firework displays provide ideal opportunities to take exciting, colourful photographs, and although the techniques involved may seem rather complicated, they're actually very easy and anyone with a basic knowledge of photography can quickly master them.

In the UK, every town and city celebrates Guy Fawkes Night on the fifth of November with an enormous firework display, but displays also take place throughout the year at festivals, concerts and other celebrations; so no matter where you live you should be able to visit at least one display each year.

WHAT YOU NEED

Camera: You need to use long exposures for firework photography, so a camera with a B (bulb) setting is essential as it will allow you to hold the shutter open for as long as you like. 35mm SLRs and medium-format cameras all include this feature, but some of the more sophisticated compacts have it as well.

Lenses: Focal lengths from 28mm wide-angle to 200mm telephoto will cover all eventualities, the wider lenses being ideal for shots of the whole aerial display and the telephotos so you can home in on the exploding rockets to produce eye-catching abstract images.

Accessories: A solid tripod to keep your camera steady, a cable release so you can trip the camera's shutter (and hold it open on B) without having to touch the shutter release button, plenty of colour film and a piece of black card about A4 in size.

HOW IT'S DONE

Arrive nice and early so you can check out the location and look for the best vantage point before the crowds arrive and the display begins. If you're unsure where to go, ask a marshal where the fireworks are expected to explode so you can position yourself to get a clear view. While it's tempting to go really close to the display, you'll get a much better view by staying well back. Doing this also means that you're less likely to have people getting

Pictures of just one or two aerial fireworks are rarely very exciting, as you can see. However, if you keep your camera's shutter open while several bursts occur, you can build up the colourful explosions on a single frame of film – see the picture opposite.

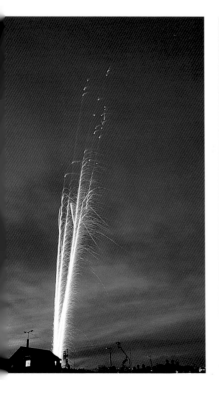 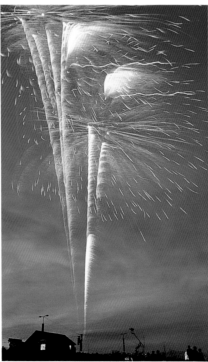 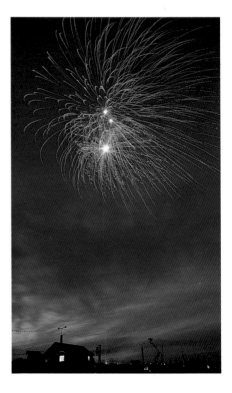

in front of you and blocking your view, or knocking the tripod.

Once you've found a suitable viewpoint, mount your camera on the tripod, decide which lens to use and roughly compose the shot so it will take in the exploding fireworks. If you're able to include people or buildings in the bottom of the frame, do so as it will add scale and extra interest. Next, fit the cable release to your camera and make sure you've got plenty of shots left on the roll of film that's in it.

When it comes to exposure, a tried and tested method is to set the lens aperture to f/11 or f/16 and the shutter to B (bulb). As the display will take place some distance away, you can focus

wide-angle lenses on infinity. Finally, make sure you've got that piece of black card handy.

When the display begins, look through the viewfinder to make sure the fireworks are exploding in the right place, and adjust the composition accordingly if they aren't. When you see the next lot of rockets go up – there's usually a tell-tale streak going up into the sky – trip the camera's shutter with the cable release and hold it open so the exploding rockets will record. Many photographers release the shutter after this, but you'll get much better results by holding it open for 30–60 seconds while more rockets explode, so they all record on the same shot.

If there's a short lull in the display and you want to record more rockets, keep the shutter open but hold the piece of card a few centimetres in front of the lens, taking care not to touch the lens or the camera. When more rockets go up, take the card away so they will be captured. Repeat this procedure two or three times until you've recorded plenty of explosions on the same shot, then release the shutter, wind the film on and do the same thing again.

TOP TIPS

• If the display takes place in winter, remember to wrap up nice and warm as you will quickly become very cold standing in the same place.

• Instead of taking similar pictures throughout the display, try changing lenses and shooting both wide-angle and telephoto shots.

• Use slow-speed film – ISO50–100 – for optimum image quality. With your camera mounted on a tripod it doesn't matter how long the exposures are, so there is little point in using faster film.

• In windy weather hang your gadget bag from the tripod to increase its stability. Doing so also means you can keep an eye on your equipment and prevent it from being stolen.

This is the type of result you can expect to obtain by following the advice given. In total, five or six rocket bursts were recorded on the same frame of film to create an exciting, colourful image that really sums up the thrills and spills of an aerial firework display.
EQUIPMENT: Olympus OM4-Ti, 28mm wide-angle lens, tripod, cable release
FILM: Fujichrome Velvia ISO50
EXPOSURE: 60 seconds at f/16

Floodlit Buildings

The old mosque in the Spanish city of Cordoba makes a spectacular sight come nightfall, when it's floodlit against the surrounding buildings. This picture was taken from across the River Guadalquivir, with shimmering reflections in the water adding extra interest. Because the mosque is relatively small in the picture, and surrounded by much darker areas, the photographer took a spot reading from the building itself, then used a range of exposures – 10, 15, 20, 30 and 40 seconds – to ensure that at least one was perfect. This proved to be the best frame from the sequence.

EQUIPMENT: Pentax 67, 165mm telephoto lens, tripod, cable release, Pentax Digital Spotmeter

FILM: Fujichrome Velvia ISO50

EXPOSURE: 20 seconds at f/16

As daylight fades towards the end of each day, man-made illumination takes over and a wander around your neighbourhood is likely to reveal a range of buildings that come to life under the colourful glow of artificial lighting. Churches, town halls, restaurants, pubs and bars, cafés, castles and cathedrals are just a few examples of perfect night-time subjects as they stand out against the ever-darkening sky.

WHAT YOU NEED

Camera: As light levels are low at night, even when you're photographing what appears to be a brightly lit building, you will need a camera that can be used at exposure times of several seconds. All 35mm SLRs fall into this category, along with many compact cameras that have a wide shutter speed range, a B (bulb) setting or a special 'night' mode.

Lenses: For most floodlit buildings, a 24mm, 28mm or 35mm wide-angle or 50mm standard lens will be required so you can photograph the whole structure at relatively close range. A moderate telephoto lens of 80–200mm can also be used in some locations to isolate a floodlit building from further away.

Film: Use slow-speed film of ISO 50–100 to make the most of the vibrant colours created by the artificial illumination.

Accessories: A tripod to keep your camera completely still during the long exposure, plus a cable release to trip the camera's shutter.

HOW IT'S DONE

Time

The optimum time to begin photographing floodlit buildings is at the point after sunset when the ambient (daylight) levels are similar to the artificial light levels. At this time, the floodlit building will stand out from its surroundings, but there will still be enough daylight left to record detail in the unlit areas, and plenty of colour

in the sky to provide an attractive backdrop. At any time earlier than this, the floodlighting on the building won't have taken effect, but if you wait too long the difference in brightness between the floodlit building and its unlit surroundings will be so great that the only thing you will record on your pictures is the building itself, with the sky coming out black.

Exposure

The only other major factor you need to consider is exposure. If the building fills most or all of the camera's viewfinder, you may find that by leaving the exposure to its integral metering system you get perfect results. This is because the lighting on floodlit buildings tends to be quite even, so providing you don't include any bright lights in the picture – such as spotlights pointing towards you – there's no reason why your camera should cause exposure error.

In these situations, use your camera in aperture priority mode so you set the lens aperture required – usually f/11 or f/16 to give plenty depth-of-field – while the camera sets the correct exposure time automatically. This may be 20 or 30 seconds, which is why a tripod is essential.

Where the building occupies less of the picture area and is surrounded by darker sky or other unlit buildings, you must determine the exposure carefully. If you rely on your camera's metering system, there's a high risk that the darker areas in the scene will cause overexposure, with the floodlit building coming out much too light on the final picture.

To overcome this, take a meter reading from the building itself, so the shady areas don't influence the exposure obtained. If your camera has a spot or partial metering facility, simply point the metering circle in the viewfinder towards the building and take a reading from it. If not, fit a longer lens to your camera so only the building appears in the viewfinder, take a meter reading, then use the exposure obtained for the final picture.

As a final safety measure, it's also a good idea to bracket exposures over the initial reading. If your first picture is taken at an exposure of 20 seconds at f/11, for example, take others at exposures of 30, 40 and perhaps 60 seconds. The main reason for doing this is that photographic film is designed for use at exposures less than one second in duration. If you use longer exposures, the effective ISO rating becomes inaccurate and underexposure may occur. This is known as reciprocity law failure.

Different brands of film respond differently to long exposures, but as a general rule, if you take pictures at exposures up to double what your meter says is correct, you should achieve at least one perfect result.

TOP TIPS

• As normal film records artificial illumination differently to how we see it, floodlit buildings usually come out a different colour to how you remembered them. The colour depends on the type of lighting – it could be blue, yellow or green. Filters can be used to correct these colour casts, but most photographers don't bother as they tend to look very effective.

• If you're unsure whether or not a building will be floodlit at night, look for spotlights around its base. Most famous monuments are floodlit throughout the year, but less important buildings may only be lit at certain times.

• The techniques used to photograph floodlit buildings can also be used on other floodlit structures, such as bridges, statues, monuments, and general night scenes.

The Eiffel Tower in Paris is another ideal night-time subject, and can be photographed in any number of different ways. On arrival, the photographer took a series of pictures using 20mm and 28mm wide-angle lenses. However, the beauty of the structure has been revealed far more by this telephoto shot, which captures its intricate design perfectly against the twilight sky. The picture was taken using a 35mm SLR set to aperture priority mode, and the exposure given by the camera's integral metering system produced a perfect result.
EQUIPMENT: Nikon F90x Prof., 80–200mm telezoom lens at 200mm, tripod and cable release **FILM:** Fujichrome Velvia ISO50
EXPOSURE: 25 seconds at f/11

Flower Power

Flowers are a subject that has intrigued and captivated photographers ever since the birth of photography itself. From the vibrant colour and intricate detail of a sunflower glowing in the summer sun to the tiny, delicate white buds of gypsophila, trying to capture the sublime beauty of something so pure and natural on film is an enduring challenge, and one that's open to endless creative interpretation.

WHAT YOU NEED

Camera: For pictures of gardens or groups of flowers captured outdoors, any type of camera can be used, but for close-ups a 35mm SLR will be required so that you can use macro lenses and other close-up accessories.

Lenses: A 28mm or 35mm wide-angle lens is ideal for pictures of gardens or fields of flowers, allowing you to fill the foreground with colour. For shots of groups of flowers or still-lifes, use a 50mm standard or short telephoto lens, while a longer telephoto lens – 200mm – will be ideal for isolating small groups of flowers or individual blooms from a distance.

For close-ups of flowers you will need a lens or an attachment that allows close focusing, such as extension tubes, a macro lens, supplementary close-up lenses or a zoom lens with a 'macro' facility (see page 30).

Accessories: Use a tripod to keep your camera steady and aid accurate framing and focusing – especially when shooting close-ups. A collection of small reflectors made from white card or foil

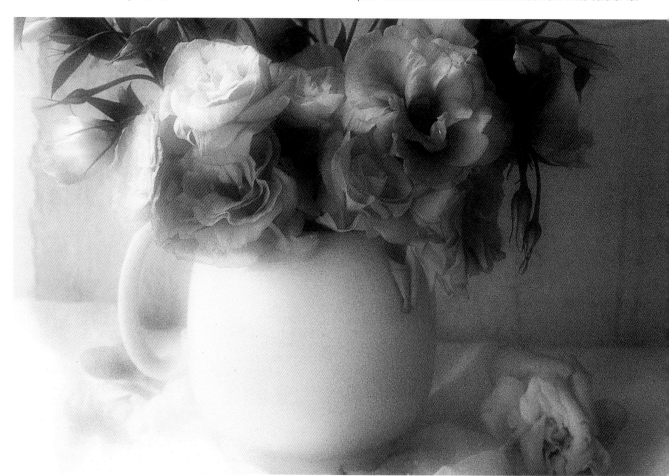

will be useful for controlling the light falling onto your subject, especially when working outdoors, while filters such as 81-series warm-ups, polarisers and soft-focus can also be used to enhance your pictures.

Film: Slow-speed emulsions (ISO50–100) are an ideal choice when you want to record the delicate colour and intricate detail, but ultra-fast grainy films (ISO1000+) are perfect for the creation of impressionistic images.

HOW IT'S DONE
Shooting outdoors

The easiest way to photograph flowers is by working outdoors in natural daylight. During the spring and summer your own garden may be alive with beautiful blooms, and these alone can be the source of endless pictures. If you don't have a garden, visit a friend or relative or, failing that, spend the day exploring a public garden nearby. The wild flowers growing in woodland, meadows, fields and hedgerows are also well worth photographing –

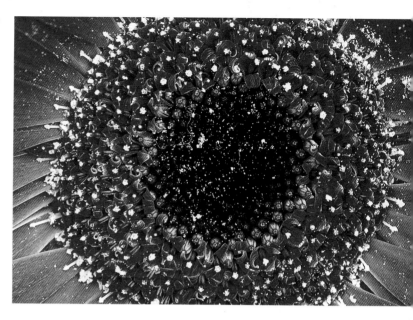

there are few sights more beautiful than a field of corn full of red poppies swaying in the summer breeze, or banks of bluebells fringing woodland in springtime.

The technique you use to capture these flowers on film will obviously depend on the type of result you want to produce. Where flowers cover a large area you could use a wide-angle lens so they fill the foreground, in the same way that you would capture a landscape, and use a small aperture – f/11 or f/16 – to ensure that the whole scene is recorded in sharp focus.

A more common approach, however, is to concentrate on a small group of flowers or a single bloom. To do this, use a telephoto lens so you can fill the frame with colour and interest from a distance – the longer the lens, the bigger the flower will be in the picture. This technique works well on beds of colourful flowers such as tulips and daffodils. Set the lens to its widest aperture, so depth-of-field is minimised. That way, only one flower will be sharply recorded while the others are thrown out of focus.

This beautiful, painterly image was taken in the photographer's home, an old seventeenth-century cottage, where the rough plastered walls painted in soft hues make ideal backgrounds. After choosing a suitable area next to a window, a makeshift tabletop was erected against the wall by resting a piece of board on a box and draping a sheet of white muslin fabric on it. The flowers were then arranged in a small vase and put into position. As the weather was very dull and the window in shade, the light was soft and virtually shadowless. To enhance this, the picture was recorded on fast, grainy film, using a soft-focus filter to diffuse the image slightly.
EQUIPMENT: *Nikon F90x Prof., 105mm macro lens, soft-focus filter, tripod and cable release* ***FILM:*** *Agfachrome 1000RS rated at ISO1000* ***EXPOSURE:*** *¹⁄₃₀ second at f/11*

The intricate details and stunning colours in this flower have been revealed with dazzling clarity by using a macro lens to record a lifesize (1:1) image; if you look closely you can even see individual grains of pollen on the petals. To take the photograph, the flower was placed next to a window and photographed from above in natural daylight.
EQUIPMENT: *Nikon F90x Prof., 105mm macro lens, tripod and cable release* ***FILM:*** *Fujichrome Velvia ISO50* ***EXPOSURE:*** *4 seconds at f/22*

Bright, sunny weather during the morning and afternoon is ideal for revealing the vibrant colours of flowers, but with more delicate species you'll get better results in bright but slightly overcast weather when the light is softer, shadows are weaker and contrast lower. Backlighting is also ideal for flowers such as poppies and tulips as it makes their translucent petals glow.

The main problem you're likely to encounter when photographing flowers outdoors is subject movement caused by the wind. It only takes a slight breeze to make flowers sway dramatically, but unless you're careful it could mean you end up with blurred pictures. The easiest way to avoid this is by shooting at a fast shutter speed so any subject movement is frozen – ¹⁄₂₅₀ second or ¹⁄₅₀₀ second should be fine.

Unfortunately, if you're shooting close-ups and need to set a small lens aperture to maximise depth-of-field, it's unlikely that you will be able to use such a fast shutter speed when working with slow-speed film, even in bright sunlight. Also, any movement will be magnified because you're so close to the flower, making composition and accurate focusing difficult.

A possible solution is to use an electronic flashgun to light the flower. Not only will this allow you to use a small lens aperture to maximise depth-of-field, but the brief burst of light from the flashgun will also freeze any subject movement (see page 30).

Shooting indoors

A much simpler alternative is to take the flowers indoors, where you don't have to worry about subject movement, but more importantly, you will have much more control over the lighting, background and composition of your pictures.

To light the flowers, all you need to do is position them next to a window. If you're shooting a close-up of a single flower, other elements such as the background aren't important, so you can just place the flower in a bottle or vase so it stands upright, then set up your equipment and get to work capturing it on film.

In sunny weather, choose a window that doesn't admit direct sunlight, otherwise you will have problems with harsh shadows and high contrast. North-facing windows are ideal, but most of the windows in your home will probably be suitable at some time during the day. Alternatively, wait until the weather is slightly overcast so that the hard edge is taken off the light. Even dull, grey days can be highly effective, because the soft, shadowless light in these conditions will allow you to record the finest details and subtlest colours.

When working in extreme close-up – around lifesize (1:1) – try not to be too literal about how the flower is photographed. Instead of recording the whole thing, look at the details, textures and colours, and perhaps concentrate on just a small part of the bloom, or exploit the patterns and symmetry that some flowers possess.

Equally, while it's normal practice to use small lens apertures when shooting close-ups so depth-of-field is maximised, experiment with wide apertures too, such as f/2.8, f/4 and f/5.6. Doing this will mean that only a tiny part of the flower is recorded in sharp focus, but far from spoiling the final image it can greatly

Some of the most successful flower pictures are the simplest – like this one, again captured in the photographer's garden on a dull, overcast day. The softness of the light has revealed the vivid yellow of the flower perfectly, while the neutral background – an out-of-focus door – makes it stand out very clearly.

EQUIPMENT: Nikon F90x Prof., 105mm macro lens, tripod and cable release **FILM:** *Fujichrome Velvia ISO50* **EXPOSURE:** *⅕ second at f/4*

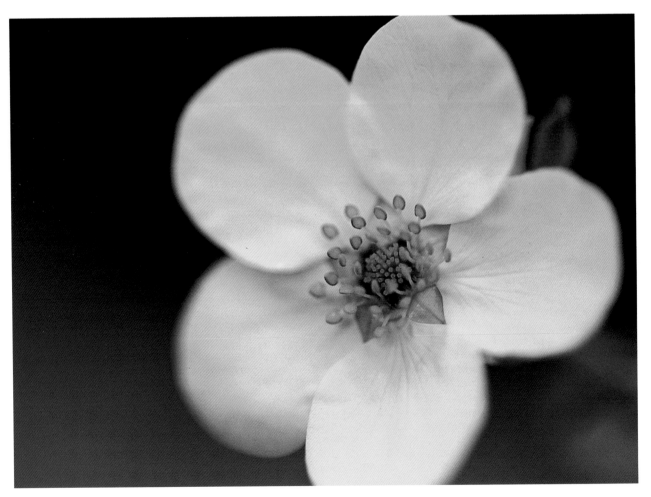

TOP TIPS

TOP TIPS

• Photograph flowers when they are still fresh, otherwise the colours tend to fade and the petals begin to wither.
• Buy flowers for photography from your local florist, where you can choose lots of different types and pick the best specimens.
• Dead flowers also make interesting subjects when laid out on slate or an old painted door, so once you've finished with the fresh flowers, leave them to dry for a couple of weeks, then take some more pictures.
• Spend time experimenting with different compositions and lenses to see how many pictures you can take of a single flower.

LEFT The vivid red petals of this tulip not only add great impact to the picture, but also provide a perfect background to the heart of the flower. To take the photograph the flower was first plucked from the photographer's garden and brought indoors. Some of the petals were then removed to give a clearer view, and the flower was placed against a large window where it was lit by natural daylight.
EQUIPMENT: *Nikon F90x Prof., 105mm macro lens, tripod and cable release* FILM: *Fujichrome Velvia ISO50*
EXPOSURE: *2 seconds at f/22*

BELOW This stunning sunflower, along with many others like it, was grown by the photographer in his garden for the sole purpose of photographing it. This may seem like an extreme measure to take, but sunflowers are actually very easy to grow and by midsummer, when they reach heights of 2m or more, make an amazing sight – as well as a perfect photographic subject. The shot was taken from a low angle so the vibrant yellows and greens of the flower could be captured against the deep blue sky. A polarising filter was also used to saturate the colours.
EQUIPMENT: *Nikon F90x Prof., 28mm wide-angle lens, polarising filter* FILM: *Fujichrome Velvia ISO50*
EXPOSURE: *⅟₃₀ second at f/11*

enhance it, producing an unusual, impressionistic effect.

By working indoors you can also set up attractive still-life displays of flowers arranged in a vase or pot, and use window light for illumination. Old houses are ideal for this as you can use crumbling plasterwork or peeling paint as a background, but 'rustic' backgrounds can just as easily be created using old doors, rusting metal, distressed mirrors, and so on. Alternatively, hang a sheet of old canvas or white cotton muslin from the wall and arrange the flowers in front of it, or make a background by painting a sheet of board.

If you set up the still-life next to a window, place a reflector on the opposite side so that light is bounced into the shadows. This helps to keep contrast low. And instead of using slow-speed film, load up with faster stock – the pastel colour rendition and coarse grain can create a beautiful painterly effect, especially if you shoot in dull weather and use a soft-focus filter.

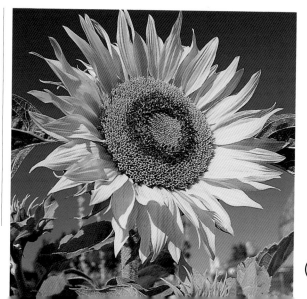

Framing a Scene

One of the most effective ways of producing a tight, structured composition is by framing your main subject in some way. Not only does this help to direct the viewer's eye towards the most important part of the picture, but frames can also be used to cover up uninteresting areas in a scene, such as a broad expanse of empty sky.

Frames can be either natural or man-made. Natural frames include the overhanging branches of a tree, the entrance to a cave, or ivy growing around a door, while man-made frames comprise features such as doorways, archways, bridges and open windows.

WHAT YOU NEED

Camera: SLRs which offer direct viewing through the lens make accurate composition easier.

Lenses: All focal lengths can be used to exploit frames. Wide-angle lenses allow you to make use of frames that are nearby – if you stand close to an archway, doorway or window you can use it to surround the edges of the picture. Telephoto lenses are more useful for exploiting frames that are further away, such as a gap between tall buildings or trees.

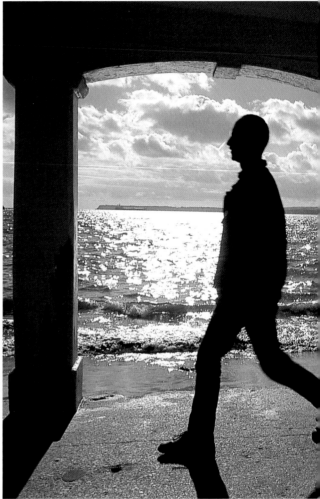

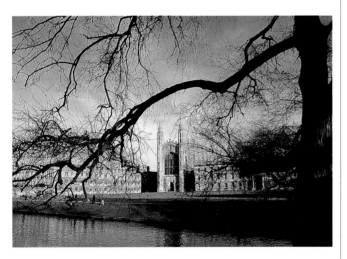

Overhanging branches make an ideal frame. In this picture of King's College in Cambridge, England, they not only lead the eye towards the buildings in the distance, but they also help to hide the pale winter sky. A wide-angle lens was used to compose the scene, and a small aperture to ensure everything was recorded in sharp focus.
EQUIPMENT: Olympus OM4-Ti, 28mm wide-angle lens
FILM: Fujichrome Velvia ISO50 *EXPOSURE:* ½₅ second at f/16

This picture came about while the photographer was walking through a sea-front passageway and noticed the interesting frame created by the columns and archways. Fixing a wide-angle lens to his camera, he composed the shot, then waited until a person stepped into his field of view before tripping the camera's shutter. A meter reading was taken off the highlights on the sea in the background so anyone standing in front of them would record as a silhouette, adding to the graphic simplicity of the image.
EQUIPMENT: Olympus OM2n, 28mm wide-angle lens *FILM:* Fujichrome Velvia ISO50 *EXPOSURE:* ½₅₀ second at f/8

HOW IT'S DONE

When using frames in a photograph you must consider a number of factors if you want to produce successful results.

First, you must consider lighting direction. If the sun is behind you, light will be falling onto the frame and the scene beyond it, so everything will be of a similar brightness and should record as

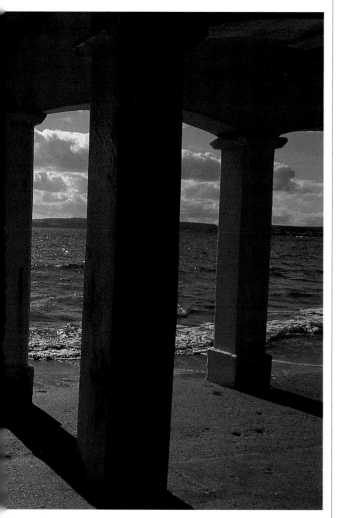

you see it. If you are shooting into the light, however, or if the sun is to the side of the camera position, the main part of the scene may be well lit, but little or no light will fall directly onto the frame and it will record as a silhouette. Trees at sunset or the view from beneath an underpass or bridge are two examples.

Closely allied to this is the way you determine correct exposure. If you're shooting with the sun to your back so that the frame and the scene beyond is evenly lit, you shouldn't experience any problems obtaining well exposed pictures. More often than not, however, you will be standing in the shadow of the frame itself, and overexposure is very likely because the low light levels around you will confuse your camera's metering system.

If your camera has spot metering you can use it to take meter readings directly from your main subject, without the darkness of the frame influencing the reading (see page 13). If not, step beyond the frame and out of the shade, take an exposure reading, set it on your camera, and don't change anything once you re-compose with the frame included.

Finally, the lens aperture you use will have a major effect on how the frame records. If you want the frame and the scene beyond to be rendered in sharp focus, set a small lens aperture, such as f/16, and use the depth-of-field scale on your lens to check that everything falls within the zone of sharp focus available (see page 42).

Alternatively, by setting a wide aperture such as f/4 and focusing on the scene or subject beyond the frame, depth-of-field will be reduced to such a level that the frame itself is thrown well out of focus and all attention is directed towards your main subject. This effect is best achieved with a telephoto lens, and can produce striking results – especially if you're using an unstructured frame such as the branches of a tree.

TOP TIPS

• Landscape and architectural pictures lend themselves to the inclusion of frames, so look out for suitable features when you're exploring a location.

• Frames can be created where none appear to exist by adopting an unusual viewpoint from which to photograph the scene. If you crouch down low among a bed of tulips, for example, the tall flowers will frame the scene beyond.

• Use frames to cover up annoying details in a scene, such a litter bins, colourful signs and other features that would catch the eye and cause an unwanted distraction.

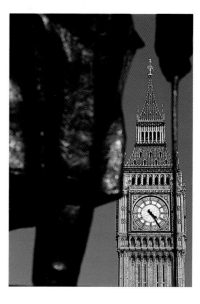

Careful choice of viewpoint has helped to make the most of this frame, while the use of a moderate telephoto lens set to a wide aperture has thrown the statue in the foreground out of focus so your attention is immediately directed towards the most important subject matter. Finally, in order to prevent the dark tone of the statue causing overexposure, a meter reading was taken from Big Ben.
EQUIPMENT: Olympus OM4-Ti, 85mm lens, polarising filter, tripod
FILM: Fujichrome Velvia ISO50
EXPOSURE: 1/30 second at f/8

Grain

The grain structure in a photographic image is produced by clusters of silver halides in the light-sensitive emulsion. The faster the film is – the higher its ISO rating – the bigger these clusters are and, as a consequence, the coarser and more noticeable the grain is in the final photograph. Grain also becomes more evident as a photograph is enlarged – it may be almost invisible on a small print, but as you enlarge the image, so the grain structure is enlarged and emphasised as well.

To the majority of photographers, grain is seen as a negative rather than positive element, and they go to great lengths to minimise it by using slow-speed film of ISO50, perhaps even ISO25. Using a larger film format will also help to minimise grain because the larger the original image is, the less it needs to be enlarged during printing or reproduction.

However, when used creatively, grain can greatly enhance an image, and when intentionally exaggerated it can produce beautiful effects. In black and white photographs it lends a stark, gritty feel to the image, while in colour the use of coarse grain adds atmosphere, and can produce images with a pleasing 'impressionistic' feel reminiscent of a painting rather than a photograph. To this end, more and more photographers are beginning to realise the benefits of exploiting rather than avoiding grain, and are using it for all manner of subjects.

HOW IT'S DONE
Using film

The easiest way to emphasise grain in a photograph is by using ultra-fast film with an ISO rating of 1000 and above. If you prefer colour slides, Fujichrome Provia 1600 and Kodak Ektachrome P800/1600 are good choices, while for colour prints you could use Kodak Ektar 1000, Ektapress 1600, Agfa XRS1000, Fuji SHG1600 or Konica SRG3200. The choice for black and white photography includes Kodak T-Max 3200, Kodak 2475 Recording Film and Fuji Neopan 1600.

All of the films mentioned offer relatively coarse grain at their normal speed rating, but if you want it to be even more obvious you could uprate the film to a higher ISO, then have it push-processed, a technique that boosts grain size and image contrast. Uprating slower ISO400 film by two stops to ISO1600 is another option that many photographers use, mainly because ISO400 film is cheaper and more readily available than ultra-fast films.

To produce the coarse grain in this graphic black and white landscape, the photographer used ultra-fast 35mm film, then enlarged the negative to make a 40x30cm (16x12in) print. Printing on a hard grade of paper – grade IV – also helped to enhance the grain, and the print was toned afterwards so as to add an attractive warmth to the image.
EQUIPMENT: Olympus OM4-Ti, 28mm lens
FILM: Fuji Neopan 1600 rated at ISO1600
EXPOSURE: 1/60 second at f/16

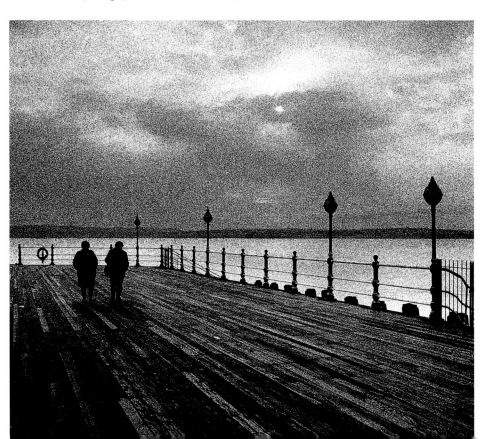

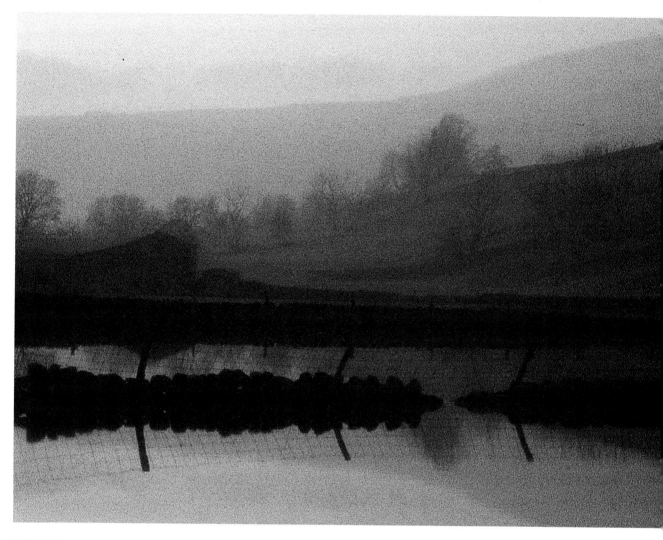

In the darkroom

If you process and print your own photographs, there are various other ways of maximising grain.

First, grain size in black and white images can be increased even when the film is rated at its normal ISO by using edge-enhancing developers such as Agfa Rodinal, Tetenal Neofin Blue or Ultrafin. These products are intended to maximise image sharpness, and in doing so emphasise grain to produce crisp, gritty results.

A more extreme and less predictable approach is to process the film in diluted print developer. This has a very quick reaction, so dilute it to half or quarter strength and try it on a few test rolls before risking anything important.

The coarse grain and pastel colour rendition of ultra-fast colour transparency film has been used effectively here to enhance the soft light of a dull, misty day. Captured at dusk near the Dales village of Muker in North Yorkshire, England, the tranquil scene was photographed with a moderate telephoto lens to compress the receding planes and highlight the aerial perspective created by haze in the damp air. A soft-focus filter was also used to heighten the atmosphere of the image and take it a step further away from reality. The overall effect is a simple yet evocative image that looks more like an impressionistic watercolour than a photograph.

EQUIPMENT: Olympus OM4-Ti, 135mm telephoto lens, soft-focus filter, tripod **FILM:** *Kodak Ektachrome P800/1600 rated at ISO1600*
EXPOSURE: *$1/15$ second at f/11*

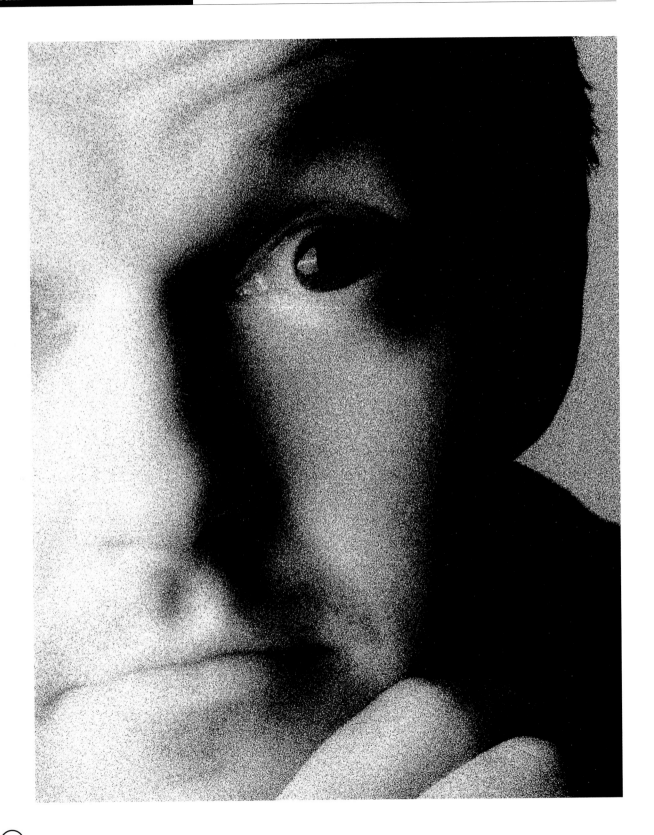

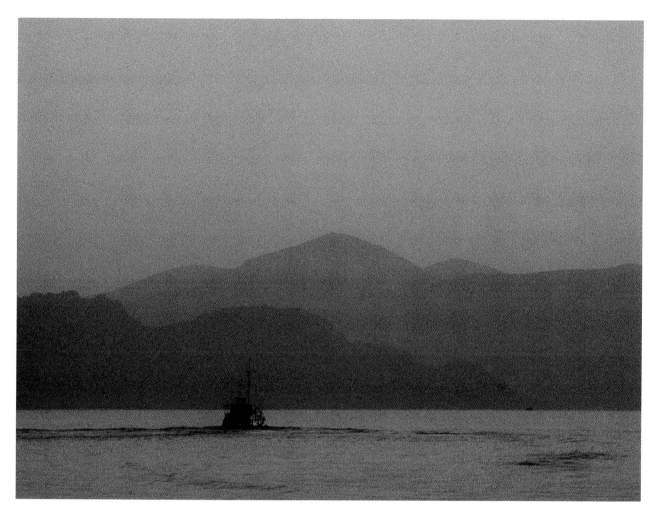

ABOVE **This Greek sunset was originally shot on ISO1000 colour slide film, but feeling it would benefit from even coarser grain, the photographer had a 6x9cm (2½x3½in) duplicate slide made from the 35mm original to produce true 'golfball' grain.**
EQUIPMENT: Olympus OM4-Ti, 200mm telephoto lens, 81C warm-up filter FILM: Agfachrome RS1000 rated at ISO1000
EXPOSURE: ¹⁄₂₅₀ second at f/8

LEFT **To create this striking, graphic image the photographer made a 40x30cm (16x12in) enlargement from the original grainy negative, which had been produced on ISO1600 black and white film. After sepia toning, a small part of the print was then copied back onto colour slide film using a 6x7cm (2½x2¾in) medium-format camera and macro lens. This final stage helped to emphasise the wonderful grain structure of the original image.**
EQUIPMENT: Olympus OM4-Ti and 85mm lens for original portrait, Pentax 67 and 135mm macro lens to copy print FILM: Fuji Neopan 1600 for original portrait, then Fujichrome Provia 100 for copy
EXPOSURE: ¹⁄₆₀ second at f/16 for original portrait

At the printing stage, the easiest way of enhancing grain is by increasing the size of reproduction. This can be done simply by making bigger enlargements – the grain on a 40x30cm (16x12in) print will obviously be more noticeable than on a 25x20cm (10x8in) print. Alternatively, try selective enlargement by blowing up a small section of the original negative. You could even shoot the original subject with a grainy print in mind. Do this by composing the shot as normal then switching to a wider lens – a 28mm if you would normally use a 50mm, for example, so your main subject matter is much smaller in the frame. All you have to do then is raise the head of the enlarger to isolate it and make your print.

Increasing the printing paper's contrast grade can also work well as it increases grain in the mid-tones. Alternatively, try printing on lith paper such as Kodak Rapid, Oriental Seagull G or Kentmere Kentona. The latter method can be quite tricky because the compounds in the developer (Kodalith RT or Champion Novalith) tend to act on the print emulsion very rapidly, so the print has to be carefully monitored as it develops,

'snatched' from the developer at the exact moment, then quickly transferred to the stop bath to arrest the development process. An added benefit of lith printing is that the prints will often exhibit an attractive warmth in the highlights, almost as if they have been partially toned (see page 140).

Duplicating

If you are working with colour slides rather than negatives, grain can be emphasised by duplicating the original (see page 44). At its simplest this may involve duping an image shot on slow film onto ultra-fast film to add coarse grain. However, you can also increase the grain size of an image that's already grainy by only duping part of it. This can be done using a simple zoom slide duplicator which fits to your 35mm SLR (see page 44). And if you're still not satisfied with the result, then just duplicate part of the dupe to make the grain even coarser!

Another option is to have a larger-format duplicate slide made from the original. Many professional processing labs offer a slide duplicating service which usually includes making 6x9cm (2½x3½in) full-frame dupes from 35mm. If you have these enlarged dupes made from an original shot on ultra-fast film, the results can look amazing. Alternatively, you can make your own

For this simple windowlit portrait the photographer used ISO1000 colour transparency film, not only to add coarse grain to the image but also to cope with the low light levels. Despite the high speed of the film, the lens still had to be set to a wide aperture so that a shutter speed fast enough to prevent camera shake could be used. The attractive warm tone of the image is completely natural, caused by the daylight coming in through the window and the colour of the walls in the room.
EQUIPMENT: Olympus OM4-Ti, 85mm lens **FILM:** *Agfachrome 1000RS rated at ISO1000*
EXPOSURE: *⅛₂₅ second at f/4*

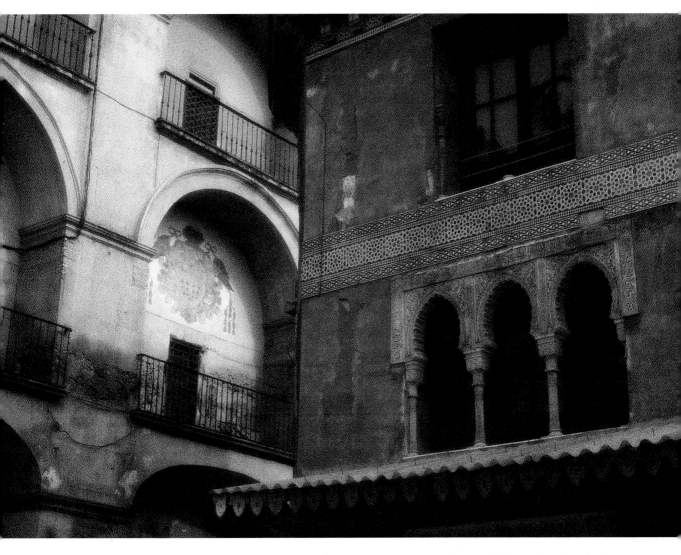

large-format dupes onto sheets of 12.5x10cm (5x4in) film using an enlarger to emphasise the grain of smaller originals. This is explored in detail on page 80.

TOP TIPS

• Experiment with a range of films to see which you prefer – all offer their own subtle blend of characteristics that can be chosen to suit a specific subject or lighting situation.

• Always keep a few rolls of ultra-fast film – ISO400–1600 – in your gadget bag so you can use them as and when you encounter a suitable subject.

• Use filters to enhance the painterly, grainy effect – soft-focus and warm-up filters work well with fast colour film, adding a wonderful 'dreamy' feel to the image.

• Choose lighting conditions carefully. Fast colour slide film

Fast, grainy film was chosen here to complement the mellow, rustic colours of the old buildings. A soft-focus filter was also used to enhance the mood of the scene. The picture was taken in fading evening light in the Spanish city of Cordoba, a place full of beautiful old buildings that make perfect subjects for impressionistic, grainy images like this.

EQUIPMENT: *Olympus OM4-Ti, 135mm telephoto lens, soft-focus filter*
FILM: *Kodak Ektachrome P800/3200 rated at ISO1600*
EXPOSURE: *1/60 second at f/8*

generally performs better in soft, low contrast light, while black and white film can be used successfully in any conditions.

• Grain can be used to enhance photographs of all types of subjects – landscapes, nudes, architecture, still-lifes, flowers, portraits and many more, so don't limit yourself.

Image Transfer

For many years now, Polaroid instant film has provided a convenient and quick way of taking exposure test shots in the studio or on location. However, more recently it has also become the basis of a fascinating technique that allows creative photographers to produce beautiful images with a delicate, fine-art quality.

When a picture has been taken on Polaroid instant film, the exposed sheet is normally removed from the camera and, after a minute or so, the two halves are peeled apart to reveal a fully processed image. However, with image transfer the film is peeled apart after just a few seconds, before the dyes in the negative part of the film have had the chance to migrate over to the print itself. The negative is then placed in contact with another material, such as textured paper or fabric, so the image is formed on that material.

WHAT YOU NEED

Polaroid image transfers can be created either by taking pictures specifically for use with the technique, or alternatively by copying existing colour transparencies onto Polaroid instant film ready for transfer. If you choose to use the first approach, you will require a camera that can be fitted with a Polaroid film back – most medium-format and large-format cameras will have this facility. Any ER instant colour film can be used with medium-format cameras, while Type 59 sheet or Type 559 pack film is required for 12.5x10cm (5x4in) cameras, and Type 809 for 25x20cm (10x8in) cameras.

This is the most versatile method as it means you can produce pictures specifically for image transfer, and if the first attempt doesn't work, simply take another photograph and try again. The effects produced using large-format Polaroid film are also superior to smaller formats and the transferred image is easier to manipulate or retouch.

Most photographers go for the more convenient method of copying existing 35mm transparencies onto Polaroid ER instant film and then transferring the copied image onto the medium of their choice. To do this you will need:

• A Vivitar slide copier, which is available from Polaroid and designed specifically to copy pictures onto Polaroid instant film
• Packs of Polaroid Type 669 or Polacolor 100 instant film, available from most good photo stores
• A selection of 35mm mounted colour transparencies
• A rubber roller
• Plastic print tray
• Textured/watercolour paper

The type of paper you use can have a big influence on the final result. If the texture is very coarse you may find that the image does not transfer very well, which can produce interesting effects in itself but should normally be avoided. Similarly, if the paper doesn't have any texture the image has a tendency to 'run' and the dyes to spread, producing a messy image.

Basic watercolour paper or newsprint paper, available from artist's supply shops, tend to be the easiest to use initially, then once you've got the hang of things you can try different materials – including fabrics, unglazed clay and wood.

HOW IT'S DONE

The following steps explain how to create image transfer pictures by copying existing slides:

1 Choose a suitable slide. Ideally it should be of a relatively simple subject and should not rely on fine details for its appeal. Still-lifes, portraits, flower close-ups and architectural shots work well.
2 Load a pack of Polaroid film into the Vivitar copier following the instructions, then place your mounted 35mm slide in the holder.
3 Take a sheet of watercolour paper and soak it in clean warm water for a few seconds.
4 Remove the paper from the waterbath, place it on two or three sheets of dry paper, then remove any excess water using a dry cloth or blotting paper so the surface is just touch-dry.
5 Press the start button on the Vivitar copier. The integral flash system will fire, and your picture will be copied onto the Polaroid instant film.
6 Pull out the sheet of exposed Polaroid film from the copier, quickly cut off the chemical pods with a pair of scissors, count to ten, then peel it apart *(step 1)*.
7 Discard the print half of the film, then carefully and quickly lay the negative half face down onto your damp watercolour paper or other material. Place a sheet of dry paper on top of the film *(step 2)*.

Step 1

Step 2

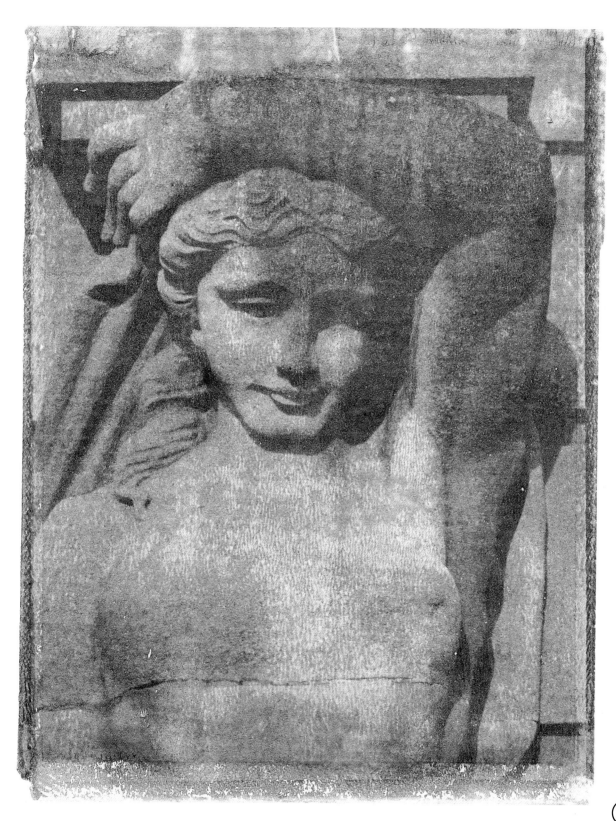

PREVIOUS PAGE **Simple, graphic subjects like this architectural detail suit the image transfer technique well, especially during your first attempts, as the need to record fine detail is less important.**
EQUIPMENT: Olympus OM4-Ti, 135mm lens for original **FILM:** *Fujichrome RFP50 ISO50 for original, Polacolor 100 for transfer* **EXPOSURE:** *⅟₆₀ sec at f/5.6 for original*

8 Using the rubber roller or your hand, apply even pressure across the film so it comes into complete contact with the watercolour paper. Keep rolling or rubbing over the film for one minute. Then stop rolling and leave the film for 60 seconds *(step 3)*.

9 Carefully lift a corner of the film. If you see areas of emulsion that haven't stuck to the paper, replace the film and burnish the area with the back of a spoon.

10 Gently peel the film off the watercolour paper from one end to reveal a beautiful painterly image on the paper like those shown here. Leave the paper to dry naturally, then flatten it with books if necessary *(step 4)*.

If parts of the image are missing, you can retouch them with watercolour paints or crayons once the paper has dried. The final image can then be copied back onto colour transparency film using a 35mm SLR and macro lens, so the original doesn't have to be handled.

If you use a Polaroid back on a camera instead of a Vivitar copier, take your picture, then follow steps 5–8.

Step 3

Step 4

TOP TIPS

• Don't expect instant success. It takes a little practice and patience to get this right, but after a few attempts you should start producing perfect Polaroid image transfer pictures.

• Experiment with different weights of paper and different levels of wetness on the paper. Smooth paper can normally be used dry, and by doing this you will retain more detail – wet paper diffuses the image.

• Vary the time that the film and paper are in contact so as to obtain different results and strange colour shifts.

• The Vivitar copier offers a little exposure control, so use it to vary the density of the copied image.

• Choose slides for copying that don't contain too many dark areas, as these tend to stick to the negative. Slides containing lots of fine detail should also be avoided for wet transfer.

• Work at normal room temperature. In a cold room, leave the exposed film for 15 seconds rather than 10 before peeling it carefully apart.

• Don't touch the surface of the print before you peel it, as pressure on certain areas will cause spots on the negative.

• Retouch spots and blemishes on the transferred image once it has dried using watercolour paints and a fine spotting brush.

ABOVE RIGHT **Although some photographers prefer to crop it out when copying their transferred images, the 'ragged' border effect created when the Polaroid film is peeled off the paper at the end of the process looks highly effective.**
EQUIPMENT: Nikon F90x Prof., 80–200mm zoom lens for original
FILM: Fujichrome RDP100 for original, Polacolor 100 for transfer
EXPOSURE: 1/15 sec at f/8 for original

RIGHT **Portraits are ideal for image transfer as the technique adds a textured, fine-art quality to the original image. Here the 35mm transparency was copied onto Polaroid instant film using a Vivitar copier, then the image was transferred onto a sheet of 80gsm white 'laid' paper, the type commonly used for headed stationery.**
EQUIPMENT: Olympus OM4-Ti, 85mm lens for original, subject lit using one flash-head fitted with a large softbox
FILM: Kodachrome 25 for original, Polaroid Type 669 instant for transfer
EXPOSURE: 1/60 second at f/11 for original, transfer not recorded

LEFT **If you transfer an image onto dry paper it's possible to record finer detail. There's a risk of the film sticking to the paper, however, so take care. If the emulsion sticks, try drying the back of the paper for a few seconds with a hair dryer. This image of the Louvre in Paris was transferred onto 100gsm white 'laid' paper.**
EQUIPMENT: Nikon F90x Prof., 28mm wide-angle lens for original
FILM: Fujichrome Velvia ISO50 for original, Polaroid Type 669 instant for transfer *EXPOSURE: 1/60 second at f/16 for original*

Instant Images

Although Polaroid are renowned for their instant colour and black and white print films, there are not many photographers who realise that the company also manufactures a range of specialist 35mm transparency films in both colour and black and white that can be processed and viewed within minutes of use.

Each roll of film comes with its own processing pack, and with the aid of a simple manual unit, the exposed film is ready for processing immediately after it has been removed from the camera, both on location and in the studio.

The remarkable speed with which slides can be produced means that these films are ideal when you need to produce a final black and white or colour transparency at very short notice. More important, however, is the fact that each film has its own unique blend of characteristics that allows you to produce all kinds of creative effects, and an increasing number of photographers are discovering the benefits of these unusual materials in their work, from shooting everything from portraits to landscapes.

The whole range of 35mm Polaroid instant transparency films can be processed on location using the small, manually operated unit shown. Each roll of film comes complete with its own processing pack, and nothing else is required.

Polaroid PolaGraph is a very contrasty and grainy film, making it ideal for stark, graphic portraits like this. The subject was lit with just one flash unit fitted with a softbox, while a second flash unit fitted with a standard reflector dish was aimed at the background to ensure it came out pure white rather than grey.

EQUIPMENT: Nikon F90x Prof., 105mm lens, 2 studio flash units
FILM: Polaroid PolaGraph rated at ISO400
EXPOSURE: 1/125 second at f/22

WHAT YOU NEED

Camera: If you want to experiment with the 35mm instant films, then a 35mm SLR will be required. Sheet film is also available for use with 12.5x10cm (5x4in) and 25x20cm (10x8in) large-format cameras, though the cost per sheet is quite high, so 35mm is a more economical format for enthusiasts – at least until you have got used to the films.

Film: There are five types of film available in 35mm format:

PolaChrome CS is a normal-contrast ISO40 colour transparency film available in 12 and 36 exposure cassettes.

PolaChrome HCP is a high-contrast colour transparency film with the same rating of ISO40, but it only comes in twelve exposure cassettes.

PolaPan CT is a medium-contrast, black and white transparency film with a recommended speed rating of ISO125.

PolaGraph is a high-contrast, black and white transparency film which produces stark, grainy images and is rated at ISO400.

PolaBlue is a high-contrast, document-copying film which produces white-out-of-blue images for projection. However, this strange characteristic can be used to produce unusual images when used for pictorial photography.

For medium-and large-format photography you can also obtain black and white instant positive/negative film. This is a peel-apart type film and gives a black and white proof print as well as a high quality, black and white negative which you can print conventionally using an enlarger.

For medium-format cameras you need Type 665 positive/negative film which is used in a Polaroid film back and nominally rated at ISO80, while for large-format 12.5x10cm (5x4in) cameras, Type 55 positive/negative film is required. This comes as individual sheets for use in a 545i Polaroid film holder, and is nominally rated at ISO50.

Processing unit: To process films, you need a Polaroid processing unit. A simple, manually operated model is available which requires no power, making it ideal for use on location. It's also the most economic way of exploring the creative potential of Polaroid instant films. You can also buy an electronic mains-powered unit which has pre-programmed development times.

HOW IT'S DONE

The 35mm cassettes of instant film are loaded into your SLR like any other film, though you should take care when winding on as the film is quite brittle and can easily be damaged.

You can then use the films for all types of creative photography – portraiture, landscapes, architecture, close-ups, flowers, still-lifes, nude studies, and so on. However, each film has its own unique characteristics which will have a strong influence on the type of results you produce, so it's worth bearing these in mind when deciding which one to use.

Images recorded on the PolaChrome instant colour transparency films are formed like the image on a TV screen, for example, so they comprise a series of lines which, when enlarged, create an unusual 'screen' effect. When used for conventional pictures this can look rather odd, but if you exploit the effect it will produce stunning results – especially if you make enlargements from the slides to exaggerate the lines. If you do intend making reversal prints from PolaChrome slides, underexpose the pictures a little in order to give a better density for printing.

For pictorial black and white photography, PolaPan is ideal as it possesses a pleasing tonality with excellent rendition of highlight and mid-tone detail but rich, dense shadows. PolaGraph, on the other hand, is a much harsher, grainier film which produces powerful images with limited tonal range. Highlights tend to burn out and record as pure white, while darker tones quickly resolve to pure black, devoid of detail. Normally such characteristics would be seen as a drawback, but when used on the right type of subject PolaGraph can produce stunning results. The most important factor with PolaGraph is exposure – you must be accurate to within ⅓ stop, otherwise you will notice a big difference in the density of the image. It's therefore a good idea to bracket when using this film.

When using PolaBlue you need to remember that it's a very high contrast film intended for copying, so dark areas in a scene will come out white and lighter areas blue – the lighter the tone, the deeper the blue. This effect is so extreme that even slight vignetting (darkening of the corners of an image) caused by an ultra wide-angle lens or lens hood can result in the corners of the image recording as white. This makes it quite a tricky film to use successfully for normal pictorial photography, which is why Polaroid advise against it. However, breaking the rules is an important part of photography, so it's well worth experimenting.

To increase your chance of success, use it on simple, graphic

The unusual line screen effect of PolaChrome takes a little getting used to, but it can add to the appeal of an image. For this shot of a vase of dried flowers, the photographer smeared a little petroleum jelly onto an old Skylight filter, then held it in front of the lens to diffuse the image. Combined with the plain background and window light, this has produced a simple yet pleasing image.
EQUIPMENT: Olympus OM4-Ti, 50mm standard lens, diffusion filter, tripod **FILM:** *PolaChrome rated at ISO40 and processed for 1 minute* **EXPOSURE:** *½ second at f/11*

subjects such as bridges, statues, monuments, a boat on the sea, and so on. It's also a good idea to shoot in contrasty light to enhance the effect, and bracket exposures over and under the metered exposure. With a nominal rating of just ISO8, shutter speeds are likely to be slow even in bright sunlight, so if in doubt, use a tripod to prevent camera shake.

Processing

Once the film has been exposed, you can go straight ahead and process it literally on the spot. This is done simply by placing the processing pack that accompanied the film into the unit, along with the exposed film, closing it up, then winding the film back out of the cassette using a manually operated handle so it comes into contact with the processing chemicals. After the required length of time the now-processed film can be removed from the unit and the transparencies viewed.

To produce consistent results it's important that you follow the instructions that come with each roll of film and the processing unit. Processing should ideally be done at a temperature of 21°C (70°F), but temperatures a little above or below this will give acceptable results. Use the following times as a guide:

Film	Time at 21°C (70°F)
PolaChrome	1 min
PolaPan	1 min
PolaGraph	2 mins
PolaBlue	4 mins

If you process PolaPan at a temperature below 21°C (70°F), increase the processing time to 2 minutes. Doing this will increase the contrast of the film, which can be used to make pictures taken in flat lighting more punchy. If you need to do this but the ambient temperature is around 21°C (70°F), place the film and processing pack in a refrigerator for a few minutes to cool them down.

If you're feeling adventurous, you can even experiment with cross-processing PolaChrome film. To do this, use the processing pack from PolaGraph film, rate the PolaChrome at ISO50 instead of ISO40, and process this for 2 minutes. The end result will be increased contrast, bolder colours and enlarged grain. Alternatively, take a normal PolaChrome slide and duplicate it onto a conventional colour slide film such as Fujichrome Velvia to create grainy images with vibrant colours.

Finally, if you make enlargements from PolaGraph and PolaPan slides on colour reversal paper such as Ilfachrome Classic, you can 'tone' the images by dialling in a colour cast using the filter head on your enlarger, or by holding a coloured filter under the enlarger lens.

Polaroid PolaPan is a much subtler film than PolaGraph, with lower contrast and a beautiful tonality that makes it perfect for everything from portraits and still-lifes to landscapes and architecture.
*EQUIPMENT: Nikon F90x Prof., 80–200mm telezoom **FILM:** Polaroid PolaPan rated at ISO125 **EXPOSURE:** 1/60 second at f/8*

TOP TIPS

• Once the film has been processed, remove it from the cassette by knocking off the end caps and lifting the film out, rather than pulling it through the felt light trap which can cause scratching.

• Wear cotton gloves when handling the processed film. Its emulsion is very delicate and prone to scratching.

• After processing a roll of PolaBlue film, remove it from the cassette as soon as possible and hang the roll in a clean, dust-free room until it's completely dry.

• To safeguard your original Polaroid transparencies, mount them in glass slide mounts to prevent damage, or even better, duplicate them (see page 44).

• If patches of the black backing film are still on the edges of the processed film, remove them using a piece of adhesive tape.

Large-Format Duping

In addition to the duping techniques explained on page 44, another method of copying 35mm originals is to enlarge them onto sheets of 12.5x10cm (5x4in) duping film. This offers all the benefits of 1:1 duping with a simple slide copier, but by making duplicates that are bigger than the image they will also be far more impressive to look at – and if you sell your work, it could increase the earning potential of your best pictures.

Many commercial labs offer a large-format duping service from 35mm originals. Unfortunately, it can be a very expensive exercise, particularly if you require dupes from several different transparencies, and a much cheaper and infinitely more satisfying approach is to make your own. Initially this may seem like a complicated procedure, but it is really no more difficult than making black and white prints, and in some ways is actually easier.

WHAT YOU NEED

Enlarger: 12.5x10cm (5x4in) duplicates are made by projecting the image from the original 35mm transparency onto a sheet of unexposed 12.5x10cm (5x4in) duplicating film, so you will need an enlarger with either a colour head or a drawer into which you can slot coloured filters.

Lens: A 50mm enlarging lens.

Masking frame: This is required to hold the 12.5x10cm (5x4in) sheets of film in place on the enlarger baseboard, although you can use a darkslide from a 5x4 camera, or make a simple masking frame from two pieces of thick black card (see below).

A simple masking frame made from two pieces of black card is all you need to hold the sheet of duping film in place on the enlarger baseboard. Make the aperture in the top of the frame slightly smaller than 12.5x10cm (5x4in) so a neat border is created around the duplicated image.

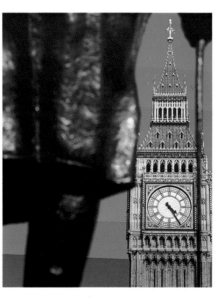

Film: A pack of 12.5x10cm (5x4in) tungsten-balanced duping film. There are two brands to choose from – Kodak Ektachrome 6121 and Fujichrome CDU. Both have a low-contrast emulsion which helps to ensure a good match between original and dupe, and both give consistently good results when used properly.

Accessories: A can of compressed air to remove any dust from your 35mm slides, plus a 0.6 (two-stop) neutral density filter.

HOW IT'S DONE

Once you've made the masking frame from black card (see picture), place a 35mm slide into your enlarger's head and project an image down onto the baseboard. Adjust the height of the enlarger head so that the projected image is slightly bigger than 12.5x10cm (5x4in), then place your card masking frame on the baseboard, align it with the projected image, then tape the masking frame to the enlarger baseboard. This will prevent you knocking it while inserting the sheet of duping film, and means that you can make several dupes in one session without having to keep re-positioning the card masking frame. Note the height of the enlarger head for future reference, so you know exactly where it needs to be the next time you make some dupes.

Making the dupe is just like making a print, really. First you need to produce a test sheet or strip to determine the correct exposure for the final duplicate, and to check that the filtration is correct. The colour head or colour filters on the enlarger are necessary because both types of duping film require filtration to ensure a good colour match with the original. Each pack of film you buy will have a recommended filtration printed on it which you should use as a starting point, but after making the initial test sheet you may find slight adjustments are required to get rid of colour shifts (see panel, page 83).

The advantage here is that once you've established the correct exposure and filtration, you can use the same settings for just about every dupe you make from the same pack of film.

Making an initial test sheet will help you determine the correct exposure and filtration for your large-format dupes. This sheet was exposed in ten-second increments, and the recommended filtration printed on the film box was used as a starting point.

As a result, it's possible to make dozens of dupes in the space of a couple of hours.

Here's a brief guide to producing your first test sheet/strip.

1 Check that your darkroom is completely lightproof, because any leaks will fog the film. It's also a good idea to cover certain areas on your enlarger, such as the filter dials and the white-light lever, with black insulation tape, so that the only light being emitted is through the enlarger lens.

The final 12.5x10cm (5x4in) dupe (below) made using information gained from the test strip shown left exhibits a high degree of image sharpness and the same vibrant colours as the original, despite a relatively high degree of magnification. The original 35mm image and the large-format dupe are both shown actual size to give you an idea just how much bigger the duplicate slide is – and how much more impressive it looks to the naked eye.

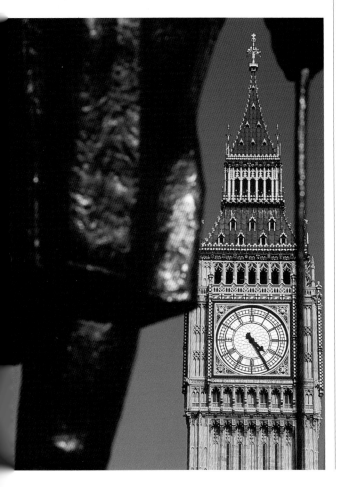

Make large-format dupes from 35mm originals shot on fast film to emphasise the grain and make it much more obvious. This dusk scene looked attractive enough on the original 35mm slide, but when enlarged to 12.5x10cm (5x4in), the grain structure becomes much more evident and enhances the atmosphere of the scene.

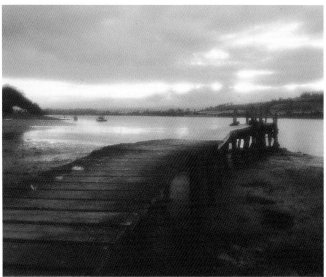

2 Choose an original slide for the test – ideally it should show a good range of detail and colour, so you can easily assess the test sheet for exposure and filtration accuracy. Clean the original and place it in the enlarger.

3 Place a thin sheet of white card in your masking frame, project the image on to it and focus. Check for total sharpness with a focus finder, set the recommended filtration from the pack of duping film, stop your enlarger lens down to f/11 and turn the enlarger off.

4 Place the neutral density filter under the enlarger lens. This is required so that you can use longer exposure times to produce the duplicates, which will allow you to manipulate the image if you like – perhaps darkening the sky in a landscape, or lightening other areas of the picture.

5 In complete darkness, remove a sheet of duping film from the packet, handling it carefully by the edges to prevent damage, and place it in the masking frame. With both the Kodak and Fuji film, the notches on the film edge should be at the top right-hand corner as you hold it upright so the emulsion is facing you. Run a finger along the top edge of the film to ensure you're holding it the correct way.

6 Hold a sheet of black card slightly above the film so that four fifths of the film is covered, switch on the enlarger and expose the uncovered strip for 10 seconds. Move the card along so only three fifths is covered, and re-expose for 10 seconds. Repeat this for the whole sheet so it shows five exposures – 10, 20, 30, 40 and 50 seconds (see box, page 82).

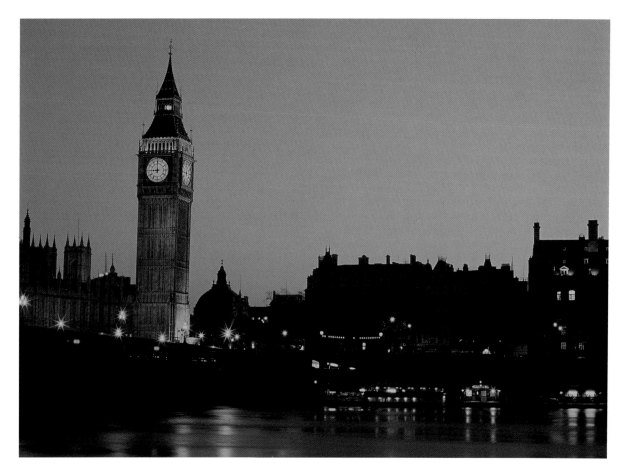

7 Place the exposed sheet of film in a lightproof bag – the black bags that printing paper is stored in are ideal – and seal it well with masking tape to prevent fogging the sheet of film processed at your local lab.

8 When you get the processed sheet back, compare it with the original 35mm slide to determine the correct exposure and filtration required. You may find that the filtration requires adjustment to correct any colour bias. If you're unsure how to do this, refer to the table (page 83).

9 If you're confident that the adjustments will yield acceptable results, you can go ahead and start making the final dupes. However, it's a good idea to make just one initially, from the same original as the test sheet, and have it processed to be doubly sure you've got the exposure and filtration right.

To give you an idea of the exposure times and filtration you should expect, here's the data the author uses when making large-format duplicates with a Durst M670K enlarger and Durst Neonon 50mm lens. Exposure times may vary if you use a different model of enlarger, because the power output of the bulb differs between makes, while filtration can vary from one pack of film to another.

While making large-format dupes you can add colour casts by holding a filter under the enlarger lens, or by dialling in extra filtration on the enlarger head. For this night shot of London's Big Ben, the magenta filtration was increased by 30 units to change the original scene from orange to magenta.

Kodak Ektachrome 6121
Exposure: 25–30 seconds at f/11 (with 2-stop ND filter)
Filtration: 45Y, 45C (recommended), 60Y, 40C, 5M (actual)

Fujichrome CDU
Exposure: 15 seconds at f/11 (with 2-stop ND filter)
Filtration: 15Y, 45C (recommended), 30Y, 35C, 5M (actual)

It took two or three test sheets before the filter values gave a colour balance that was as close to the original slide as possible. In each case the test sheets showed a slight blue/green bias, so the recommended filtration was adjusted to balance them out. Increasing yellow and slightly reducing cyan got rid of the blue, while a touch of magenta helped to balance the green.

If your test dupe has a colour cast, refer to the table (right) for advice on how to correct it. Don't make huge adjustments to the filter values, as even small changes can have a noticeable effect – try reducing or increasing in units of 5 or 10 to begin with.

Once you have established the correct exposure and filtration, you can go ahead and make the final dupes. To do this, simply repeat steps 1 – 5 on page 81, then once the sheet of film is in the masking frame, make the exposure.

After making each dupe, store the sheet of film away in a lightproof bag or box, then after the session is over take the film to your local lab where it can be processed.

Well made 12.5x10cm (5x4in) dupes look excellent mounted in individual black card masks and presented in a portfolio or as part of a proposal for a book, and potential clients can look at your work without the need for a lightbox.

TOP TIPS
• If you make card masking frames with different-sized apertures you can vary the format of the duplicate, perhaps making 6x12cm (2½x5in) panoramic images by cropping off the top and bottom of the 35mm original.
• Try enlarging just part of the original image by raising the enlarger head so the grain is emphasised. If you do this you will need to increase the exposure time.
• Filter effects can be added to the duplicate image simply by holding the chosen filter under the enlarger lens during exposure. Soft-focus filters are ideal, plus strong colour filters to add a colour cast.
• Colour casts can also be introduced by increasing the filtration on your enlarger head.

• Once you've mastered the art of making 12.5x10cm (5x4in) dupes from 35mm originals, try it with medium-format originals such as 6x4.5cm (2½x2in), 6x6cm (2½x2½in) and 6x7cm (2½x2¾in). Because less enlargement is required, the quality of the duplicated image will be much higher.

Correcting colour casts

Colour cast	Reduce filters	or increase filters
cyan	cyan	yellow + magenta
magenta	magenta	yellow + cyan
yellow	yellow	cyan magenta
red	magenta + yellow	cyan
green	yellow + cyan	magenta
blue	magenta + cyan	yellow

If you are using a 'below-the-lens' filter holder on your enlarger, reduce rather than increase the filter values, so you can keep the number of filters to a minimum – the more you use, the more image quality will be affected.

Should you find it necessary to adjust the recommended filtration, you may also need to adjust the exposure to account for the increased or reduced density of the filter pack. The table below shows the increments you will need to use.

Correcting the exposure

Filter	Increase exposure by
05 yellow	None
10 yellow	None
20 yellow	None
05 magenta	⅓ stop
10 magenta	⅓ stop
20 magenta	½ stop
05 cyan	None
10 cyan	⅓ stop
20 cyan	⅓ stop

For example: if you add 5 magenta and 10 cyan to the recommended filtration, the exposure must be increased by $^2/_3$ stop. So if the correct exposure on your test sheet is 25 seconds, it must be increased to 42 seconds when you use the new filter values to prevent the image coming out too dark.

Keep this filtration data taped to your darkroom wall so you can refer to it whenever necessary. Sometimes you may decide to increase a particular filter value to add a colour cast, for example, so by referring to the chart you will know immediately how much to increase the exposure by, instead of guessing.

For this tranquil scene in Pisa, Italy, the photographer held a soft-focus filter under the enlarger lens during exposure, to add a delicate glow to the original image. Extra yellow filtration was also set on the enlarger's colour head to increase the warm glow of the evening light.

Line-Out

Whenever you compose a picture, your aim should be to arrange the elements of the scene before you in such a way that they form a visually pleasing whole, so the viewer's eye is carried naturally through the scene, from the foreground to the background. This latter factor is of particular importance, as a composition only works if it grabs and holds the viewer's attention for as long as possible.

One of the easiest ways to achieve this is by including lines in a picture. These could be obvious lines such as roads, walls, hedges, rivers, paths and fences, the furrows created by a ploughed field, straight rivers and ditches, or the shadows cast by lamp posts and trees. Including lines in a picture helps to give the composition direction and stability. Humans are very inquisitive, so when we see a line our eye naturally follows to find out where it goes. If you use those lines creatively, that usually means the viewer's eye is taken on a journey around the picture, thus holding their attention.

Lines can also be assumed rather than real. A row of trees stretching off into the distance will form a line, even though there's a gap between each tree, because our brain joins up the gaps. Similarly, the direction a person is looking in a photograph will create an imaginary line because our eye naturally follows the direction of their gaze.

HOW IT'S DONE

Different types of line create a different effect compositionally, so it's worth bearing this in mind.

Horizontal lines created by shadows, fences, walls, hedges and the natural planes in the landscape are restful and easy to look at because they suggest repose and echo the horizon. They also carry the eye from left to right in a picture.

Vertical lines are more powerful and energetic because they suggest vertical movement, and the eye follows them from bottom to top. Think of trees standing sentry-like in a forest, or the sides of a tall building stretching up to the sky – tension is created when you look at them.

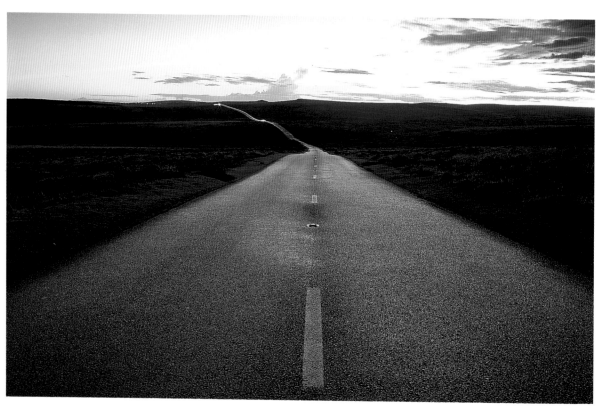

Diagonal lines created by a river, road or fence cutting through a scene cover more ground, so they're ideal for carrying the eye up through a picture from the foreground, taking in the other elements as they go. Our eyes naturally move from bottom left to top right, so a diagonal line moving in this direction will have the greatest effect.

Converging lines are the most powerful of all, however, because they add a strong impression of depth. If you stand in the middle of a long, straight road or path and look down it, you'll see that the parallel sides move closer together, or converge, with distance. Because we know the road or path is roughly the same width all the way along, our brain automatically registers that it must be moving into the distance. The same effect can be created using railway tracks, the furrows in a field, a river or drainage ditch, a path, or any other feature that has parallel lines. To make the most of this, use a wide-angle lens such as a 28mm or 24mm to exaggerate the effect, and stop the lens down to its smallest aperture – usually f/16 or f/22 – to ensure there is enough depth-of-field to render the whole scene in sharp focus.

The effect of converging lines is also heightened if you include the vanishing point – the point where the lines appear to meet on the horizon – in your picture, as it provides a natural resting place for the eye.

TOP TIPS

• Why not put together a series of pictures showing the use of lines? Whenever you see a long, straight road, for example, you could take a picture of it with a wide-angle lens.

• Learn to look for lines in a scene, and don't always expect them to be obvious. Repeated features such as trees, electricity pylons and telegraph poles can all add impact to a composition, even though at first glance their effect may not be seen.

• You can vary the effect lines have on a composition by altering camera format. If you hold the camera horizontally, for example, horizontal lines will be emphasised, whereas turning the camera on its side will make better use of vertical lines.

ABOVE **This tranquil landscape scene has been composed in such a way that the rough track through the field creates a diagonal line travelling from bottom left to top right. This means that the viewer's gaze is carried through the scene from the foreground to the horizon. Without the path, the picture would lose much of its appeal.**
EQUIPMENT: *Olympus OM4-Ti, 28mm wide-angle lens*
FILM: *Agfachrome 1000RS rated at ISO1000* **EXPOSURE:** *⅟₆₀ second at f/16*

RIGHT **The strong vertical lines in this shot of the leaning Tower of Pisa charge the composition with tension and create a dramatic feeling of height compared to the tiny figures in the bottom of the frame. Turning the camera on its side to produce an upright picture has added to this by maximising the effect of the lines in the scene.**
EQUIPMENT: *Nikon F90x Prof., 28mm wide-angle lens, polarising filter*
FILM: *Fujichrome Velvia ISO50* **EXPOSURE:** *⅟₃₀ second at f/8*

LEFT **Here is a classic example of how lines can be used to add impact to a composition. Look at the picture and your eye can't resist following the road as it stretches off to the distant horizon, while the converging sides of the road create a powerful sense of depth. The scene was photographed at dusk on open moorland, with the beautiful colours in the sky reflecting in the wet tarmac. The photographer stood in the middle of the road and used a wide-angle lens to exaggerate perspective and make the most of the converging lines. A small lens aperture was also set to maximise depth-of-field.**
EQUIPMENT: *Pentax 67, 55mm wide-angle lens, tripod*
FILM: *Fujichrome Velvia ISO50* **EXPOSURE:** *4 seconds at f/16*

Mirror Lenses

A mirror lens is basically a powerful telephoto lens which uses a special design so as to keep its size and weight to a minimum. This is achieved by using a series of internal mirrors and lenses, instead of normal glass elements, which reflect the light back and forth inside the lens until it reaches the film plane.

The design is very similar to that of modern telescopes, which need extreme power while being relatively compact in size. This means that mirror lenses can boast a powerful focal length – usually 500mm, although 600mm, 1000mm and even 2000mm models are available – while remaining relatively small.

By using mirrors instead of glass elements, the overall weight of the lens is also minimised, so you end up with a long telephoto lens in a compact, lightweight body; a typical 500mm mirror lens weighs around 700g and measures 100–125mm, whereas a conventional telephoto with the same focal length would measure and weigh at least double this.

This makes the mirror lens ideal for photographers who need to travel light, but also require a long telephoto lens for subjects such as sport or nature photography.

HOW TO USE IT

Mirror lenses are designed for use with 35mm SLRs and are made by major camera manufacturers such as Nikon, Minolta and Canon, as well as by a range of independent lens manufacturers including Sigma.

Due to the way the lens is designed, only one aperture setting is available – usually f/8 for 500mm models. Compared to conventional telephotos this is quite small, and it means that in order to manage fast, action-stopping shutter speeds you either need fast film or very high light levels. In bright summer sunshine, you will probably find that ISO100 film allows a shutter speed of $\frac{1}{500}$ second, even $\frac{1}{1000}$ second, but in dull conditions, film of at least ISO400 will be required, and indoors ISO800 or more will be a good starting point.

Occasionally, this fixed aperture can also be too wide. If you're shooting into the light in sunny weather, for example, or using your mirror lens to take sunset shots, you may suddenly find that

The 'doughnut' effect produced by mirror lenses is clearly shown in this simple silhouette of a man and his young son sitting by a lake. Before taking the picture, the photographer had to make several changes of position before the effect was obtained. A lens hood was also used to prevent the sun causing flare patterns across the image.
EQUIPMENT: Nikon F90x Prof., Sigma 600mm mirror lens, tripod
FILM: Fujichrome Velvia ISO50 **EXPOSURE:** *$\frac{1}{500}$ second at f/8*

The minimal depth-of-field that mirror lenses give with their fixed aperture is very evident in this picture. The only element in sharp focus is the single flower, which stands out clearly from the hazy green background and seems to be hanging in thin air. Extra interest has been added by the faint doughnut rings in the background – an effect only mirror lenses can produce.
EQUIPMENT: Nikon F90x Prof., Sigma 60mm mirror lens, tripod
FILM: Fujichrome Velvia ISO50 *EXPOSURE:* ¹⁄₁₂₅ second at f/8

your camera doesn't have a fast enough shutter speed to give correct exposure, and you really need to set a smaller aperture, which isn't an option. Fortunately, this problem is easily solved by fitting a neutral density (ND) filter to reduce the amount of light entering the lens. Mirror lenses have a slot near the rear end which accepts small filters, and most models come complete with a selection, usually comprising ND, plus red, orange and yellow for black and white photography.

Another disadvantage of the fixed aperture is that it makes the camera's viewfinder image rather dark, which in turn makes manual focusing tricky in all but the brightest weather. This can be annoying because accurate focusing is particularly important with long telephoto lenses as they offer very limited depth-of-field, so it's easy to take a picture where the main subject isn't quite sharply focused.

With practice, however, you can overcome all these problems and use your mirror lens to produce superb results. The limited depth-of-field, for instance, is ideal for producing dramatic 'fall-off' effects where only your main point of focus is recorded sharply while everything else is reduced to a blur.

Mirror lenses also allow you to produce an effect that can add lots of impact to a picture. Due to the way the lens is designed, out-of-focus highlights in the background record as doughnut-shaped rings. These rings are actually reflections of the rear element in the lens, which has a hole in the middle for light to pass through, but when paired with the right subject they can look incredibly strong.

To create the effect, look for backlit subjects that have bright highlights in the background. The specular highlights produced by sunlight reflecting on water always work well and make an excellent backdrop to silhouettes of people, boats and windsurfers. Raindrops on a surface such as a car door also work well, along with street lights reflecting in puddles at night. Doughnut-shaped rings can also be produced by more subtle highlights, such as backlit dew in a grassy meadow, reflections in windows, or when the sun is low in the sky close to dusk and creates a hazy backlit effect on the landscape.

Experimentation is the key to success with mirror lenses. Sometimes the results will be perfect, at other times you won't be able to tell a mirror lens was ever used because the highlights in the background need to be a certain distance from the subject you're focusing on.

TOP TIPS

• Even though mirror lenses are very light considering their focal length, camera-shake can still be a problem. To avoid it, make sure the shutter speed you use at least matches the focal length of the lens – ¹⁄₅₀₀ second for a 500mm and so on. Alternatively, mount your camera on a tripod to keep it very steady.

• Always focus your mirror lens carefully. Depth-of-field is minimal, and it's really quite easy to end up with your main subject out of focus.

• Use your mirror lens to enlarge the size of the sun's golden orb at sunset (see page 138), but be careful never to look directly at the sun through it as you could damage your eyesight.

• Always use the lens hood when shooting into the light to avoid flare.

Mirror lenses are ideal for action photography, especially when your subject is some distance away from the camera, like these paragliders drifting across a deep blue Turkish sky. Captured from the balcony of a hotel, careful focusing was required to keep the moving subjects sharp, plus a fast shutter speed to freeze them.
EQUIPMENT: Nikon F90x Prof., Sigma 600mm mirror lens
FILM: Fujichrome Velvia ISO50
EXPOSURE: ¹⁄₅₀₀ second at f/8

Mono Infrared

F irst developed in the 1930s for aerial survey, reconnaissance and scientific photography, mono infrared film is also an excellent material for creating a range of weird and wonderful images, and is a popular choice among creative, imaginative photographers.

To help you understand how mono infrared film works you first need to know a little about light and the spectrum. Basically, the visible spectrum – the light we see with the naked eye – comprises light rays of different colours, just like a rainbow. Each colour has its own wavelength, and wavelengths of light are measured in nanometres (nm) – one nanometre is equivalent to one thousand-millionth of a metre.

The light in the visible spectrum covers wavelengths from 400 to 650nm, with violet light at the lower end and red light at the top. Infrared light has a wavelength between 700 and 1200nm, so it's not visible to the naked eye, but infrared film is sensitive mainly to light in this range, so it can record the effects produced by infrared radiation.

These effects are many and varied, because some things contain more infrared radiation than others, and different lighting/weather conditions can alter the levels of infrared radiation in the light. However, the most common effects produced are for blue sky and water to turn black, while foliage and skin tones appear to glow with an amazing white luminescent quality because they reflect most of the IR radiation falling on them.

WHAT YOU NEED

Camera: Mono infrared film can be used in the vast majority of 35mm SLRs. However, some modern models use an infrared sensor in the film frame counter which may cause fogging of the film, so check that your SLR is suitable.

Lenses: Wide-angle lenses are usually preferred for infrared photography, mainly because they give extensive depth-of-field at small apertures, which helps to prevent any problems with focusing error (see page 91).

Accessories: A dark red or a visually opaque infrared filter.

Film: There are two main types of mono infrared film available – Kodak High Speed Mono Infrared 2481 and Konica 750 Infrared – plus a more recent addition from Ilford known as SP815 which was originally designed for use in police speed cameras.

Kodak 2481, available in 35mm cassettes, produces the most marked effects because its peak sensitivity goes up to 900nm and beyond, which is well into infrared territory. It's also very grainy, so you can use it to create stark, gritty images.

Konica 750 is available in both 35mm and 120 formats. Its peak sensitivity is 750nm, so the infrared effect is not quite as

This moody portrait was shot indoors using one studio flash head on the left of the subject, fitted with a softbox for bold side-lighting. A deep red Cokin filter was put over the camera lens to add the infrared effect.
EQUIPMENT: Olympus OM4-Ti, 85mm telephoto lens, Cokin deep red filter
FILM: Kodak 2481 rated at ISO400 **EXPOSURE:** *1/60 second at f/11*

strong as the Kodak and it is more sensitive to the visible spectrum. It is also a very fine-grained film and records a much wider range of tones, making it ideal for landscape photography.

The third option, Ilford SP815, has a peak sensitivity around 730–740nm, and so it has the subtlest effect of all.

HOW TO USE IT

To make the most of mono infrared film it is important to follow certain guidelines.

Filtration

Mono infrared films are sensitive to the visible spectrum in varying degrees, so you need to filter that out to produce the strongest effect. This can be done using a visually opaque infrared filter, such as the Kodak Wratten 87, 87C and 88A gels or the B+W

093 and 094, which blocks out all visible light. The main problem with opaque filters is you can't see through them, so shots have to be composed and focused before they're fitted. They also require greater care with exposure.

To overcome this, many photographers use a deep red filter instead, which blocks out the blue and green parts of the visible spectrum but admits light at the red and infrared end to give a strong infrared effect. Any deep red filter will do the trick – examples include the Cokin 003, B+W 092 or Kodak Wratten 29.

ISO rating and exposure

There are no definite ISO ratings for mono infrared film, only suggestions from the manufacturer. This is because levels of infrared radiation vary with lighting/weather conditions, and camera meters can't measure it accurately.

As a guide, if you take TTL meter readings with a deep red filter on your lens, rate Kodak 2481 and Ilford SP815 at ISO400, and Konica 750 at ISO50. Your camera's TTL metering system will automatically account for the 2½–3 stop light reduction caused by the red filter.

If you're taking an exposure reading with a handheld meter, or using your camera's TTL metering without the filter in place, you need to compensate for the filter's light loss before taking a reading. Do this by rating the Kodak and Ilford films at ISO50 and the Konica film at ISO6–10, and don't change anything when the filter is fitted. This method is recommended as some camera meters can be fooled by the red filter and give a false reading.

In bright, sunny weather with a deep red filter, expect an exposure of around $\frac{1}{125}$ second at f/11 from the Kodak and Ilford films, and $\frac{1}{30}$ second at f/8 with the Konica. If you are taking pictures in shady or dull conditions, increase the exposure by around two stops to account for the lack of infrared radiation.

All three films are reasonably tolerant to exposure error as you can make adjustments at the printing stage, but it is advisable to bracket the exposures for every shot one stop over and one stop under the recommended reading, in full stop increments.

This image exhibits classic mono infrared characteristics – white grass and foliage, black sky. Photographically the scene isn't particularly special, but when given the infrared treatment it has come to life.
EQUIPMENT: *Olympus OM4-Ti, 28mm wide-angle lens, Cokin deep red filter*
FILM: *Kodak 2481 rated at ISO400* **EXPOSURE:** *$\frac{1}{60}$ second at f/16*

ABOVE **Taken on my very first roll of mono infrared film, this image captured my enthusiasm when, after many attempts, I managed to get a decent print from the negative. Although the infrared effect isn't strong, the glowing highlights, dark sky and coarse grain are an immediate giveaway.**
EQUIPMENT: Olympus OM1n, 28mm lens, Hoya deep red filter
FILM: Kodak 2481 rated at ISO400 **EXPOSURE:** *¹⁄₆₀ second at f/11*

Loading/unloading

Great care must be taken when loading and unloading mono infrared film as it is prone to fogging. Kodak 2481 is the worst culprit due to its high sensitivity. Infrared radiation can enter the felt light trap of the cassette, so you must load and unload in complete darkness – on location, a black changing bag will be required in order to do this.

Some autofocus SLRs use an infrared sensor to count the film's sprocket holes, which can create a fog line down the centre of the film, and if your SLR has a cloth shutter you should change lenses in the shade to avoid the risk of infrared radiation passing through the shutter curtain.

The sensitivity of Konica and Ilford film is lower down the infrared spectrum, so you can load and unload in subdued light rather than complete darkness. Stepping into the shade or holding the camera under your jacket is usually sufficient.

LEFT **Konica 750 Infrared film offers much finer grain and a wider gradation than Kodak 2481, but in the right conditions still produces a very obvious infrared effect – best seen here in the white foliage either side of the statue.**
EQUIPMENT: Nikon F90x Prof., 28mm wide-angle lens, tripod, Cokin deep red filter **FILM:** *Konica 750 rated at ISO50* **EXPOSURE:** *¹⁄₁₅ second at f/11*

Focusing

Infrared radiation focuses on a different point to visible light, so care must be taken when focusing. If you are using a wide-angle lens and a smallish aperture setting – f/8 or smaller – you can focus normally, as there will be enough depth-of-field to cope with the difference. Apochromatic lenses can also cope with infrared light because they're designed to ensure that all colours of the spectrum focus on the same point.

If you are using a telephoto lens you need to adjust the focus point to compensate. Most lenses have a small red marker on the barrel which is the infrared focusing index. All you do is focus normally, then adjust the lens so that the required focusing distance falls opposite the infrared index rather than the normal focusing index.

If your lens does not have an infrared index, reduce the focusing distance a little and use the smallest aperture you can to maximise depth-of-field.

PROCESSING AND PRINTING INFRARED FILM

Here are some suggested development times for mono infrared film with various common brands of developer. Figures quoted are for a working temperature of 20°C (68°F). All other stages are as for conventional black and white film.

DEVELOPER	FILM		
	(developing time in minutes)		
	KODAK 2481	KONICA 750	ILFORD SP815
KODAK D76 STOCK	11	6	-
KODAK HC110 DILUTION B	6	7	-
KODAK D19	6	-	-
PATERSON ACULUX	12	8	13
PATERSON ACUTOL	12	8	13
ILFORD ID11 STOCK	12	6	-
ILFORD ID11 NORMAL DILUTION	-	-	10
ILFOSOL S 1+9	-	-	9.5
ILFORD PERCEPTOL STOCK	15	-	-
AGFA RODINAL 1:50 DILUTION	-	5	-
AGFA RODINAL 1:25 DILUTION	11	-	-

You will find that many negatives appear too light or too dark on a standard contact sheet, so it is worth making two or more sheets to give you a well exposed proof print of every negative.

When it comes to printing, use a hard grade of paper – IV or V – to produce stark, contrasty results. This may mean that bright highlights such as white foliage or skin tones have to be burned in, but it's well worth the effort as you will end up with punchy prints with rich blacks and glowing highlights.

TOP TIPS

• Generally, you'll get the best results from mono infrared film outdoors in sunny weather, when there is more infrared radiation around. You can use it in dull or misty weather, but the effect is not as strong.

• Concentrate on scenes that contain blue sky and plenty of foliage. Gardens or vegetable plots captured on infrared film can look stunning.

• Electronic flash generates a lot of infrared radiation, so you can use it to produce surreal portraits where your subject's skin goes a ghostly pale shade. Place red gels over the lights or a red filter over the lens.

• You can take infrared candid shots in places like discos and clubs. All you have to do is fit a red filter or gel over the tube of a hotshoe-mounted portable flashgun and fire away. The red filter makes the flash almost invisible to the naked eye, so you can grab pictures from close range without anyone even knowing they're being photographed.

Wide-angle lenses are ideal for infrared photography as the extensive depth-of-field at small apertures means that you don't have to adjust focus, even when shooting from relatively close range, as here. The distortion introduced by wide lenses can also add extra impact to your pictures.
EQUIPMENT: Olympus OM4-Ti, 21mm lens, Hoya deep red filter
FILM: Kodak 2481 rated at ISO400 *EXPOSURE:* 1/60 second at f/11

Multiple Exposures

Multiple exposure photography, as you might imagine, involves combining two or more images on the same frame of film to produce unusual effects. This could be something as simple as adding the moon to a night scene, or capturing the same person more than once on a single photograph, but once you become accustomed to the techniques involved, you can let your imagination run riot and create all kinds of amazing effects.

These days, many photographers use a computer and special software to create multiple exposures – individual images are scanned, then their digital files are merged on screen.

However, there are much simpler methods which allow you to try it for yourself.

WHAT YOU NEED

Camera: A 35mm SLR with a multiple exposure facility is ideal, although medium- and large-format cameras are more versatile when it comes to planning complicated multiple exposures.

Lenses: Use any focal length required to create the effect you want – when superimposing the moon on a night scene, for example, you may use a 300mm telephoto to photograph the moon, then a 28mm wide-angle for the night scene.

HOW IT'S DONE
In-camera multiple exposures

The trickiest but most versatile way to produce multiple exposures is by re-exposing the same frame of film while it is in your camera. Many modern SLRs and some compacts have a multiple exposure facility for this very purpose, which allows you to re-cock the shutter without advancing the film, so you can expose it as many times as you like.

If your camera does not have this facility, then you need to employ a little trick, as follows:

1 Make your first exposure in the usual way.

2 Gently turn the film rewind-crank clockwise to tighten up the film. Stop when tension is felt.

3 Activate the film release button (usually found on the camera's base plate) as though you want to rewind the film into the cassette. This will disengage the sprockets.

4 Firmly hold the film rewind-crank on the camera's top plate so it doesn't move, do the same with the film release button, and carefully crank the film advance lever so that the shutter is cocked again without advancing the film.

5 Now make your second exposure.

6 Repeat steps 2–5 until your multiple exposure is complete.

7 Wind the film on as usual to the next frame, then fire the shutter with the lens cap on. This prevents any overlapping if the film moves slightly between exposures.

The beauty of this method is that you can put your ideas into practice on the spot. However, there are a few important factors which need to be taken into account.

First, you need to plan the complete shot so you know exactly what you want to include and can take any steps to ensure suitable subject matter is accessible. So make sketches and jot down notes detailing the order in which the exposures will be made well before you even think about tripping the shutter.

You also need to remember exactly where everything is on each exposure, otherwise you'll add features in the wrong place, or overlap images unintentionally. This is easy if you own a large- or medium-format camera, because you can mark the position of important features on the ground glass focusing screen with a chinagraph pencil. Unfortunately, with a 35mm SLR the screen is very small, so you have to rely on luck and judgement.

Backgrounds can cause problems too, because unless they're completely black you'll get a ghostly semi-transparent image superimposed across your subject. If you're working indoors, shooting portraits or still-lifes, you can easily get around this by using a plain black backdrop. Outdoors, all you can do is take steps to minimise the effect by making sure that important features fall in relatively plain, dark areas.

LEFT **This simple double exposure was created in two stages. First the full moon was photographed on a clear night using a 300mm telephoto lens. The photographer waited until the sky was completely black and used an exposure of ¹⁄₁₂₅ second at f/5.6, which is the normal exposure for a full moon on ISO50 film. The moon was recorded on each frame of a 36 exposure roll of film, then the film was rewound and removed from the camera. At a later date the same roll of film was re-loaded into the camera and the night scene was photographed using a 135mm telephoto lens. Marking the film leader with a fine pencil line meant it could be re-loaded for a second time and aligned perfectly to avoid overlapping of the images.**
EQUIPMENT: *Olympus OM4-Ti and 300mm lens for the moon, 135mm lens for night scene, tripod and cable release* ***FILM:*** *Fujichrome Velvia ISO50* ***EXPOSURE:*** *¹⁄₁₂₅ second at f/5.6 for moon, 20 seconds at f/16 for night scene*

This graphic multiple exposure is not a multiple exposure at all – it was created using a multiple image filter that added another four repeated images of the electricity pylon to the picture in one single exposure. An orange filter was also used to add the strong colour cast and heighten the impact of the final image. Simple bold shapes like this work particularly well with multiple image filters – for best effect avoid detailed subjects or scenes. You should also set your lens to a reasonably wide aperture, such as f/5.6, so the division between each image isn't too obvious.
EQUIPMENT: *Olympus OM4-Ti, 50mm standard lens, multiple image and orange filters* ***FILM:*** *Fujichrome Velvia ISO50* ***EXPOSURE:*** *¹⁄₆₀ second at f/5.6*

The next factor to bear in mind is the exposure, and basically the rule is this: when the images in a multiple exposure overlap across the whole frame – if you were combining a portrait with a shot of a brick wall, for instance – the exposure used for each one must be reduced proportionally so that when they all combine the end result will be correctly exposed.

This is something of a hit and miss affair, and it is advisable to bracket your exposures just to be on the safe side. As a general rule, with two images you should underexpose them both by a stop, with three images underexpose each by 1½ stops, with four images underexpose each by two stops, and so on.

The only exception to this is if important subject matter falls against a black background and won't be overlapped by another image, such as if you're photographing the same person more than once on a single picture. In these situations you will have to expose as normal, otherwise the individual images will be underexposed.

Re-loading film

A simpler method is to re-load the same roll of film into your camera then re-expose it. This technique is ideal for creating double or multiple exposures, such as adding the moon to a

night scene, because you can take pictures of the moon on every frame of a whole roll of film, keep it in your gadget bag, then whenever you come across an interesting night scene such as a floodlit building (see page 58), you can re-load the film and take a few pictures, knowing that the moon is already on each frame. Here's how to do it:

1 Load a roll of film and mark the film edge next to a reference point on the camera. Close the camera back and wind on to frame one.
2 Make your first exposures, then rewind the film either mid-roll or once you've finished it, making sure the film leader doesn't go all the way back into the cassette.
3 Re-load the film, making sure that the mark on the leader and the reference point on the camera are perfectly aligned. Close the back and advance the film to frame one again.
4 Make your second exposures, making sure the moon or anything else you have already recorded on the film is not obscured by another feature, such as a building or a tree (see picture on page 92).

Slide sandwiching

This technique involves combining two or more existing slides to create your multiple exposure. It's much easier than in-camera multiple exposures because you're working with images which have already been processed, so you can see immediately how they will work together, then make any changes as necessary.

The key to success lies in choosing your images carefully so they complement each other. So avoid using well saturated or detailed slides, and instead combine one strong image such as a silhouette, with one or more weaker ones such as a colourful sky. Taking pictures of skies, bright splashes of colour, creative filter effects, patterns and textures specifically for sandwiching makes the process much easier.

Combining two or more images on the same sheet of printing paper is another way of creating unusual multiple exposures. Although not the best example in the world, this eerie portrait shows you the kind of effects that can be achieved. To create it, the photographer placed two negatives together in his enlarger – the portrait and a shot of a net curtain, combining them in a single exposure. The final print was then partially solarised to enhance the effect.
EQUIPMENT: *Olympus OM1 and 50mm lens for both images*
FILM: *Ilford HP5 for both images, rated at ISO400* **EXPOSURE:** *⅓₀ second at f/5.6 for portrait, ⅙₀ second at f/8 for net curtain*

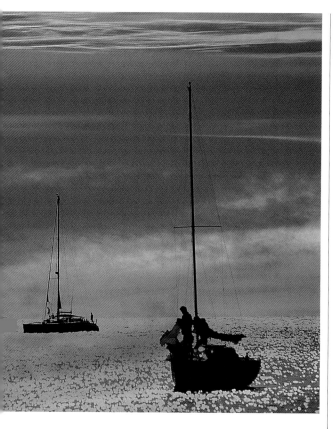

For example, imagine you've got a picture of a building and you want to superimpose an unusual sky around it. Here's a brief step-by-step guide:

1 Make a test print for both negatives so as to determine their correct exposures.

2 Place a sheet of thin card in your masking frame, project the building onto it, accurately trace the outline, then carefully cut out the building to produce two masks – one in the shape of the building (mask 1) and another of the card with the building shape cut out (mask 2).

3 Expose the building on a sheet of printing paper and at the same time shield the area around it using mask 2. For the best results, hold the mask a centimetre or so above the paper and move it gently so you don't get a hard edge.

4 Swing the red safety filter over the enlarger lens, remove the first negative, and replace it with the second negative of the sky. Now make your second exposure, this time using mask 1 to shield the building, then develop the print as usual.

Using filters and masks

You can create interesting double exposures using special masks which allow you to expose one half of a frame of film at a time. They are ideal for capturing the same subject – such as a person peeping from behind a tree – twice on the same picture, and require you to re-expose the same frame of film twice by re-cocking the shutter without advancing the film, as explained on page 93.

Alternatively, you could cheat by using a multiple exposure filter. This is basically a prism which surrounds your main subject with anything from 3 to 25 repeated images, as shown on page 94, but the effect is created using a single exposure, making it quick and easy.

Using flash

Another way of creating multiple exposures in-camera without even having to re-cock the shutter is by using a flashgun outdoors at night, or in a totally darkened room. All you have to do is mount your camera on a tripod, set the shutter to B, lock it open with a cable release, then start blipping your subject with bursts of electronic flash as it moves.

For the best results when working indoors use a black velvet background, otherwise you'll get a ghostly image across your subject. When outdoors at night, keep away from features that might fall within the range of your flashgun.

TOP TIPS

• Plan each shot carefully so you know exactly what you want to produce before you begin.

• Experiment – sometimes a picture will work, and at other times it won't. Don't let initial failure dampen your spirits: it can take a lot of time and effort to master some of the techniques covered.

• Always keep notes of what you do during each stage of a multiple exposure, especially the exposure used for each image, so you can learn from your mistakes.

Sandwiching slides together allows you to produce unusual effects using pictures that are already in your collection. For this example, the silhouette of the boats on the sea was paired with a variety of different sky pictures until a suitable match was chosen. In the end it was decided that this sunset image gave the most pleasing results, adding attractive colours to the background without detracting from the simplicity of the silhouette. Once the image selection had been finalised, the two slides were simply taped together at the edges, then placed in a plastic mount.

EQUIPMENT: Nikon F90x Prof. and 80–200mm zoom for silhouette, Olympus OM2 and 200mm lens for sky. **FILM:** *Fujichrome Velvia ISO50 for both images* **EXPOSURE:** *1/500 second at f/5.6 for silhouette, 1/30 second at f/8 for sky*

Multiple printing

If you have access to a darkroom you can create multiple exposures by printing more than one negative onto the same sheet of paper.

The easiest way to make a multiple print is by exposing each negative in turn so that they all overlap. However, by using masks to prevent light reaching certain parts of the paper during each exposure, you can selectively print sections from different negatives without any overlap and exercise far more control over the final result.

Neon Signs

Nightfall provides many interesting photographic opportunities, but one of the most accessible has to be the colourful illuminated signs that are used in our towns and cities. You'll find them outside pubs, clubs, wine bars, discotheques, restaurants, cinemas, all-night stores, fast-food outlets and many other places, and all are intended to lure passers-by with their welcoming glow.

WHAT YOU NEED

Camera: Even though illuminated signs appear bright to the naked eye, their output is still low compared to, say, average daylight. For this reason you will need a camera that can be used at exposure times of several seconds. All 35mm SLRs fall into this category, along with a growing number of compact cameras that have a wide shutter speed range, a B (bulb) setting or a special 'night' mode.

Lenses: Your choice will depend on how close you can get to the sign and how big it is. Usually a short telephoto lens of 135mm or 200mm will be powerful enough to produce frame-filling pictures, although in some situations a shorter focal length of 50–100mm will suffice.

Film: Use slow-speed film of ISO50–100 to make the most of the vibrant colours in the sign.

Accessories: As light levels are low, you will need a tripod to keep your camera completely still during the long exposure. A cable release is also handy for tripping the camera's shutter.

HOW IT'S DONE

If you don't already know the location of an interesting illuminated sign, go for a stroll through your local high street during the daytime and make a mental note of any interesting signs you find. Obviously they will not be lit during the day, but you will still be able to tell whether or not they will make suitable subjects.

You should then return as dusk falls so you have time to prepare. If you intend including sky in your pictures, the ideal time to photograph illuminated signs is during the first 30–40 minutes after sunset, when the sky is a deep blue colour. However, if the sign itself will fill the whole picture area, you can photograph it at any time after dark.

When you arrive, erect your tripod, mount your camera on it and compose the picture. Take your time at this stage, making sure that there are no distracting features in the viewfinder, such as street lights which may cause flare, litter on the ground, and so on.

Once you're happy with the

This simple sign was photographed outside a nightclub on the Greek island of Crete. The photographer noticed it while strolling down to the beach during the daytime, and determined to return that night when it was illuminated. The exposure was left to the camera's integral metering system, which the photographer used in aperture priority mode.
EQUIPMENT: Olympus OM4-Ti, 135mm lens, tripod and cable release
FILM: Fujichrome Velvia, ISO 50
EXPOSURE: 15 seconds at f/11

composition, fit the cable release and take an exposure reading. I normally select a lens aperture of f/8 or f/11, then set my camera to aperture priority mode so that the exposure time required will be set automatically by the camera.

This approach usually gives a well exposed picture, because the light levels in an illuminated sign tend to be quite even and shouldn't cause exposure error with a modern SLR. However, just to be sure, I also bracket the exposures by one stop over and under the metered exposure, in half-stop increments for colour transparency film and full-stop increments for colour negative film. This is done using my camera's exposure compensation facility, which provides a quick and easy way of overriding the integral metering system and allows an increase of up to +/-5 stops in ⅓ stop increments.

TOP TIPS

• Use filters to make your pictures more interesting. A starburst will turn bright points of light into twinkling stars, while a multiple image will multiply the sign to produce eye-catching pictures.
• Illuminated signs are ideal subjects for the 'zooming' technique (see page 158). As light levels are low you will have plenty of time

The illuminated billboards at London's Piccadilly Circus have been photographed literally millions of times, but if you're ever there you will see why – it's an amazing sight at night, and one that always merits a few pictures. For this one, a wide-angle lens was used to capture the whole building from the opposite side of the road, and include the light trails from passing traffic to add extra interest. Notice that the picture was taken while there was still colour in the sky – the optimum time for 'night' photography.

EQUIPMENT: *Nikon F90x Prof., 28mm wide-angle lens, tripod and cable release* **FILM:** *Fujichrome Velvia ISO50* **EXPOSURE:** *20 seconds at f/16*

to zoom through the focal length range, turning an ordinary sign into an explosion of colourful streaks.
• Some signs flicker, or are illuminated one part at a time; the famous illuminated signs at Piccadilly Circus in London are a good example. If you photograph this type of sign, watch it first and make sure you use an exposure that's long enough so the whole sign is illuminated while your camera's shutter is open.
• You can use exactly the same methods outlined above to photograph scenes such as outdoor Christmas illuminations, or seaside illuminations.

Panning

When photographing moving subjects, the normal approach is to set your camera to a high (fast) shutter speed so that any traces of movement are frozen. However, while this can produce dramatic pictures in most situations, it can sometimes give the impression that your subject was never moving in the first place, and may fail to capture the sense of drama and excitement you felt at the time the picture was taken.

A good way of avoiding this is by using a technique known as panning, which involves setting a slower shutter speed and tracking the subject with your camera while taking the picture. The idea of panning is to render your subject more or less sharp – though as you will see, this isn't absolutely necessary – while reducing the background to a blur so a sense of movement is captured. As well as using panning for sports photography, it is also a good technique to use on everyday action subjects, such as joggers in the park, your children riding their bicycles, even people walking down the street.

WHAT YOU NEED

Camera: Most sport and action photographers use 35mm SLRs as they are quick to operate and easy to handle.
Lenses: The focal length you choose will depend on how close you are to your subject. Most sporting events take place some distance away, making it necessary to use long telephotos from 300mm upwards. However, sports such as cycling, moto-cross, rallying and athletics tend to be more accessible, so you can take successful pictures with shorter focal lengths – anything from 28mm wide-angle to 200mm telephoto.
Accessories: A monopod will be handy if you are shooting with a long telephoto lens.
Film: Slow-speed film from ISO50–100 is fine for panning. As you will be working at slower shutter speeds than normal, there is no need to use anything faster.

HOW IT'S DONE

Subjects which follow a predetermined route are ideal for panning, as you can predict exactly where they will be at a given time and prepare for it. In terms of viewpoint, a position where you can photograph your subject when it is directly opposite is ideal, although you can also create interesting results by shooting on corners so that your subject is at an angle. If you do this, there will obviously be a higher degree of blur in the pictures.

To show the panning effect clearly, choose a background containing details that will look effective when blurred, such as foliage or the advertising billboards used around racing circuits. Plain, neutral backgrounds do not work as well.

An important aspect of panning is setting a shutter speed which is slow enough to produce sufficient blur in the background, but not so slow that everything blurs beyond recognition. Once your panning skills improve you can experiment with slower shutter speeds, but in the beginning use the following as a guide:

Motorsport racing	$\frac{1}{250}$ or $\frac{1}{500}$ second
Horse-racing, cycling, sprinting	$\frac{1}{125}$ second
Joggers, children on bicycles	$\frac{1}{60}$ second
People walking briskly	$\frac{1}{30}$ second

Now here's a simple step-by-step guide to panning which will be effective with any subject.

1 Set the exposure on your camera, paying close attention to the shutter speed you'll be using, then choose a point where your subject will pass and focus on it.
2 As your subject approaches, track it towards the predetermined point with your camera, making sure that you move the camera at the same pace as your subject.
3 Just before your subject reaches the point you've focused on, gently squeeze the camera's shutter release button while swinging the camera to keep your subject in the viewfinder.
4 Continue panning the camera as your subject passes, making sure you move in a smooth, even motion so that the pan is smooth. Be careful not to jerk the camera.
5 When you hear the camera's shutter close to end the exposure, continue panning to ensure a smooth result.

This sounds very easy, but in reality it's quite tricky and you will probably need a lot of practice before you get it just right. The key to success is in the smoothness of your pan, so adopt a stable stance with your elbows tucked into your sides, and swing your whole upper body from the hips rather than just moving the camera on its own.

Don't worry if your first attempts turn out a little blurred and jerky – as you can see from the photograph on page 99, you can produce powerful images even when your subject is blurred as well as the background.

TOP TIPS

• Once you've mastered the basics of panning, try experimenting with slower shutter speeds of ¼, even ½ second, so you intentionally introduce more blur into your pictures. This can create dramatic, impressionistic results from even the most everyday moving subjects.

• You need to have very quick reactions to capture fast-moving subjects such as racing cars, so practise on cars going down the street until you know exactly when to trip the shutter to take a perfectly timed shot.

• Autofocusing can help to ensure your subject is sharply focused, but most sport and action photographers prefer to focus manually on a predetermined point.

• Add extra drama to your panning shots by using electronic flash to create 'slow-sync' images (see page 126).

• You can create a similar effect to panning by moving alongside a moving subject at the same speed and photographing while you're in motion. This technique, commonly referred to as 'tracking', works particularly well when photographing cars and motorbikes through the open window of another car.

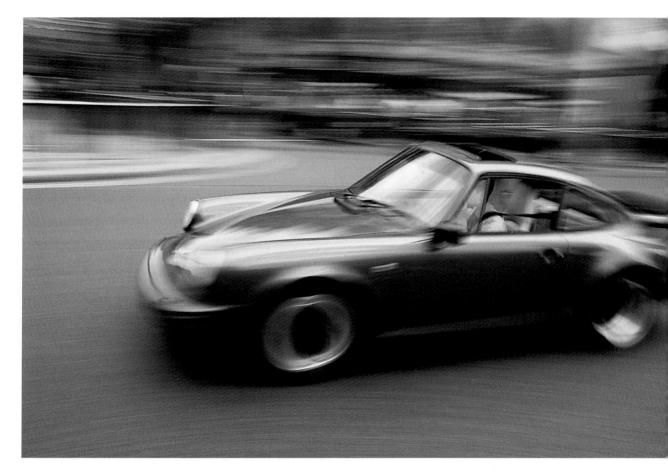

ABOVE **This Porsche 911 sports car was photographed as it moved around a sweeping bend at London's Piccadilly Circus. The panning technique was used to add impact to the subject which, due to the dull weather and overall greyness of the scene, could easily have looked rather boring. A slow shutter speed was chosen in order to create plenty of blur in both the car and the background. To take the picture, the photographer simply stood on the pavement nearby and waited for interesting cars to approach.**
EQUIPMENT: *Olympus OM4-Ti, 28mm wide-angle lens*
FILM: *Kodachrome 64, ISO64* **EXPOSURE:** *⅛ second at f/16*

BELOW **This illustration shows the ideal stance for undertaking panning. Note that the photographer has his elbows tucked well into his sides to provide a solid platform for the camera, and to enable smooth panning from the hips.**

Panoramic Pictures

Over the last few years, a new type of image format has suddenly become very popular – the panoramic. This is basically an elongated picture that is much longer and thinner than other formats and allows you to produce more interesting results with all types of subject, especially scenics such as landscapes, architecture and gardens.

The main appeal of the panoramic format is that it appears to reveal much more than we can see with the naked eye, thus producing images that are refreshingly different. In truth, most of the cameras with a panoramic option don't actually record any more than a moderate wide-angle lens – they simply crop off the top and bottom of a normal full-frame image. Despite this limitation, however, interesting pictures can still be taken with this type of image format.

WHAT YOU NEED

Camera: There are various different types of camera available that allow you to produce panoramic images.

A growing number of 35mm SLRs and compacts now boast a panoramic facility which can be used as and when required, and switched on or off mid-roll. They work simply by masking off the top and bottom of the picture with retractable blades, while guidelines in the viewfinder show what will be recorded.

Although these cameras do not produce true panoramic images – the angle-of-view of the lens is no different than if you were using it full-frame, you just record less of the scene – they're fun to use for snapshots. Some processing labs will also print the panoramic images on 25x10cm (10x4in) sheets of paper if requested so you can appreciate fully the impact of a panoramic image. If you don't request this, the panoramic pictures will come back on normal 15x10cm (6x4in) prints.

If you're more serious about panoramic photography, a specialist panoramic camera is worth considering. They do tend to be very expensive, but image quality is far superior.

For 35mm film the 'Widelux' is probably the most well known model, producing 24x59mm images. A more recent addition is the Horizon 202 which produces 24x58mm images, or the Noblex which gives 24x66mm images on 35mm film.

For the ultimate in quality, however, nothing can compare with a medium-format panoramic camera that produces 6x17cm images on 120 or 220 roll-film. The two most popular 617 models among professional photographers are the Linhof Technorama and the Fuji GX617, both of which can be fitted with a variety of interchangeable lenses – 90mm, 105mm, 180mm and 300mm lenses are available for the Fuji GX617, though for general use the 90mm or 105mm are most suitable.

Models using 120 and 220 roll-film are also available from Noblex, Art, Cyclops and Widelux, or you could buy a second-hand Fuji G617, which has a fixed 105mm lens.

Failing that, you could take pictures using your widest lens on normal 35mm – such as a 20mm – or medium-format, then mask off the top and bottom of the pictures you take to create panoramics. Obviously, image quality won't be quite as good, but at least it's a start.

HOW IT'S DONE

Purpose-made panoramic cameras work using one of two methods. Some models, such as those from Widelux, have a rotating lens which scans the scene and records it gradually through a slit in the front of the camera. Others, such as the Fuji GX617 and Linhof Technorama, record the image all at once.

Panoramic cameras are relatively easy to use, providing you think carefully about what you're doing. Pictures have to be composed through a separate viewfinder, for example, so you can't gauge the effect of filters such as polarisers and graduates. However, these problems can easily be overcome. With a polariser (see page 110), all you have to do is rotate the filter in front of your eye until the maximum effect is obtained, then slot it into the filter holder on the lens. Similarly, when using a graduated filter, look through the viewfinder to see how much of the image is occupied by sky, then slide the filter into the holder so that it covers that area.

Panoramic cameras do not have an integral metering system, but you can always take a meter reading using your SLR or a handheld meter, then set the required aperture and shutter speed on the camera – remembering to increase the exposure to compensate for any light loss caused by filters.

Finally, as you're not viewing your subject through the lens, you need to take care when focusing the lens. If you're shooting a landscape, this problem can be overcome by setting the lens to a small aperture – f/32 or f/45 – then using the depth-of-field scale to maximise depth-of-field at that aperture (see page 42).

TOP TIPS

• If you can't afford to buy a panoramic camera, hire one from a professional dealer.
• Depth-of-field is not as extensive as you might think, so whenever possible use a small aperture and use the depth-of-field scale on the lens to check the nearest and furthest points of sharp focus (see page 42).
• Although panoramic cameras can be handheld, a tripod is recommended in order to prevent camera shake and aid accurate alignment.

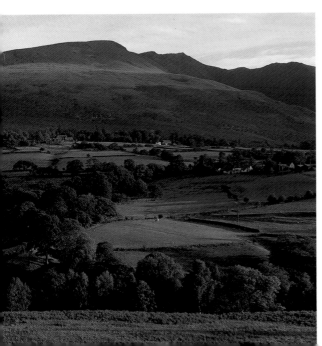

ABOVE **The panoramic format is ideal for scenes where the sky and foreground are not particularly interesting, but the area across the centre of the scene is. This picture, taken on a dull, misty day, is a perfect example. When viewed through a 28mm wide-angle lens on a 35mm SLR the scene looked rather empty, with a grey sky and equally grey lake occupying far too much of the picture area. However, by using a 6x17cm panoramic camera, the photographer has excluded these areas and produced an image that is incredibly evocative.**
EQUIPMENT: Fuji G617 and 105mm lens **FILM:** *Fujichrome Velvia ISO50*
EXPOSURE: ½ second at f/22

LEFT **This panoramic image was shot using a Fuji G617 camera which has a fixed 105mm lens and produces 6x17cm images on 120 or 220 roll-film. The image quality is superb, allowing pictures to be reproduced to large sizes with no significant loss of sharpness or definition. Despite the fact that there are no features close to the camera, a small lens aperture was still set to ensure sufficient depth-of-field.**
EQUIPMENT: Fuji G617 camera and 105mm lens **FILM:** *Fujichrome Velvia ISO50* **EXPOSURE:** *1 second at f/32*

Patterns

P atterns are formed by the repetition of similar shapes, objects, lines or colours. If you place one car in a car park it's unlikely to look very appealing, but place another dozen cars next to it and a strong pattern suddenly emerges. It's the same with telegraph poles lining the street, chimney pots on rows of terraced houses, faces in a crowd, tables and chairs outside a street café, and so on.

The natural world is full of fascinating patterns too, but because most are on a small scale you have to really look to find them. Dewdrops on a spider's web glistening in the early morning sunlight, a multicoloured field of tulips, the regimented rows of fungi on an old oak tree or the delicate veins in a leaf are just a few examples of what you are likely to encounter.

WHAT YOU NEED

Camera: A 35mm SLR is the ideal tool for the job as it allows you to fit different lenses.

Lenses: Telezoom lenses, such as an 80–200mm or 70–210mm, are ideal for shooting patterns as they allow you to home in on interesting details and exclude periphery information by making slight adjustments to focal length.

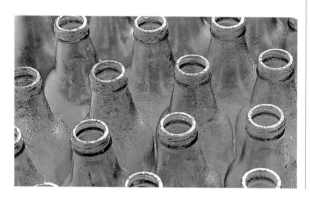

ABOVE **The photographer created this simple pattern shot by lining up a selection of identical green bottles that had been put to one side ready for delivery to the bottle bank.**
EQUIPMENT: Nikon F90x Prof., 105mm macro lens
FILM: Fujichrome Velvia ISO50 **EXPOSURE:** *⅟₆₀ second at f/8*

RIGHT **Reflections in water create graphic patterns. The blue in this shot is the reflected summer sky and the pattern is details of boats in a harbour.**
EQUIPMENT: Olympus OM4-Ti, 300mm lens
FILM: Fujichrome RFP50, ISO50 **EXPOSURE:** *⅟₁₂₅ second at f/8*

ABOVE **Geometric patterns in the famous leaning Tower of Pisa stand out clearly – especially when a 200mm telephoto lens is used to isolate them.**
EQUIPMENT: Olympus OM4-Ti, 200mm lens
FILM: Fujichrome Velvia ISO50 **EXPOSURE:** *⅟₆₀ second at f/11*

Another benefit of telephoto lenses is that they compress perspective, so you can emphasise the patterns created by repeated features by crowding them together – such as a line of telegraph poles, or an avenue of trees.

Film: For general pattern shots a slow film around ISO50 or 100 will provide optimum sharpness and colour saturation. Black and white film is also ideal for pattern pictures, as the lack of colour helps you concentrate on the fundamental elements of an image.

HOW IT'S DONE

When it comes to capturing patterns on film, the most important tools are your eyes and lenses. Use your eyes first to explore your surroundings and locate interesting patterns, then different lenses to make the most of them. It's as simple as that.

Light plays an important role in creating patterns. On a dull day the only patterns you're likely to notice are those that really exist, but if the sun comes out, shadows create patterns all of their own and lend a strong graphic quality to your pictures.

The best time to exploit shadows is early or late in the day, when the sun is low in the sky and the shadows are long. Keep the sun to one side of your camera so the shadows become an integral part of the picture. This can look superb when a series of shadows are cast by things like trees, railings, stone pillars, people walking down the street or tables and chairs outside a café because you end up with a contrasting series of vertical and horizontal lines that compete for attention.

Patterns need not always be regimented, and they need not comprise the same elements. You can take successful pictures of such objects as windows on the side of a building, for instance, where lines, circles, squares and different colours create several patterns all at once.

Interesting patterns can be created using objects you find around the home. Small objects like matches, paperclips, coloured pencils, marbles, buttons, nails, screws and balloons are ideal – try arranging them in neat, ordered patterns, or just scatter them on the floor and see what happens.

Books, records and collections of stamps or coins can also be used. Anything that suggests repetition through shape, line or colour will make a great pattern picture, and our lives are filled with such objects, so you should find plenty to photograph.

The repeated shapes of the balconies, windows and columns in this Georgian building made an irresistible subject. A telephoto lens was again used to compress perspective so that the architectural features were crowded together to emphasise the strong pattern.
EQUIPMENT: Olympus OM4-Ti, 200mm lens, tripod FILM: Fujichrome Velvia ISO50 EXPOSURE: ⅟₃₀ second at f/11

When viewed from an elevated position, these cars parked in neat lines formed an interesting pattern. Sunlight glancing off the bodywork heightened the graphic simplicity of the scene, making it appear almost black and white and helping to reveal the pattern more clearly.
EQUIPMENT: Olympus OM4-Ti, 200mm lens FILM: Fujichrome Velvia ISO50 EXPOSURE: ⅟₂₅₀ second at f/8

TOP TIPS

• Urban areas are ideal places to find patterns – look closely at office blocks, windows, doors, street furniture, road markings, the designs painted on cars, vans, buses and lorries, fancy brickwork and paving, and displays in shop windows and on market stalls.

• Building sites and builder's yards are also perfect locations. Piles of bricks, concrete blocks, timber, drainpipes, roofing slates, gravel, paving slabs, buckets, reinforcement bars, scaffold tubes and ladders are just some of the subjects that create patterns.

• In the countryside, natural patterns abound, such as furrows in a ploughed field, stone walls, rows of flowers and crops, trees in woodland, and so on.

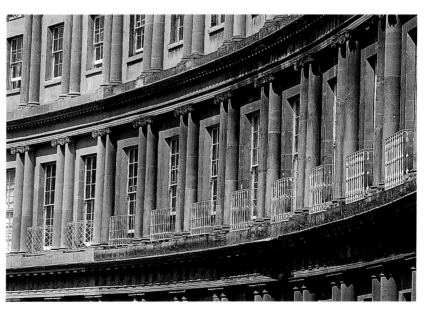

Perspective and Scale

By its very nature, a photographic image can only record two dimensions – width and height. However, the things we photograph are almost always three-dimensional, so it's important to try and create a sense of that all-important third dimension – depth – in your work.

To a certain extent, the human eye and brain does this automatically, based on our knowledge of distance, and the effect it has on the size of an object. If you look at a picture you can usually tell which parts of the scene were close to the camera and which were further away, due to their size in relation to each other. This spatial relationship is more commonly known as perspective, and when exploited creatively in a photograph it can give a strong sense of depth and scale.

WHAT YOU NEED

Lenses: When it comes to exploiting perspective and scale, lenses are your most powerful weapon.

Wide-angle lenses appear to 'stretch' perspective so nearby objects loom large in the frame while everything else rushes away into the distance. This can produce dramatic results, especially when showing diminishing scale or exploiting foreground interest.

Telephoto lenses do the opposite – they 'compress' perspective so that the elements in a scene appear much closer together. Use this to emphasise aerial perspective, or to create a dramatic sense of scale by juxtaposing small and large elements.

HOW IT'S DONE

There are various types of perspective which you can exploit as a photographer, and all are capable of producing effective results.

Diminishing scale

If you stand outside your house and look up at it, the building will appear very large and imposing. If you move 100m away, however, it suddenly seems much smaller. This isn't because the

size of the house has physically changed, but because you are further away from it. This principle is the basis of diminishing perspective, and it can be used in various ways to make a photograph more successful.

If you photograph an avenue of trees, for example, each tree will appear slightly shorter than the last, even though they are all roughly the same size. Depth is therefore implied because you know that if the trees are getting smaller it is because they are stretching off into the distance. The same effect can be achieved

In this beautiful scene, captured in the Vaucluse region of Provence in southern France, depth is implied in a number of ways. Most obviously, the inclusion of buildings against a mountainous backdrop adds scale. Due to patchy sunlight catching the buildings, the village also stands out prominently against the shady mountains, so a strong three-dimensional feel has been created. Finally, slight compression of perspective caused by a moderate telephoto lens has added a somewhat claustrophobic feel to the scene by giving the impression that the mountains tower over the village when in actual fact they are some distance away.

EQUIPMENT: Pentax 67, 165mm telephoto lens, tripod
FILM: Fujichrome Velvia ISO50 **EXPOSURE:** ⅟₁₅ second at f/16

with a row of lamp posts, a long straight wall or any repeated features of a similar size.

To emphasise the diminishing effect, move up close and use a wide-angle lens. Doing this causes the repeated features to get much smaller much more quickly. With an avenue of trees, for instance, the first tree will seem enormous and the last one tiny, while the gaps between the trees seem to close up very quickly as the avenue stretches off into the distance – to the point where the last trees will appear to be touching.

If you photograph the same type of scene with a telephoto lens the effect is completely different. You will need to shoot from much further away for a start, and because telephoto lenses compress perspective, the trees will appear much closer together than they really are, while the shrinking size is far less pronounced; the last tree in the avenue may not look much smaller than the first.

Aerial perspective is very evident in mountainous scenery, where atmospheric haze and early morning mist reduce the distant hills to a series of simple shapes, while colour density is reduced with distance. This effect is best shown by using a telephoto lens to isolate part of the scene.
EQUIPMENT: *Nikon F90x Prof., 80–200mm zoom at 200mm, 81B warm-up filter* **FILM:** *Fujichrome Velvia ISO50* **EXPOSURE:** *⅛ second at f/11*

Linear perspective
This type of perspective is clearly shown by the convergence of parallel lines formed by a straight road, railway tracks or the furrows in a ploughed field. Although the lines are roughly the same distance apart, they seem to get much closer together with distance, thus suggesting depth.

To maximise this perspective effect, stand between the parallel lines and photograph the scene with a wide-angle lens, so that the lines converge very quickly and meet on the horizon at the 'vanishing' point.

Size recognition
Another way to imply scale, depth and distance in a picture is by including subjects that are instantly recognisable. People are an obvious choice. We know that adults are all more or less the same size, give or take a few centimetres, so including them in a picture not only gives us an idea of distance – if they're small they must be far away – but also provides an instant size comparison with other features in the scene to suggest scale. Animals, and to a lesser extent buildings, are also useful for this.

For example, if you photograph a landscape scene and in the distance two tiny people can be seen walking up a hill, it can be deduced not only that they're far away due to their small size, but also that the scene is enormous because it dwarfs the figures.

Recognisable features can also be used to imply depth in a picture due to diminishing scale. If you include a person in the foreground of a landscape picture, for instance, that person will

seem very big compared to the rest of the scene, suggesting that the scene beyond must be much further way from the camera than the person.

The same effect can be obtained by using all types of feature to provide foreground interest, such as boats moored by the side of a lake, a gate or fence, rocks, flowers, and so on. Wide-angle lenses are ideal for emphasising this as they allow you to include nearby features in the picture. They also appear to stretch perspective so that size diminishes very quickly with distance.

A sense of distance and depth has been captured in this graphic winter scene using three different types of perspective. First, linear perspective is shown by the converging lines of the path and drain. Second, the avenue of trees illustrates diminishing scale as the trees gradually reduce in size with distance. Third, the tones in the scene appear lighter in the distance than close to the camera, so aerial perspective is also evident. To emphasise linear perspective and diminishing scale a wide-angle lens was used.
EQUIPMENT: *Olympus OM4-Ti, 21mm wide-angle lens*
FILM: *Ilford XP2 rated at ISO40* **EXPOSURE:** *⅕ second at f/16*

Aerial perspective

If you stand on a hilltop in perfectly clear weather, it's possible to see for miles around, and features in the distance seem much closer than they really are due to the clarity of the atmosphere. More often than not, however, distant features and fine details are obscured by atmospheric haze, and bold features in the scene look like flat cardboard cutouts.

This phenomenon, known as aerial perspective, is based on the fact that colour and tone diminish with distance due to haze, mist and fog. If you photograph a range of hills on a hazy morning, for example, the hills closest to the camera will appear darker in colour or tone than those further away. The same applies with woodland in misty or foggy weather. To emphasise the effect, use a telephoto lens to fill the frame with more distant parts of the scene, so that distant features are crowded together and perspective compressed. Haze tends to be more common in mountainous areas and morning is the best time of day to photograph it.

Colour can also be used to make the effects of aerial perspective more obvious. Warm colours such as red and yellow

Including foreground interest in wide-angle scenic pictures is an ideal way of adding depth and scale. In this tranquil lake scene, the moored rowing boats in the foreground seem much bigger than other boats in the middle distance and the hills in the background, suggesting that the rowing boats are much closer to the camera and the other features must be further away. When exploiting foreground interest in this way, set your lens to a small aperture – f/16 or f/22 – so there's enough depth-of-field to render the whole scene in sharp focus.
EQUIPMENT: Pentax 67, 55mm wide-angle lens, 81B warm-up filter, tripod **FILM:** *Fujichrome Velvia ISO50* **EXPOSURE:** *½ second at f/16*

are said to 'advance' while cooler colours such as green and blue 'recede'. Cooler colours therefore make ideal backgrounds to warmer colours, and by composing pictures in this way a feeling of depth will be implied.

Overlapping forms

Allied to aerial perspective, but also seen in other situations, is the idea of overlapping shapes or forms. If you gaze across a mountainscape, for example, some part of each mountain will be obscured by the mountain in front of it. This can only be possible if one mountain is closer to the camera than the next, so distance and depth is implied. The same type of effect can be seen in urban areas, where one building obscures part of another, or in the countryside where a wall close to the camera obscures part of the scene beyond.

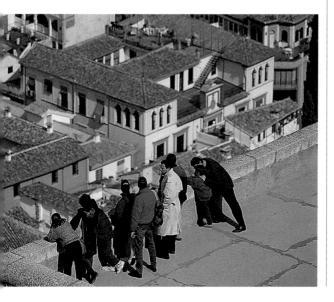

We take this simple concept for granted, but when used consciously in your work it can make all the difference.

TOP TIPS

• Creating a sense of depth, scale and distance is vitally important – especially in scenic photography – so always think very carefully about how you can achieve it when composing a picture.
• If you look around, it's possible to find something to suggest scale or depth in most scenes. Sometimes you may be able to include more than one.
• The quality of light can make a big difference to a picture. Strong sidelighting reveals texture and modelling and the inclusion of shadows in a picture suggests depth; on the other hand, pictures taken with the sun behind you tend to look rather flat because the shadows are falling away from the camera and out of sight.

We know that buildings are almost always much bigger than the human form, so the fact that the people in this picture seem bigger than the buildings in the background suggests that there must be some distance between them. By using a telephoto lens and a wide aperture, the photographer has also minimised depth-of-field so that only the people are in sharp focus, adding a three-dimensional feel to the image which implies depth.
EQUIPMENT: Olympus OM2n, 180mm telephoto lens **FILM:** *Fujichrome Velvia ISO50* **EXPOSURE:** *1/500 second at f/2.8*

Pinhole Photography

iven the current level of technology and sophistication available in modern cameras and lenses, photographers new to the hobby could be forgiven for thinking that it would be impossible to take successful pictures with anything less complicated.

However, if you strip away all the fancy electronic features and functions in a camera you will see that, in essence, it is basically just a lightproof box that holds a roll of film. Similarly, while modern multi-coated lenses may contain many separate glass elements and an adjustable aperture, you don't need all these things to record an image. In fact, all you really need is a pinhole!

Not convinced? Then why not try out pinhole photography for yourself? It may not be as reliable as using an automatic SLR, but there's a lot of fun to be gained from trying.

WHAT YOU NEED

Although it's relatively simple to make a pinhole camera from scratch and use it to record images on sheets of black and white printing paper, a much quicker and more predictable method is to adapt your 35mm camera so pinhole images can be captured on film in the 'normal' way. For this you will need:

Camera: Any type of 35mm SLR, compact or rangefinder.

Accessories: A black plastic body cap for the camera, an empty aluminium drinks can, a needle, a sheet of fine abrasive paper such as 'wet-and-dry', some tape, a ballpoint pen and finally a tripod.

Film: Any type or speed of film can be used.

HOW IT'S DONE

1 Cut out a piece of aluminium from the can and flatten it out.

2 Using the ballpoint pen, make a small dent in the middle of the piece of aluminium.

3 With the wet-and-dry paper, gently rub down the protrusion on the back of the aluminium caused by the dent, until there is just a very thin layer of metal left. Be very careful not to rub it all the way through.

4 Place the aluminium on a flat, hard surface and carefully push the needle point through the thin part of the metal, making sure that only the point of the needle passes through.

5 Turn the aluminium over, place the needle point through the back of the hole and twist it gently to get rid of any imperfections in the tiny hole. You now have your pinhole.

6 Drill or cut a hole in the centre of the plastic body cap measuring 5–6mm across.

7 Tape the piece of aluminium with the pinhole in it over the hole in the body cap and fix the body cap to your camera body. You now have a pinhole camera and are ready to take pictures.

The focal length of the pinhole is roughly equivalent to the distance from the pinhole to the film plane. If the camera body is a 35mm SLR, this means that the focal length will be around 45mm – similar to the standard focal length for that format.

Because the pinhole is very small, its f/number will be quite large and exposure times will, as a consequence, be long – usually several seconds with slow-speed film, even in bright sunlight. For this reason you should always mount your camera on a tripod.

One advantage of pinhole photography is that you don't need to focus. This is because the f/number of the pinhole is very big compared to normal lenses, so depth-of-field is almost limitless. You should, however, be just about able to see an image through your camera's viewfinder which will aid focusing.

When it comes to calculating exposure, you may find that your camera's integral metering system gives reasonably accurate results, especially if you use colour or black and white

The pinhole is made by cutting a small square from an aluminium drinks can, then punching a tiny hole in it.

With the pinhole fixed to a plastic camera body cap, your pinhole camera is ready for action. Mount your camera on a tripod as exposure times will be long due to the small size of the pinhole.

CALCULATING THE PINHOLE'S F/NUMBER

This is not essential, but it does give you a little more control over the exposure. To do it you will need a slide projector, two empty 35mm slide mounts, a piece of clear film, a fine fibre-tipped pen and a ruler. Here's what you do:

1 Set up the slide projector so that it forms a large image on a white wall or screen.

2 Draw a 10mm line on the clear piece of film, then place it in one of the empty slide mounts. Put the mount in the slide projector and focus the image on the wall.

3 Take the ruler and measure the length of the projected line. As an example, let's say it is 150mm long. Divide this number into the original length of the line – 10mm. The answer – 15 – is your magnification.

4 Now take the piece of aluminium with the pinhole in it and, using two pieces of sticky tape, secure it firmly to the other empty slide mount.

5 Remove the first slide from the projector, replace it with the mount containing the pinhole and focus the projected image of the pinhole.

6 Measure the diameter of the projected image of the pinhole – let's say it measures 45mm.

7 Now divide this number by the magnification figure – 15 – to find the actual size of the pinhole: 15/45 = 0.3. This means that your pinhole's diameter is 0.3mm.

8 To calculate the f/number of the pinhole, all you have to do now is divide the focal length of the pinhole into its diameter. In this example it's 45/0.3 = 150. Your pinhole therefore has an f/number of 150.

With the f/number of your pinhole established, you can calculate the exposure required with a much greater degree of accuracy. The easiest way to do this is by using a handheld meter or another camera to determine the exposure time (shutter speed) required at an aperture of f/16. All you have to do then is refer to the table below, find the pinhole f/number closest to the f/number of your pinhole, then multiply the shutter speed by the factor shown. This will give you the exposure time that is required for your pinhole.

Pinhole f/number	50	100	150	200	250	300
Exposure factor	16x	40x	90x	160x	200x	400x

For example, let's say that the exposure reading you take is $\frac{1}{60}$ second at f/16 and that you have a pinhole with an f/number of f/150. The exposure time you need is therefore $\frac{1}{60}$ x 90 = 1.5 seconds.

Finally, remember that reciprocity failure needs to be accounted for with exposures longer than one second to avoid underexposure, especially with colour transparency film. So, if your calculations reveal an exposure of 1 second, increase it to 2 seconds, if 10 seconds is calculated, increase it to 30 seconds, and for 60 seconds increase it to 5 minutes.

negative film, as any exposure error can be corrected at the printing stage. If you want to have a little more control over the exposure you can actually calculate the f/number of the pinhole, then take exposure readings with a handheld meter (see panel).

Once you've got everything sorted, just go out and take some pictures. Static subjects are ideal for pinhole photography as they will not move during the long exposure, so try it on landscapes, architecture, still-lifes and so on. Have fun!

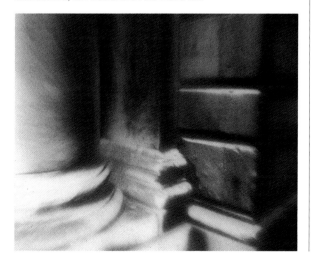

TOP TIPS

• Don't expect pin-sharp results from your pinhole camera.

• If at first you don't succeed, try, try again!

• Experiment with filters when using your pinhole camera – try soft-focus and coloured filters.

• Colour negative film has more exposure latitude than transparency film, so you can obtain acceptable prints even if the image is badly exposed.

If all goes well this is what you should end up with. Image quality is obviously not as high as you'd expect from a purpose-made lens, but it's surprisingly good considering the simplicity of the set-up. The exposure was calculated by first measuring the pinhole with a slide projector to establish its f/number then applying the necessary exposure factor. Exposures were bracketed two stops over and under the initial reading in 1/2 stop increments to ensure one was perfect.
EQUIPMENT: *Nikon F90x body with a 45mm f/225 pinhole, tripod*
FILM: *Fujichrome Provia 1600 rated at ISO1600*
EXPOSURE: *7 seconds at f/225*

Polarising Filters

A polarising filter is a specially made accessory which fits to the front of a lens in the same way as any other filter and helps to control the amount of polarised light which is being admitted. This is achieved by using a 'foil' which is sandwiched between two layers of glass or optical resin; this foil only allows light rays that are perpendicular to it to enter. As a result of this propensity, it performs three important and very useful jobs:

• Blue sky is made to look a much deeper colour.
• Glare on non-metallic surfaces, such as foliage, plastic and paintwork, is reduced so colours look much stronger and clarity is improved.
• Reflections in water, glass and other shiny surfaces are reduced or removed.

WHAT YOU NEED
Camera: A polarising filter can be used with any type of camera, but ideally you need one that has through-the-lens viewing – in other words an SLR. Compact, rangefinder or TLR cameras all have separate viewing and taking lenses, so if you use a polariser on one of these cameras, you won't be able to see the effect it has and will simply have to guess.

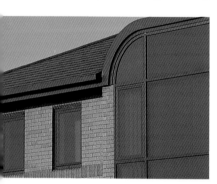

Lenses: Any.
Polariser types: There are two type of polarising filter available – linear and circular. If you use an SLR with autofocusing or spot

This pair of pictures shows the effect a polarising filter can have on a scene. The top picture was taken without a filter in place and the bottom picture with a polariser fitted. Notice how the sky is a deeper blue, while glare has been removed from the red paintwork on the building to increase colour saturation, and hazy reflections in the tinted windows have been reduced, therfore producing a much clearer, crisper image.

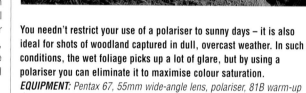

You needn't restrict your use of a polariser to sunny days – it is also ideal for shots of woodland captured in dull, overcast weather. In such conditions, the wet foliage picks up a lot of glare, but by using a polariser you can eliminate it to maximise colour saturation.
*EQUIPMENT: Pentax 67, 55mm wide-angle lens, polariser, 81B warm-up filter **FILM:** Fujichrome Velvia ISO50 **EXPOSURE:** 2 seconds at f/16.*

metering, you must buy a circular polariser, otherwise exposure error will result due to the way the camera works. A linear polariser can be used with all other camera types.

HOW TO USE IT
The effects produced by a polarising filter can be best appreciated by slowly rotating it in its mount while looking through your camera's viewfinder. When you are happy with what you see, stop rotating the filter and take the picture. To get the best possible results it is also important to bear in mind the following factors:
• Polarisers work best in bright, sunny weather when glare and reflections are more pronounced and there's more polarised light around.
• When using a polariser to deepen blue sky, ideally keep the sun to one side of the camera so you are aiming towards the area of sky where maximum polarisation occurs. In this way, you will get the strongest effect.
• Polarisation is uneven across the sky, so take care when using lenses wider than 35mm, otherwise the sky in your pictures may

be darker on one side than the other and the effect looks odd.

• Glare will only be removed from non-metallic surfaces such as paintwork, foliage and plastic.

• To remove reflections from surfaces such as water and glass, the angle between the surface and the lens axis must be around 30°. You can find this by making slight adjustments to your position, then rotating the polariser to see what happens.

• Polarising filters reduce the light entering your lens by two stops. This means if you were using an exposure of ⅟₁₂₅ second at f/11 without a polarising filter in place, for example, the exposure would drop to ⅟₃₀ second at f/11 once you fitted the polariser. If you are using an SLR with TTL metering, this light loss will be accounted for automatically to give the correct exposure. However, if you take a meter reading without the filter in place,

you must then remember to adjust the exposure accordingly.

• Polarising filters can sometimes give your pictures a slight blue colour cast when used in bright, sunny weather. To remove this, use an 81B or 81C warm-up filter. In fact many photographers do this as a matter of course, and some filter manufacturers even produce 'warm' polarisers.

This Turkish seascape demonstrates clearly the effects a polariser can have on a scene. As well as deepening the blue sky, it has also increased colour saturation in the buildings and foliage, while cutting down reflections in the sea. The end result is an image that looks just too good to be true.
EQUIPMENT: Pentax 67, 55mm wide-angle lens, polariser, 81C warm-up filter **FILM:** *Fujichrome Velvia ISO50* **EXPOSURE:** *⅟₁₅ second at f/11*

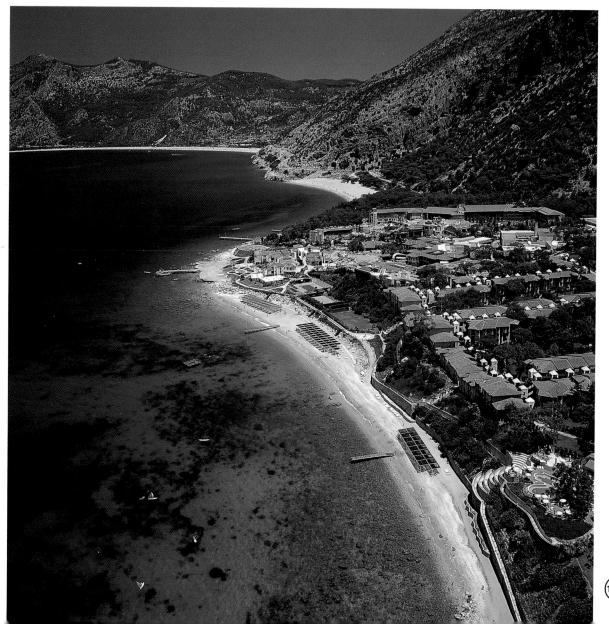

Pushing Film

This technique involves rating a roll of film at an ISO higher than it was intended to be used at, so you can use faster shutter speeds or smaller lens apertures. You could put a roll of ISO100 film in your camera, for example, but set the film speed to ISO200 or ISO400, or use a roll of ISO400 film at ISO800 or ISO1600. All this really means is that you are underexposing the film, so to compensate, the development has to be adjusted to give acceptable results – this is known as 'push-processing' or 'pushing'.

The way pushing works is that every time you double the recommended ISO of a film, it must be 'pushed' by an extra stop. So if you uprate ISO100 film to ISO200, it must be push-processed by one stop, while rating it at ISO400 will require two-stop push-processing.

Why bother to do this? Well, you could be at a sporting event taking action pictures when suddenly the light levels drop and the fastest shutter speed you can manage with your lens set to its widest aperture isn't quite fast enough to freeze the action. Similarly, you may want to take handheld pictures in low light, but find that the shutter speed required is too slow and there's a high risk of camera-shake. In an ideal world you would have a roll or two of faster film in your gadget bag, but if you don't, the only alternative is to uprate the film you do have to a higher ISO.

Uprating was necessary to secure this action picture, taken on a dull, rainy day. The photographer used ISO100 film uprated two stops to ISO400 so he could use a shutter speed of ⅟₅₀₀ second and freeze the motorcyclist as he rounded a bend on the circuit.
EQUIPMENT: *Olympus OM2n, 400mm telephoto lens* **FILM:** *Fujichrome RDP100 rated at ISO400* **EXPOSURE:** *⅟₅₀₀ second at f/4*

Uprating and push-processing also offer pictorial benefits. When a film is push-processed, for example, the grain size increases and you can use it to your advantage (see page 66). Contrast is also increased so that shadows become denser and highlights brighter. In bright, sunny weather this can be a drawback, but in flat, dull light increased contrast will help to give your pictures a little more life and impact.

WHAT YOU NEED

Film types: Colour slide films and black and white films are the easiest to uprate because most processing labs offer a push-processing service – all you have to do is tell the lab how many stops to push the film by. Colour negative film is not quite so straightforward as it tends to give unpredictable results when push-processed. Also, very few commercial labs offer a push-processing service for colour negative film.

HOW IT'S DONE

If your camera has a film speed dial or control, all you have to do to uprate is load the film, then set the speed to the ISO of your choosing.

If your camera is DX-coded and the film speed is set automatically, you can't do this unless it has an additional film speed control. Fortunately, there is a simple solution – DX re-coding labels. These handy items are small labels which you stick over the chequered DX pattern on a film cassette, so the camera is fooled into setting a different speed.

Once you have shot a whole roll of uprated film, remove it from the camera and write on the cassette the speed you rated it at so you don't forget – otherwise you can easily get exposed films mixed up and not know which have been uprated and which haven't.

If the film is to be processed by a commercial lab, you should stick a label on the cassette telling them how many stops to push-process it by. Alternatively, you can push-process films yourself. Increasing the development time for black and white film by about 30 per cent for every stop you've uprated is a simple guide, but there are some developers specially designed for uprated film, such as Ilford Microphen and Paterson Acuspeed.

This picture was taken at a rock concert in very low light levels. To provide a decent aperture/shutter speed combination and avoid any risk of camera-shake, the photographer rated ISO400 film at ISO1600, then push-processed it by two stops.
EQUIPMENT: Olympus OM1n, 35mm lens *FILM:* Kodak T-Max 400 rated at ISO1600 *EXPOSURE:* ⅟₆₀ second at f/5.6

Uprating has been used here for pictorial effect. By rating ISO400 colour slide film at ISO1600, then push-processing it by two stops, grain has been noticeably increased, adding an extra element to what could easily have been a rather dull image due to the flat, misty weather conditions.
EQUIPMENT: Nikon F90x Prof., 300mm telephoto lens, blue 80B filter
FILM: Scotchchrome 400 rated at ISO1600 *EXPOSURE:* ⅟₁₂₅ second at f/16

Original film speed	Push one stop	Push two stops	Push three stops
ISO50	ISO100	ISO200	ISO400
ISO64	ISO125	ISO250	ISO500
ISO100	ISO200	ISO400	ISO800
ISO200	ISO400	ISO800	ISO1600
ISO400	ISO800	ISO1600	ISO3200
ISO1000	ISO2000	ISO4000	ISO8000
ISO1600	ISO3200	ISO6400	ISO12800

E-6 slide processing kits will also include times for push-processing colour slide film.

The panel on the right gives some examples of how common film speeds can be uprated, and the amount by which they must be push-processed at different speeds.

TOP TIPS

• You can uprate and push-process any speed of film, but the effects differ from brand to brand, so experiment. Some slow-speed films give better quality results when uprated than using a faster film from the same manufacturer.
• For general use, avoid uprating by more than two stops, perhaps three stops in the extreme. If you go beyond this you may find that image quality deteriorates, and that the film speed dial on your camera doesn't go to high enough – most stop at ISO6400. Also, it's rare for a processing lab to offer a push-processing service beyond three stops.
• If you want to produce grainy images, uprate a fast film. Uprating ISO400 film to ISO1600 will give a noticeable grain effect, but you could go even further and rate ISO1000 film at ISO4000, or ISO1600 film at ISO6400.

Rule-of-Thirds

Although photographic composition is open to endless interpretation, there are various rules or guides that can be adopted to help produce images that are visually balanced and pleasing to the eye. Of these, the most useful and popular is the rule-of-thirds. Originally devised by artists, the rule works on the basis that if you divide an image in a ratio of 2:1, the composition will possess order and stability.

HOW IT'S DONE

To use the rule, all you have to do is divide your camera's viewfinder into nine sections using imaginary horizontal and vertical lines. You can then use this grid to help with the positioning of important elements in a scene.

If there's an obvious focal point, such as a single tree in a field, a red flower growing among a group of yellow flowers, or a boat bobbing on the ocean waves, you should position it on one of the four intersection points of the grid so that it is one-third in from either the top or bottom of the frame, and one-third from one side of the frame. Any point can be used, but by arranging it in this way you will automatically produce a more pleasing composition than if the focal point was positioned in any other way.

The vertical lines of the grid can also be used as a guide to dividing up the frame vertically. If you are shooting a building through a gap between trees, for example, place the gap one-third in from the left of the picture and the building in that gap one-third from the top of the picture, so the eye travels readily through the gap to the building beyond.

Similarly, if you shoot a full-length portrait, instead of placing your subject in the middle of the picture, move them over to one side so they are one-third in from the left or right of the frame.

As another example, when the sun sets in the sky over the sea, it creates a shimmering line of light on the surface of water which acts as a powerful frame, dividing the scene up. A natural response is to place the reflection down the middle of your camera's viewfinder, but positioning it according to the rule-of-thirds will be more effective.

Finally, when shooting landscapes, many photographers have a habit of placing the horizon across the centre of the frame. While this works well on scenes that are obviously symmetrical – when capturing the mirror image of a scene in the surface of a

The rule-of-thirds has been used in three ways in this Caribbean scene, photographed on the beautiful island of St Lucia. Not only has the horizon been carefully positioned roughly one-third up from the bottom of the frame, but the palm tree is also one-third in from the side of the frame and the crown of the tree is on the top third. The result is a balanced, harmonious composition that is pleasing to the eye.

EQUIPMENT: Pentax 67, 55mm wide-angle lens, polarising filter, tripod **FILM:** Fujichrome Velvia ISO50 **EXPOSURE:** 1/30 second at f/8

Although the rule-of-thirds is undoubtedly effective, you don't have to comply with it for every picture you take. In this scene, for example, the only way the photographer could make a feature of the symmetry created by the vivid reflection in the harbour was to place the horizon across the centre of the frame. Normally, such a tactic produces lifeless, static compositions, but here it works wonderfully, and is a perfect example of how breaking the rules is sometimes necessary.
EQUIPMENT: *Pentax 67, 55mm wide-angle lens, polarising filter, tripod* **FILM:** *Fujichrome Velvia ISO50* **EXPOSURE:** *⅕ second at f/11*

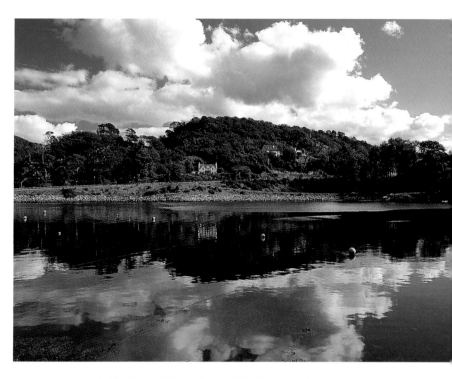

calm lake, for example – it should normally be avoided, because a central horizon divides a picture into two equal halves and usually results in a rather static and unimaginative composition.

A more successful approach is to use the horizontal lines in your imaginary grid as a guide to where the horizon should be. Placing the horizon along the top line of the grid will give a landscape-to-sky ratio of 2:1 and emphasise the foreground of a scene, while placing it on the bottom line of the grid will give a landscape-to-sky ratio of 1:2 and emphasise the sky. You needn't follow this slavishly, but generally, the further away from the centre of the viewfinder you keep the horizon the better.

TOP TIPS
• Photographers mainly use the rule-of-thirds for landscape and scenic pictures, but it's just as useful for still-lifes, portraiture, architectural photography, close-ups, and any subject where there's a main point of interest or natural divisions in the scene.
• Although the rule-of-thirds is a useful aid in composition, never force a picture to comply with it – or with any other rule for that matter. Doing so will make your work predictable, and, more importantly, boring.

This picture shows classic use of the rule-of-thirds, with a single, prominent focal point – the cottage on the hillside – being positioned on the intersection of the thirds to produce a more aesthetically pleasing composition, as shown by the grid on the right.
EQUIPMENT: *Pentax 67, 165mm telephoto lens, tripod*
FILM: *Fujichrome Velvia ISO50*
EXPOSURE: *⅕ second at f/11*

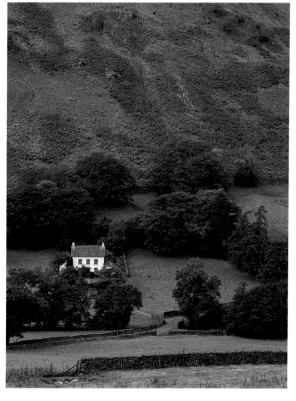

Shoot a Theme

No matter how enthusiastic you are about photography, every once in a while you may find that your motivation is at a low ebb because you can't think of anything new to take pictures of. If this happens, don't worry – it's a problem all photographers have to face from time to time, especially when trying to combine their interest with a full-time job and raising a family, and the opportunities to go out and take pictures are relatively limited.

One solution is to set yourself a photographic project, so that whenever you happen to have a little time on your hands you know exactly how to make the most of it, instead of staring blankly out of a window hoping that the 'muse' will eventually alight on your shoulders.

This project could be more or less anything, and take as long as you like to complete, although an approach which seems to work well is to shoot a theme based around a simple subject, idea or concept. For example, whenever you're out and about with a camera, you could make a specific point of looking for and photographing numbers, a certain colour, interesting road signs, graffiti, letter boxes, doors, roads, neon signs (see page 96), interesting cars, car badges, patterns, textures, and so on.

Once you start to think about it, you'll see that the options are literally endless. You can also take as long as you like working on the theme – from a single day spent wandering around your neighbourhood to a week, a month, or even a year. And when you're tired of working on one theme, all you have to do is choose another.

WHAT YOU NEED

Camera: A basic 35mm SLR is all you really need to work on a theme. Compact cameras are also suitable for some subjects.

Lenses: The lenses you use will obviously depend on the type of subject you decide to photograph, so it obviously makes sense to choose something that you can capture with the equipment you already have. Many photographers use the same lens for all the pictures in their theme project, to add uniformity. Doing this also means you can minimise the equipment you need to carry if you decide to spend a little time working on your theme.

Film: Most themes are best shot on normal slow-speed film (ISO50–100), although really you can use whatever you prefer, and this may be in colour or in black and white.

HOW IT'S DONE

Compiling a photographic theme is self-explanatory really – it's simply a case of deciding what you want to photograph, then looking for it. Some subjects are more elusive than others, of course. If you decide to photograph numbers, you may have to spend quite a lot of time searching them out – look on doors, vehicles, market stalls, containers, boxes, badges, and so on.

But if you choose a more accessible subject, such as doors, an afternoon spent exploring your neighbourhood will probably reveal a whole range of different colours, sizes and designs.

The key is to choose a subject that is not so difficult to find that you become tired of looking, but equally is not so obvious that the challenge of looking for it is taken away. Remember also that the subject you choose should have some kind of visual merit, otherwise the pictures you take will look rather boring, and you will quickly lose interest in the whole idea.

If you do choose the right kind of subject, shooting a theme can be an excellent way of making use of the limited photographic time you have. And once you do start looking for a particular subject, the chances are that you won't be able to stop, with the result that in the long term you will end up with a fascinating collection of pictures, all of them linked by a common factor.

Shooting a theme can also be a real benefit to your photography skills, because by training yourself to seek out something very specific you will naturally become more observant, develop a keener eye for a picture and over time become a better photographer.

TOP TIPS

• You don't even need to leave home to work on a theme – just look for interesting objects around the house. You may have a collection of old coins, bottles, badges or stamps, for example, which will make the ideal basis for a photographic theme.

• An interesting theme you can produce literally anywhere is to photograph the same scene with the same lens, from exactly the same position every month of the year, to record how seasonal changes affect it. Alternatively, photograph the same scene every hour from sunrise to sunset, to show how it changes throughout a single day.

• When you've completed your theme, why not select your favourite pictures from it, have a small print made from each, then mount them all side by side in one frame to produce an interesting collage of images.

These pictures are just a few examples from an extensive theme concentrating on carved stone faces – the type you find on churches, cathedrals, castles and other ancient or contemporary buildings. What started off as a short-term project is still on-going after several years, and whenever he is visiting a new location, the photographer makes a special effort to add another one or two images to the collection.
EQUIPMENT: Various 35mm SLRs, 80–210mm zoom lens, tripod
FILM: Fujichrome RFP50 and Velvia ISO50 **EXPOSURE:** *Various*

Silhouettes

A silhouette is basically the outline of a solid figure as cast by its shadow. This phenomenon was first documented by the eighteenth-century French politician Etienne de Silhouette, but it was popularised by the Victorians who used silhouettes as a form of portraiture – the outline of a person's profile would be cut from black paper and would then be mounted on a bright background.

Photographically, silhouettes are very simple to produce. All you have to do is position a solid object between the camera and a bright light source or background, then expose for the brighter background. Doing so means that the solid object – which is in shadow on the camera side – is grossly underexposed and rendered a silhouette because it is much darker than the brighter parts of the scene.

WHAT YOU NEED

Camera: A 35mm SLR is ideal for creating silhouettes, but if you use it carefully even a basic compact camera will give pleasing results.

Lenses: Any lens can be used, but telephotos are particularly useful for isolating distant subjects such as a solitary tree on the horizon at sunset.

Accessories: As you are shooting into the light you should be able to use fast shutter speeds and small apertures. However, when light levels are lower – after sunset, for example – a tripod will be necessary to keep your camera steady. A selection of warm and coloured filters will also be handy for enhancing the background of your silhouettes.

Film: Use slow-speed – ISO50–100 – film for general use, to maximise the impact and colour saturation of your silhouettes.

HOW IT'S DONE

All types of subject can be turned into striking silhouettes – people, boats, trees, buildings, statues, towers, electricity pylons, bridges, windmills, to name but a few – the list is really endless.

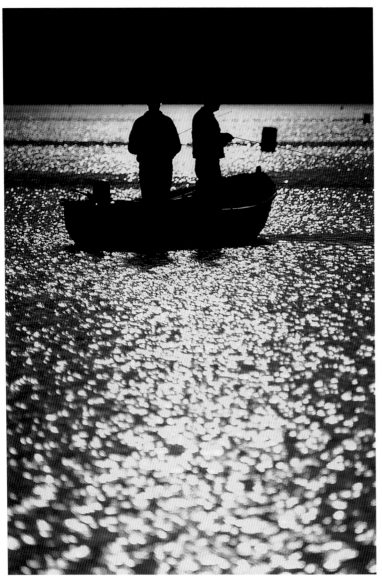

This is a classic silhouette situation – anglers on a lake with the setting sun behind them creating golden highlights on the water. Noticing the anglers in the distance, the photographer wandered along the lake shore until the shimmering highlights from the sun fell directly towards the camera. He then fitted a long telephoto lens to magnify his subjects, and an orange 85B filter to enhance the golden light. The exposure was left to the camera's integral metering system, and the picture taken in aperture priority mode.
EQUIPMENT: Olympus OM4-Ti, 400mm lens, 85B filter, tripod and cable release **FILM:** *Agfachrome 100RS rated at ISO100* **EXPOSURE:** *¹⁄₅₀₀ second at f/5.6*

The most important criterion is that it will form an easily recognisable shape when reduced to a silhouette, otherwise the appeal of the image will be lost. You should also keep the composition of your picture nice and simple, with perhaps just one or two bold objects against the background so you don't end up with a confusing muddle of overlapping forms.

The best time to shoot silhouettes outdoors is around sunrise and sunset, when the sun is very low in the sky and the sky is full of beautiful colours which will make a perfect backdrop. All you have to do then is place a solid object – such as a building or tree – between you and the sky and fire away. If the sun is very bright, hide it behind your subject so the risk of flare is reduced.

Sunlight shimmering on water during the morning and evening also makes an ideal background for silhouettes of boats, piers, bridges, surfers or people standing on the shoreline. The approach is just the same – find a position where your subject is against the bright background so that it is rendered a silhouette.

When it comes to getting the exposure right, most photographers find that their camera's integral metering system produces perfect results. This is because the meter sets an exposure that is correct for the bright background, which is exactly what you want to create a silhouette.

The only exception to this is if the background, or part of it, is very bright. At sunset, for example, the sun is often much brighter than the surrounding sky. In situations like this there is a high risk of underexposure because the intensity of the sun can fool your camera's meter. To avoid exposure error, move the camera to one side so that the sun is excluded from the viewfinder, take a meter reading, then use the exposure set for the final picture.

You should also take care if the silhouette occupies a large part of the picture area, as its dark, solid mass can again fool your camera's meter – this time into causing overexposure. The easiest way around the problem is to step beyond your subject, take a meter reading from the sky, then use the exposure obtained when you're back in position.

Finally, in some situations you may find it necessary to use a filter to make the background to your silhouette more interesting. Pictures taken at sunrise or sunset can be enhanced with an 81-series warm-up filter such as an 81C or 81D, or an orange 85-series filter which will add a golden glow to the background. This can work particularly well on pictures taken against water. Strong coloured filters can also be used to add impact to silhouettes: try blue, orange and red.

TOP TIPS

- Make sure your main subject forms an easily recognisable shape when reduced to a silhouette.
- Keep your composition simple to avoid messy, confusing images, and look for clear, clutter-free backgrounds.
- Your camera's integral metering system will give well exposed results in most situations, but you will have to take care if the background is very bright.
- Use coloured filters to brighten up dull backgrounds.

Silhouettes taken against water during the middle hours of the day tend to appear rather monochromatic, with the harshness of the sun reducing the whole scene to a series of grey tones. It therefore helps if you can add a splash of colour to liven up the scene. In this picture, the backlit windsail has done exactly that, but filters can be used just as effectively if no natural colour exists in the scene.
EQUIPMENT: Olympus OM4-Ti, 300mm telephoto lens handheld
FILM: Fujichrome Velvia ISO50 *EXPOSURE:* ¹⁄₁₀₀₀ second at f/5.6

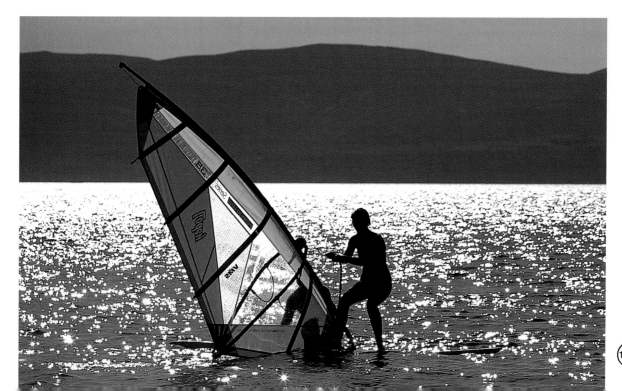

Simple Still-Lifes

till-life photography is probably one of the least popular subjects among enthusiast photographers. Some consider it to be boring and unnecessarily time-consuming; others can't see the sense in playing around with inanimate objects when they could be outdoors shooting landscapes, or capturing high action at a sporting event.

A more likely reason for avoidance, however, is the fact that still-life photography demands far more creative input from the photographer than most other subjects. With landscapes you start off with a full canvas and simply have to decide which 'bit' you want to record on film. Unfortunately, still-life photography is not like that – you begin with an empty canvas, and the success, or failure, of the images you produce is entirely reliant on your imagination and skill with composition and lighting.

To many photographers this is reason enough to avoid the subject altogether. But, once you do start to experiment with still-lifes, you'll see that it can be a rewarding and incredibly challenging discipline made as complicated or as simple as you like. Remember, too, that if you do produce a successful image, there will be no one to congratulate but yourself.

WHAT YOU NEED

Camera: Still-life photography does not have to involve complicated techniques, so a simple 35mm SLR or medium-format camera is ideal.

Lenses: The standard 50mm lens is perhaps the most useful, but a standard zoom – 28–80mm or 35–70mm – will give you more scope.

Film: Optimum image quality is generally of paramount importance, so use slow, fine-grained film of ISO50–100. Beautiful still-lifes can also be created using the subtle colours and coarse grain of super-fast film of ISO400+.

Filters: A soft-focus filter can be useful for adding a touch of atmosphere, together with 81–series warm-ups to enhance the light.

Accessories: A tripod and cable release, white reflector boards, tracing paper, cloth and brushes to clean props, background materials.

Light source: Window light can be used to great effect, but an electronic flashgun, tungsten reading lamp or slide projector can all be pressed into action.

HOW IT'S DONE

There are many ways of approaching still-life photography, and the one you choose will depend upon the amount of

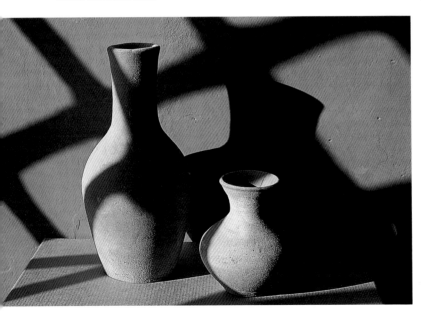

LEFT **This simple still-life image was created when the photographer noticed interesting shadow patterns being cast across the wall of his study, and realised that it would make a perfect background. As the wall was painted in a rustic terracotta colour, he decided that the two clay pots would be ideal as props, and simply placed them on a box against the wall before taking a picture.**
EQUIPMENT: *Olympus OM4-Ti, 55mm macro lens, tripod* **FILM:** *Fujichrome Velvia ISO50* **EXPOSURE:** *⅟₃₀ second at f/11*

equipment at your disposal, the time you're willing to dedicate to it, and the type of result you wish to produce.

Professional still-life photographers are renowned for extremes. If one apple is needed, an assistant will be duly despatched to the local market to buy a whole crate so the best specimen can be selected; wine is purchased by the case in the hope that one bottle will be perfect. You needn't go to such lengths, of course. Simple household items can be used as props in your still-lifes, such as a bowl of fruit, fresh vegetables, garden implements, or artist's brushes, paints and palette. Collections also make ideal subject matter – coins, stamps, old bottles, postcards, thimbles and teapots are popular examples.

This beautiful still-life study was set up on the photographer's dining room table and illuminated by the light from a window to the left of the set. The pastel-coloured background is the plain, painted wall of the room, and the sweep of white fabric, which carries the eye down to the vase of dried flowers, was created by pinning a sheet of muslin to the wall then draping it across the table. Despite the simplicity of the props and composition, the combination of soft colours, diffuse light and the coarse grain of ultra-fast film has produced an evocative, atmospheric image.

EQUIPMENT: *Olympus OM4-Ti, 85mm lens, tripod, soft-focus filter*
FILM: *Agfachrome 1000RS rated at ISO1000* **EXPOSURE:** *1/125 second at f/11*

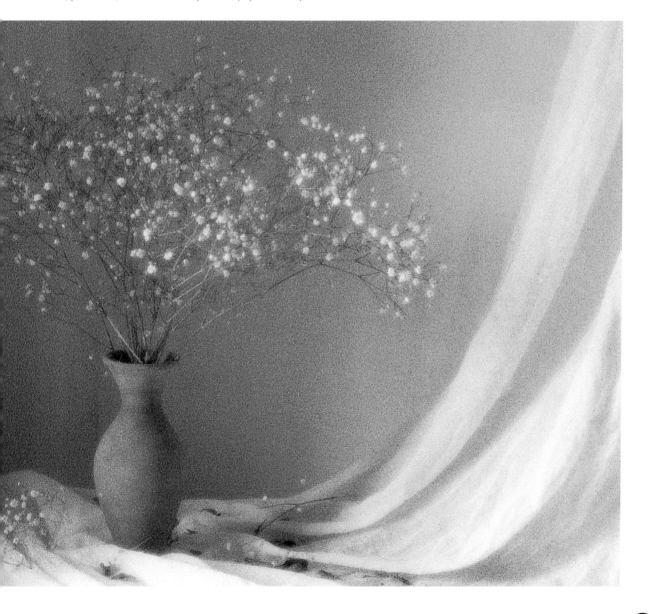

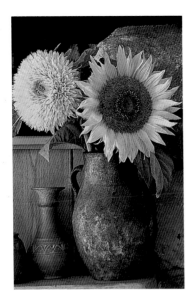

Often you don't need to plan and arrange still-life pictures – some of the most interesting results can be produced by capturing objects as you find them. These sunflowers were photographed in just that way. They had been cut a day or so earlier and placed in an old Moroccan pot on the photographer's kitchen mantelpiece. He then happened to notice how attractive the bright colours looked against the rustic, mellow stonework, and decided to commit them to film in the available window light.
EQUIPMENT: Nikon F90x Prof., 105mm macro lens, tripod
FILM: Fujichrome Velvia ISO50
EXPOSURE: 6 seconds at f/16

Alternatively, you could devise a theme, such as Christmas, the swinging sixties, your favourite colour or a specific shape, then look around for suitable objects.

The great outdoors or other locations such as your attic, garden shed or basement can be an equally rewarding source of 'found' still-lifes, which can be photographed in situ using natural light for the illumination: an old pair of muddy boots on a building site; the pattern created by terracotta plant pots stacked behind your greenhouse; cobweb-covered bottles, tins and tools on the shelves in your garden shed; a rusting plough; fishing tackle laid out on the riverbank; or seashells and pebbles on the beach.

These are just a few examples of what you're likely to discover as you search around.

Composition

Once you've decided what to photograph, the next stage is to compose the objects in an interesing way. The key to success here is simplicity. Most photographers over-complicate their still-lifes by trying to cram too many things in, and the end result is then usually a confusing muddle. A far better approach is to start off with one or two key props and concentrate on creating an interesting composition from those alone. Further objects can be added later, but only if they are relevant, and if the composition will benefit from their inclusion.

The background should be given careful consideration too, as it can make all the difference between the success and failure of a well composed still-life. Again, plain, simple backdrops tend to work best. A sheet of black card or velvet will make an uncluttered background that emphasises and sets off the objects in the still-life. To create a seamless background, bend the card or fabric so that it forms a smooth sweep, and stand the props on it. This can be achieved using a tabletop or chest of drawers placed against a wall, so that the background sweeps down onto the flat work surface.

For still-life shots of small objects, all kinds of background materials can be used. Oiled slate works well with jewellery or shiny ornaments because it emphasises the smoothness of the props, while black perspex is ideal for creating perfect reflections. Old canvas, sackcloth, the back of your leather jacket, an old denim shirt, rusting sheet metal and rough timber are also ideal – many photographers find their backgrounds in rubbish bins and scrapyards. Roughly plastered walls or sheets of timber can also be used, painted in the colour of your choice.

Fast, grainy film and a soft-focus filter were again used for this still-life composition of garlic. Despite its simplicity, the picture was planned in advance with the photographer buying the fresh garlic from a local supermarket, and a copy of a French newspaper for use as an authentic background – the idea being that the garlic had been brought home from a French market wrapped in newspaper, even though it was taken in the dining room of the photographer's home, in England! The props were illuminated by window light from one side on a dull, overcast day.
EQUIPMENT: Nikon F90x Prof., 105mm macro lens, tripod, soft-focus filter
FILM: Fujichrome RHP400 rated at ISO1600 and push-processed by two stops EXPOSURE: ⅕ second at f/11

Lighting

Next comes the most crucial job – lighting your still-life. The way in which you do this will depend on what type of equipment you have at your disposal, and the type of effect you are trying to achieve, but top-quality results can be produced with the simplest light source so don't automatically assume that you will need banks of expensive studio lights.

Daylight flooding in through the windows or skylights of your home can be used to produce all sorts of lighting effects – all you need to do is place a table close to a large window and arrange your props on it. If you shoot during late afternoon, warm, low-angle sidelighting will cast long shadows that reveal texture and form in your still-life. Or you could reduce the size of the window opening using black card, so a more directional shaft of light is created.

The diffuse light of an overcast day is perfect for atmospheric still-lifes. Use a north-facing window, which only receives reflected light, and pin a sheet of tracing paper over the window to soften the light even further. Any shadows that are cast can be controlled using reflectors.

Your portable flashgun is another handy source of illumination. If you connect the gun to your camera with a long sync lead it can be used in different positions around the props to create a range of lighting effects. To simulate window light using flash, construct a diffusion screen from a timber frame and tracing paper, place it a metre or so away from the side of your still-life and fire the flashgun through it to produce diffuse illumination. Alternatively, make a softbox for your flashgun by painting the inside of a cardboard box white, fitting the flashgun inside, then taping a sheet of tracing paper over one open end. It may look a little crude, but you'll be surprised how effective such an accessory can be.

The action-stopping ability of your flashgun is also worth exploiting. If you use a sheet of opal perspex as a backdrop, and place the flashgun behind it, pointing towards the camera, the

Backlighting is an exciting technique to use with translucent objects such as glasses of wine, coloured bottles, and so on. To produce this simple, graphic image, a large softbox was fitted to a studio flash unit. A sheet of black card was then used to cover the central third of the softbox and effectively divide it into two strips of light, one on either side of the card. The glass of red wine was placed about a metre in front of the black card so that the strips of uncovered softbox rim-lit the edges of the glass and its stem, and the picture was taken in a darkened room so the glass didn't pick up reflections from other objects near it. Calculating the correct exposure was tricky, so the photographer took a series of pictures at apertures from f/5.6 to f/16, reducing the aperture by half a stop for each shot. This was one of the most successful frames, as the aperture used – f/11 – ensured that the rim-lighting effect on the glass was revealed, without the flash penetrating the wine in the glass.
EQUIPMENT: *Nikon F90x Prof., 105mm macro lens, studio flash unit and softbox, black card, tripod* ***FILM:*** *Fujichrome Velvia ISO50* ***EXPOSURE:*** *¹⁄₆₀ second at f/11*

If you keep your eyes peeled, it's also possible to come across interesting 'found' still-life subjects outdoors, like this pair of old hiking boots on the floor of the photographer's garage. Normally they wouldn't have demanded a second glance, but with evening sunlight raking through a window, casting long shadows and revealing texture in the worn leather, they suddenly made a fascinating subject – at least worthy of a few frames of film at the end of a roll. As the boots were black, the photographer decided that black and white film would enhance their graphic simplicity. After printing, the image was toned in sepia to add a pleasing warmth.

EQUIPMENT: Olympus OM1n, 50mm standard lens *FILM:* Ilford HP5 rated at ISO400 *EXPOSURE:* 1/125 second at f/8

brief burst of light can be used to freeze water being poured from a bottle, or the splash of ice cubes dropped into a glass.

If you don't have a flashgun, a simple angle-poise reading lamp can be used. The tungsten bulb in it will give pictures which are taken on normal daylight-balanced colour film a yellow/orange colour cast because the colour temperature of the light is very low, but this in itself can add a beautiful warm glow to your still-lifes. If you want to avoid the colour cast, place a blue 80A filter on your lens, or use tungsten-balanced colour transparency film such as Fujichrome 64T. With black and white film, of course, you don't have to worry about colour casts at all.

The light from a reading lamp can be quite harsh, so keep it a metre or two away from your props and perhaps diffuse the light

with a tracing paper screen – again kept well away from the bulb, which gets very hot.

Alternatively, the powerful light from a slide projector can be used to illuminate still-lifes. It isn't quite as versatile as the other sources mentioned, but it's ideal to use at low level to create glancing light that casts long shadows and reveals texture.

LIGHTING DIRECTION

The way you position your light source in relation to the still-life composition will also have a great influence on the type of picture you end up with.

Frontal lighting is ideal for revealing the colour of an object, but because shadows fall behind the props you use the results tend to look flat and lack modelling. Shadows become more evident as you move the light to the side.

Sidelighting produces very bold, dramatic results. Shadows become an integral part of the composition, revealing texture and form to give your still-lifes a strong three-dimensional feel.

One light diffused with a softbox and placed to the side of the still-life will produce an effect similar to window light on an overcast day. Often this is all you need to light your still-life.

Backlighting a still-life by positioning the light source behind the props and pointing it towards the camera will render solid objects as silhouettes, while translucent or transparent materials such as glass or plastic will take on a wonderful luminosity, as shown in the picture above right.

LEFT **Often, interesting still-life pictures can materialise literally out of nowhere. This shot, for example, was created when the photographer noticed beautiful colours in the twilight sky through his kitchen window, and quickly arranged a selection of old bottles on the windowsill. Shooting from a low angle meant that the bottles were backlit by the sky, and the exposure set by the camera gave a perfect result.**
EQUIPMENT: *Olympus OM2, 50mm standard lens and +2 dioptre close-up attachment, tripod* **FILM:** *Kodak Ektachrome 64*
EXPOSURE: *⅕ second at f/8*

BELOW **With a little imagination it's surprising what can be used as the basis of an interesting still-life picture. Here the photographer placed four fresh herrings side by side so their shiny skin created a simple background, then positioned a fifth herring on top. The fish were lit with a single studio flash unit fitted with a softbox to produce even, diffuse illumination. After the film was processed, the chosen slide was then copied onto a sheet of Polaroid Type 669 instant film, and the image transferred onto watercolour paper to produce the impressionistic effect (see page 72).**
EQUIPMENT: *Nikon F90x Prof., 105mm macro lens, studio flash and softbox, Vivitar slide copier, watercolour paper* **FILM:** *Fujichrome Velvia ISO50 for original image, then Polaroid Type 669*
EXPOSURE: *1⁄60 second at f/11 for original slide*

Attractive rim-lighting can also be obtained when the light source is positioned behind your subject. If you backlight a bottle of red wine, for example, very little light will actually pass through the wine itself, but the outline of the bottle will be revealed as a fine white line.

Top-lighting is popular with still-life photographers. Usually the light is diffused using a large softbox attachment known as a 'fish fryer' or 'swimming pool', which is suspended above the tabletop set-up. You could make one using a wooden frame with two or three sheets of tracing paper stapled to it.

If you don't want any obvious shadows in the picture, stand the props on a white or light-toned surface, so that the light is reflected upwards.

TOP TIPS

• Patience, creativity and imagination are the three most important aspects of still-life photography – you have to create the picture before you can take it, instead of simply shooting what's already there.

• Choose your props carefully so that they relate to each other, and so they form an attractive composition.

• Still-life photography has no time limit, so never rush a shot.

You can leave the props in position for days if necessary, while you experiment with different compositions and lighting set-ups or work on different ideas with the same objects.

• Keep your eyes peeled for interesting objects while you're out and about, or browsing through junk shops and car boot sales, and gradually build up a collection of props that can be used in future still-lifes.

• Remember to keep things simple. If you over-complicate a composition it will lose impact and create confusion.

Slow-Sync Flash

The aim of this exciting technique is to combine a burst of electronic flash with a slow shutter speed/long exposure. At its simplest, doing so allows you to take pictures that have a flash-lit foreground against a low-light scene – such as a person standing in front of a floodlit building at night, or an upturned boat on a beach at sunset.

However, the technique is more commonly used to create dramatic action pictures of moving subjects – the brief burst of flash will freeze the fastest subject while the slow shutter speed causes that subject to blur. The end result is a picture where your subject is frozen and blurred at the same time to give an effective feeling of movement, even if they're moving relatively slowly.

WHAT YOU NEED

Camera: Some modern compact cameras have a slow-sync flash mode which automatically combines a burst of flash with a slow shutter speed. However, for the best results, use a 35mm SLR with a hotshoe-mounted flashgun, so you have more control over the flash/ambient light combination.

Lenses: Shorter focal lengths tend to be used – from 28mm wide-angle to 50mm standard. This is not essential, but the power of most flashguns is relatively limited so you need to photograph close-range subjects.

ABOVE **This humorous shot was set up specifically to show the dramatic effect slow-sync flash can have. All the photographer did was ask his subject to run towards the camera waving his arms, so there was plenty of motion. When he reached a predetermined point, the photographer tripped the camera's shutter, triggering the flash and securing the image.**
EQUIPMENT: Olympus OM2n, 28mm wide-angle lens, Vivitar 283 automatic flashgun **FILM:** *Fujichrome RFP50 ISO50*
EXPOSURE: ¹⁄₁₅ second at f/11

LEFT **Another example of slow-sync flash used to dramatic effect at a moto-cross event. The photographer chose a corner on the circuit next to a large puddle, knowing that the motorcyclists would splash through and create a lot of spray. By standing very close he was able to take a series of shots which 'froze' both the rider and muddy water, while the background was blurred by panning the camera.**
EQUIPMENT: Olympus OM4-Ti, 28mm lens, Olympus T45 flashgun
FILM: Fujichrome Velvia ISO50 **EXPOSURE:** *⅛ second at f/11*

Flashgun: Any type of electronic flashgun can be used, but the type you choose – automatic or dedicated – will influence the way the technique is carried out.

Film: Slow-speed film – ISO50–100 – is ideal for slow-sync flash. If you use fast film you may not be able to set a shutter speed that's slow enough to give a good effect.

HOW IT'S DONE
With an automatic flashgun

1 Set your camera to aperture priority, so that you can select the aperture of your choice while the camera automatically sets the correct shutter speed to record the ambient (existing) light. Selecting a small aperture – f/11 or f/16 – will help to ensure that the camera sets a slow shutter speed in daylight – anything from ⅟₃₀ to ¼ second will give a strong effect with moving subjects. If you are using the technique at night or in low light, the exposure time is unimportant so you can use whatever shutter speed the camera sets.

2 To get the right balance between ambient light and flash, a ratio of 1:2 is normally used. This is achieved by setting the auto aperture scale on your flashgun one stop wider than the aperture set on the lens. So, if you've set f/11 on the lens, set f/8 on the flashgun using the auto aperture dial or switch.

3 To emphasise the slow-sync effect on moving subjects, track your subject by panning the camera, and trip the shutter while panning. This will increase the blur in the background and produce dramatic, action-packed images.

If you are using the technique to illuminate a foreground subject in front of a floodlit or low-light scene, mount your camera on a tripod to keep it steady.

With a dedicated flashgun

1 Set your camera to shutter priority mode. This means that you can select the shutter speed required and prevent the camera automatically selecting the correct flash sync speed, which is too fast to produce a good effect.

2 In shutter priority mode the camera automatically sets the correct lens aperture. As it is the aperture and not the shutter speed that controls the flash exposure, you can just fire away because dedicated flashguns automatically output the correct amount of light for the lens aperture set. All you have to do then is follow step 3 above and start shooting!

TOP TIPS

• Use slow-sync flash to create dramatic pictures of everyday subjects, such as your pet dog running around, kids on their bicycles, joggers in the park and so on.

• To make your pictures even more unusual, you could place a coloured filter on your flashgun so any subjects lit by the flash will take on the colour of the filter.

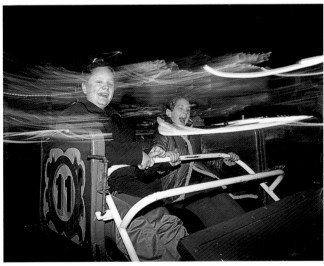

Using slow-sync flash at fairgrounds is a great way to capture the fun and excitement of the rides. This shot was taken by panning the camera as the people approached, then tripping the shutter as they passed. The flash has frozen them, while a slow shutter speed recorded the lights in the background as colourful trails.
EQUIPMENT: Olympus OM4-Ti, 28mm lens, Vivitar 283 flashgun
FILM: Fujichrome Velvia ISO50 EXPOSURE: ¼ second at f/5.6

Soft-Focus Effects

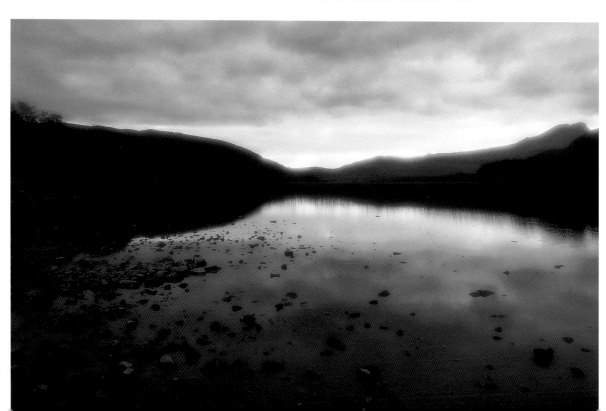

Photographers today seem to have an obsession with sharp images. Slow film is chosen to record the finest detail and minimise image grain, and modern multi-coated lenses are purchased to maximise clarity and sharpness. However, sometimes a picture can be enhanced greatly if that biting sharpness is subdued by the addition of a little diffusion, which makes highlights and shadows blend gently together, masks fine detail and heightens the mood of the image to give it a pleasing romantic quality.

This effect, commonly known as soft focus, can be created in a number of ways and used successfully on a variety of subjects. Portrait photographers often use soft focus to suppress spots

A surreal glow has been added to this lake scene by holding the frosted half of an anti-newton glass slide mount in front of the lens. This technique creates a strong form of diffusion without making the final image look misty or 'washed-out' and is a favourite of many photographers – especially for landscapes. The metered exposure was also increased by one stop to lighten the tones in the scene and to emphasise the glow on the horizon where the brightness of the sky meets the darkness of the distant hills.
EQUIPMENT: Nikon F90x Prof., 28mm wide-angle lens
FILM: Fujichrome Velvia ISO50 ***EXPOSURE:*** *¹/₆₀ second at f/11*

A purpose-made soft-focus filter from the popular Cokin range – a Diffuser 1 – was used on this Spanish street scene, which the photographer shot from a hotel balcony. The filter was chosen to add a gentle diffusion to the image and reduce the 'grittiness' of the grain. This helped to enhance the pastel colours in the scene and give the picture a gentle, romantic quality. Setting the lens to a small aperture also helped to minimise the strength of the diffusion.
EQUIPMENT: Olympus OM4-Ti, 180mm telephoto lens, Cokin Diffuser 1 filter, tripod, cable release ***FILM:*** *Agfachrome RS1000 rated at ISO1000*
EXPOSURE: *¹/₂₅₀ second at f/11*

and blemishes and make a person's skin look more attractive, for example. Equally, it can be partnered with fast, grainy film to produce beautiful painterly images (see page 66), or to enhance landscapes, still-life shots and nude studies shot on normal film, in both colour and black and white.

WHAT YOU NEED

Camera: A camera which offers direct viewing through the lens, such as a 35mm SLR, is the best choice when experimenting with soft-focus filters, as it allows you to see the effect the filter will have on the final image.

Lenses: Soft-focus effects can be created with any lens – some manufacturers even produce specialist soft-focus lenses for photographers who use the effect on a regular basis.

HOW IT'S DONE

The easiest way to add soft focus to your pictures is by purchasing a purpose-made soft-focus filter, also called a diffuser or 'softar' by some manufacturers. The effect obtained varies enormously from brand to brand: some are very strong, others weak, and you may find it necessary to purchase a variety so you can produce different effects.

Alternatively, you can make your own using simple materials. If you smear a tiny amount of petroleum jelly onto a piece of clear plastic or an old Skylight filter, for example, you can create all kinds of unusual soft-focus effects – just smear different patterns into the jelly with your finger or a cotton bud to transform the effect. You need to use the jelly sparingly, however, as even a small amount can distort the image beyond recognition – which itself can produce appealing results if you are aiming for a more abstract approach.

Another simple method is to use the frosted half of a medium-format anti-newton glass slide mount – a 6x6cm GePe mount is ideal, and can be purchased from most good photographic dealers. All you have to do is hold the mount in front of your lens, or, better still, make a cardboard mount so you can slot it into your filter holder.

Basically, any clear or slightly frosted material can be used as a soft-focus filter, so experiment with plastic sweet wrappers, food wrap, a piece of stocking stretched over your lens, and so on. This latter method was common in the movie industry during the 1940s as it gives a very subtle effect, and one which you can vary by using different 'deniers' (the grading used for stockings) and colours. For instance, flesh-coloured stockings are ideal for portraiture as they add an attractive warmth to the image which will enhance your subject's skin tones. Even breathing on your lens can be used to good effect if you wait for the 'mist' to clear a little before taking any pictures.

If your camera has a multiple exposure facility you can create soft-focus images without using a filter. First, focus on your subject and take a picture with the correct exposure reduced by one stop. Next, slightly de-focus the lens so that your subject is out of focus, then take a second picture on the same frame of film, again with the correct exposure reduced by one stop. The end result will be an unusual effect where the sharply focused subject or scene is surrounded by a delicate glow created by the out-of-focus image. Some modern SLRs even have this facility built in, with two pictures being taken simultaneously on the same frame of film.

Soft-focus effects can also be created in the darkroom while printing colour or black and white pictures – all you have to do is hold a soft-focus filter under the enlarger lens during exposure. If

For this beautiful portrait of the author's baby son, a very gentle level of diffusion was used – just enough to soften the baby's skin tones a little and heighten the overall mood of the picture. The subject was lit with a single flash unit fitted with a large softbox.
EQUIPMENT: *Pentax 67, 165mm lens, Cokin Diffuser 1 filter*
FILM: *Fujichrome Provia 100* **EXPOSURE:** *¹⁄₃₀ second at f/16*

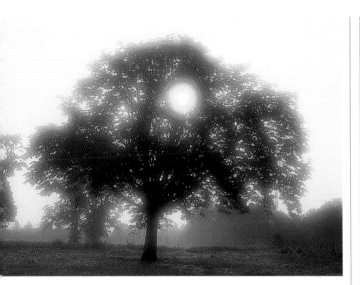

This dreamy image shows how soft-focus filters are particularly effective when used on backlit scenes and subjects. In this case the photographer exposed for the mid-tones, by taking a spot reading from the sunlit grass. This in turn meant that the bright background burned out, so light appears to 'bleed' through the branches of the tree, producing a very atmospheric effect. The soft-focus filter used was again the frosted half of an anti-newton glass slide mount.
EQUIPMENT: Olympus OM4-Ti, 28mm wide-angle lens, glass slide mount *FILM:* Fujichrome Velvia ISO50 *EXPOSURE:* $\frac{1}{125}$ second at f/11

you add soft focus at the taking stage, the highlights bleed into the shadow areas of the image. However, if you add soft focus at the printing stage, the shadows bleed into the highlights and the effect looks quite different.

To vary the strength of diffusion when using a soft-focus filter on your lens, adjust the aperture setting. Wide apertures such as f/2.8 and f/4 give maximum diffusion, whereas smaller apertures such as f/11 and f/16 reduce the effect of the filter and produce much weaker soft focus.

Finally, subjects that are backlit tend to show soft-focus effects the best due to the way the highlights and shadows merge, or 'bleed', into one another. If you photograph a subject against a dark or black background, for example, a faint halo will be created around it which the background emphasises. Woodland scenes with light passing through the branches also respond well to the soft-focus treatment.

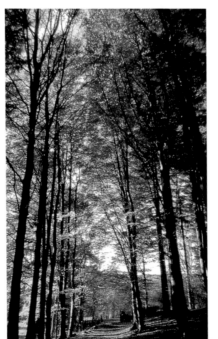

LEFT **This autumnal woodland scene, captured in North Wales, looks more like a watercolour painting than a photograph thanks to the use of a strong soft-focus filter – a Cokin Diffuser 2 – and gentle backlighting which has emphasised the vibrant colours of the leaves. Strong diffusers should be used with care as they can easily spoil an image. However, when partnered with the right type of scene the result can be beautiful. When taking pictures in such lighting conditions you should also meter carefully, because the bright background can easily cause underexposure. To avoid this the photographer increased the metered exposure by a full stop using his camera's exposure compensation facility.**
EQUIPMENT: Olympus OM2n, 28mm wide-angle lens, Cokin Diffuser 2 *FILM:* Fujichrome Velvia ISO50 *EXPOSURE:* $\frac{1}{30}$ second at f/11

TOP TIPS

• Soft focus subdues fine detail, so take care when using it on subjects which rely on this for their appeal.
• Colour saturation will be slightly reduced too, so if you photograph a scene containing strong colours, don't expect them to look as strong on the final image.
• With home-made soft-focus filters, cut a small hole in the centre so part of the image will be rendered sharp while the area around it shows the soft-focus effect.
• When shooting backlit subjects and scenes, overexpose your pictures slightly – by a half-stop – to make the bright background burn out a little and to enhance the romantic feel of the image.
• Like any effect, soft focus can become a little tiresome if you over-use it.
• When adding soft focus to an image at the printing stage, you can minimise the effect by only holding the filter under the enlarger lens for part of the exposure.

BELOW **Although you can use a soft-focus filter on your lens when shooting black and white film, it's much better to add soft focus at the printing stage instead; in this way you can control the level of diffusion, and make prints from the same negative with no soft focus at all if you like. If you do this, you may find it necessary to increase the contrast grade of the paper by a full grade over what you would normally use. This is because the addition of diffusion tends to suppress the tonal range of the print and can result in rather insipid results. Increasing the contrast grade also increases image contrast to maintain rich blacks in the shadows. Here, the soft-focus print was also split sepia toned to add an attractive warmth to the image (see page 140).**
EQUIPMENT: *Olympus OM1n, 28mm wide-angle lens* **FILM:** *Kodak T-Max 400 rated at ISO1600* **EXPOSURE:** *¹⁄₂₅₀ second at f/16*

ABOVE **This simple picture was taken in the English city of Cambridge, a place famous for its university, ancient architecture – and rusty old bicycles that appear at every turn. To create the soft-focus effect the photographer smeared a tiny amount of petroleum jelly on to a piece of glass and held it in front of the lens. The result is a beautiful, evocative image that symbolises the bohemian feel of the place.**
EQUIPMENT: *Olympus OM4-Ti, 28mm wide-angle lens, home-made soft-focus filter*
FILM: *Agfachrome 1000RS rated at ISO1000* **EXPOSURE:** *¹⁄₆₀ second at f/8*

Stained Glass Windows

If you wander into a church or cathedral in any town or city throughout the world, one of the most striking features you are likely to encounter are beautiful stained glass windows, fashioned from brightly coloured glass in all kinds of intricate designs. In older buildings the ancient windows usually depict biblical scenes or remember local saints and legends, while in modern religious establishments it's more common to find contemporary abstract designs with a spiritual theme.

WHAT YOU NEED

Camera: Any type of camera can be used to photograph stained glass windows, including 35mm compacts.

Lenses: Anything from a 28mm wide-angle to a 200mm telephoto will prove useful, depending on how big the window is, how close you can get to it and how much of it you want to record.

Accessories: Light levels inside churches and cathedrals are usually quite low, so a tripod will be essential to support your camera and keep it steady while using slow shutter speeds.

Film: Use slow-speed film (ISO50–100) to record the stunning colours in the stained glass with maximum saturation.

HOW IT'S DONE

Slightly overcast weather tends to provide the best conditions for photographing stained glass windows. This is because the contrast of the light is much lower than in bright sunlight, so the colours in the glass tend to look stronger. Windows that are not directly lit also tend to produce better pictures because the light entering through them is softer and more even.

Once you have chosen an interesting window, mount your camera on a tripod and decide how you want to record the stained glass. Use a wide-angle or standard lens to capture the whole window, or switch to a moderate telephoto and concentrate on just part of the design. This latter approach is usually the most successful, as it is much easier to appreciate the intricate detail and wonderful colours in selective compositions. If you include the whole window you may find that the designs and patterns are too small in the final picture to really appreciate.

Once you have decided on the composition, set your camera to aperture priority mode, stop the lens aperture down to f/8 or f/11, then prepare to take your picture. Shutter speeds tend to be quite slow because of the low light levels, so it's worth using a cable release to trip the camera's shutter.

As the tonal range in a stained glass window is usually quite even, you should find that your camera's metering system will give perfectly exposed results with no adjustment. That said, if you're using colour transparency (slide) film which requires a high degree of exposure accuracy, it's always worth bracketing half a stop under and over the metered exposure (see page 14).

When you have taken your first picture, consider other options – perhaps capturing a different part of the window, or using filters to enhance the results. A soft-focus filter gives an attractive effect on shots of stained glass, adding a delicate glow to the image.

TOP TIPS

• Most churches and cathedrals allow photography inside, though you may need to ask permission to use a tripod.
• Try 'zooming' your lens through its focal length range to turn stained glass windows into eye-catching abstract images (see page 158).
• Never stand on the church pews or seats or rest your tripod legs on them, otherwise you could be asked to stop taking pictures altogether.
• As well as photographing the windows, take a few shots of the coloured patterns created on the floor when light shines through the glass.

LEFT **Here a soft-focus filter was used to add a delicate glow to the image and slightly diffuse the highlights into the shadows. The photographer also decided to include the carved stone window frame, knowing it would record as a silhouette and help to show off the window itself.**
EQUIPMENT: Olympus OM4-Ti, 50mm standard lens, tripod, cable release, soft-focus filter **FILM:** *Fujichrome RFP50 ISO50*

RIGHT **This colourful stained glass window was captured in the village where the photographer was born. The local church is almost 900 years old, and the ornate windows date back hundreds of years – a testament, if you'll excuse the pun, to the skills of the craftsmen who made them. Photographed on an overcast day, the colours in the north-facing window have been revealed at their best, with every detail.**
EQUIPMENT: Olympus OM1n, 50mm standard lens, tripod, cable release **FILM:** *Agfachrome CT18 ISO50* **EXPOSURE:** *1/15 second at f/11*

Stormy Weather

Although bright sunshine and brilliant blue skies may make landscape photography comfortable and convenient, if you want to produce dramatic, exciting images you need to brave the elements and spend time exploring the countryside in less desirable weather conditions.

The most rewarding photo opportunities tend to occur on stormy days, when the wind sends dark, heavy clouds rushing across the sky and every once in a while allows rays of sunlight to burst through and illuminate the landscape below. This combination of a sunlit scene against a brooding sky can produce amazing images, and if rain happens to fall at the same time you may also have the chance to capture a colourful rainbow arcing across the countryside.

Mist, fog, frost, snow and all the other things that most people associate with so-called 'bad' weather are also ideal for creating dramatic pictures.

Many photographers avoid such conditions, as they offer no guarantee of success and days can pass before a single picture is taken. However, where landscape photography is concerned you have to speculate to accumulate, and unless you make the effort to brave the weather you'll never find yourself in the right place at exactly the right time.

WHAT YOU NEED

Camera: Any type of camera is suitable for landscape photography. The most important factor is that you can operate it quickly, as the light tends to change without warning in stormy weather and you may only have a few seconds to grab a picture.

Lenses: A wide-angle lens with a focal length of 24mm or 28mm is ideal for capturing sweeping views and emphasising foreground interest to give your landscape pictures depth and scale. Telephotos from 85–300mm are also useful for isolating parts of a scene, or capturing distant hills on the horizon.

Accessories: In strong winds a tripod is recommended for keeping your camera steady – especially when using a telephoto lens. You may also need to increase its stability by hanging your gadget bag over it. A grey graduated filter will be invaluable for darkening the sky to make it look as dramatic as possible, plus an 81B or 81C warm-up filter to enhance the light. Finally, if you're taking pictures in the rain it's a good idea to shield your camera and lens using a large polythene bag.

Film: Use slow-speed film (ISO50–100) to maximise image quality and colour saturation. Ultra-fast film can also be used to produce graphic, grainy images in colour or black and white, and to give high shutter speeds in low light if you don't have a tripod.

Stormy weather is also suited to black and white film, and by manipulating the image in the darkroom it's possible to emphasise the drama of the original scene. This picture was taken from the roadside, using a telephoto lens to home in on the distant hills and the shafts of sunlight breaking through the stormy sky. The camera was set to aperture priority mode and the exposure was left to the camera's integral metering system. At the printing stage, the photographer burned in the sky to ensure that plenty of detail was recorded, then sepia-toned the print to add a pleasing warmth to the image.
EQUIPMENT: Olympus OM4-Ti, 180mm telephoto lens FILM: Fuji Neopan 1600 rated at ISO1600 EXPOSURE: $\frac{1}{250}$ second at f/11

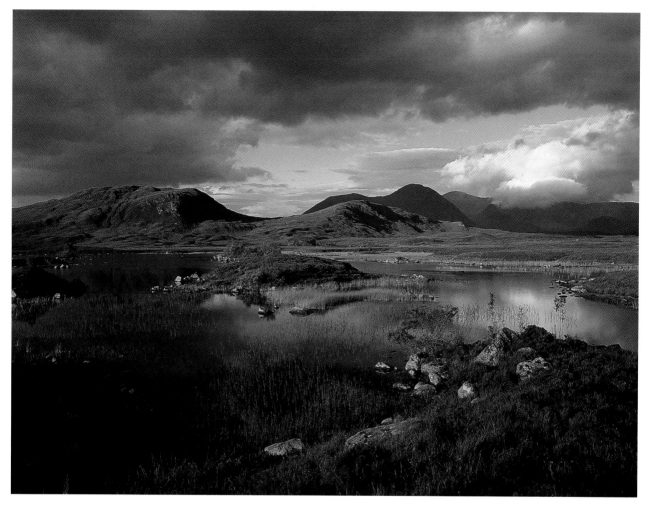

HOW IT'S DONE

The main problem with stormy weather is that light levels tend to change very quickly. One minute the sky can be covered by thick cloud, and the next minute rays of sunlight suddenly burst through. This means you need to take full control of what you're doing – especially when determining the correct exposure.

The key is to be prepared. If you come across an interesting scene and there's a chance the weather could break, set up your camera on a tripod, compose the picture you want to take, focus, set a small lens aperture – f/11 or f/16 – and then wait.

Sometimes you may only need to wait for a couple of minutes, at others an hour or more. However, being patient at this stage is crucial as you can guarantee that the minute you pack away your equipment, the weather will momentarily break and you'll miss the opportunity.

If you look at the sky it's often possible to predict when a break is likely. Usually you can see the pale disc of the sun behind the clouds. All you have to do then is note the direction the

This dramatic picture of Rannoch Moor in Scotland was a result of both luck and judgement. While driving along a road that skirts the moor during early morning, the photographer sensed that a break in the weather was imminent and decided to stay for a while just in case his prediction came true. After finding a convenient lay-by for the car, he mounted his camera on a tripod, composed the scene, placed a two-stop (0.6) grey graduated filter on the lens and waited. Moments later, sunlight burst through from behind, illuminating the moorland scene. An incident light reading was quickly taken using a handheld meter, the exposure set on the camera and the picture taken. This process was repeated for an hour or more, with the sun appearing for a few seconds each time before being obscured by cloud again. On each occasion the photographer managed to fire off two or three frames of film, and by the end of it had produced over twenty correctly exposed pictures, each slightly different to the last.

EQUIPMENT: Pentax 67, 55mm wide-angle lens, 2-stop grey graduated filter, tripod and cable release, Minolta Autometer IVF handheld meter
FILM: Fujichrome Velvia ISO50 **EXPOSURE:** *¹/₁₅ second at f/16*

clouds are blowing, and look for a gap in the distance. Before too long that gap should pass over the sun, and sunlight will be able to shine through.

Exposure

The crucial factor now is to get the exposure right, and there are various ways of doing this.

1 If the sun is behind you, you should be able to take perfectly exposed pictures by relying on your camera's integral metering system. Just switch the camera to aperture priority mode, so that the shutter speed will be set automatically, and start shooting. If your camera has a spot metering mode, you could use it to take a meter reading from the sunlit foreground.

2 If you're shooting into the sun the sky will be very bright and could cause underexposure. To prevent this, set your camera to manual exposure mode, tilt it down to exclude the sky from the viewfinder, take a meter reading direct from the sunlit foreground and use the exposure when you re-compose.

If you intend to use a grey graduated filter, which you probably will in this kind of situation to prevent the sky from burning out, take the meter reading without the filter in place, then once you've set the exposure, align the filter.

3 If you have a handheld meter, a much quicker method is to set up the shot with the graduated filter on your lens. Then, when the sun breaks through, take an incident reading of the light

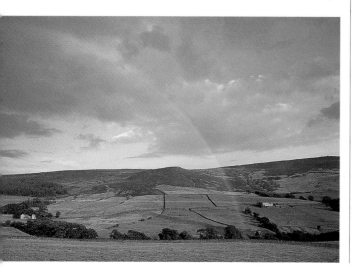

ABOVE **This simple image, taken in the Moroccan town of Tafraoute, owes its appeal to the golden evening sunlight flooding over the distant hills and making them stand out boldly against the sky. After a long day in the mountains, the weather took a turn for the worse so the photographer decided to retire to the roof of his hotel, where he could relax and enjoy a clear view over the dusty town. As the sun sank towards the horizon, however, it suddenly appeared through a gap in the clouds, and on turning around he noticed sunlight striking the sandstone mountains behind him. This only lasted for a minute, but with a camera to hand he managed to shoot off a roll of film before the sun finally set, resting the lens on the top of a wall to prevent camera-shake. The exposure was determined by taking a spot meter reading from the sunlit hills.**
EQUIPMENT: *Nikon F90x Prof., 80–200mm f/2.8 zoom at 150mm*
FILM: *Fujichrome Velvia ISO50* **EXPOSURE:** *1/30 second at f/8*

LEFT **If sunlight breaks through during rainfall, there's a strong chance that a rainbow will be created by light passing through the falling raindrops. The photographer spotted this scene while driving through a terrible storm in North Yorkshire, and despite the deluge just couldn't resist stopping to record it on film. As the rain was so heavy he had to protect himself and the camera, so the picture was taken by holding the camera in one hand – there was no time to set up a tripod – and a large golfer's umbrella in the other! It's at times like this that a motor-driven camera is invaluable.**
EQUIPMENT: *Nikon F90x Prof., 28mm wide-angle lens*
FILM: *Fujichrome Velvia ISO50* **EXPOSURE:** *1/60 second at f/5.6*

falling on the landscape, set the exposure on your camera (which should be in manual mode) and take the picture.

As your experience grows, you will know exactly which method to use so that a correctly exposed picture is obtained. With any luck the sun will also stay out long enough so you can bracket exposures over and under the initial reading and further increase your chances of success.

When photographing rainbows a similar approach can be used, though you may not need to use a grey graduated filter. It's also a good idea to underexpose the shots slightly so the colours in the rainbow stand out against the dark sky.

TOP TIPS

• When you're outdoors in stormy weather, always have your camera ready for use – some of the best landscape pictures are taken completely by chance.

• Remember to protect yourself as well as your camera equipment – wear warm, waterproof clothing so that you remain dry and comfortable no matter how bad the weather gets.

• When the weather looks bad, don't just stare through your kitchen window wishing it would get better: grab your camera and go out. When it comes to landscape photography, the more chances you take the luckier you tend to be.

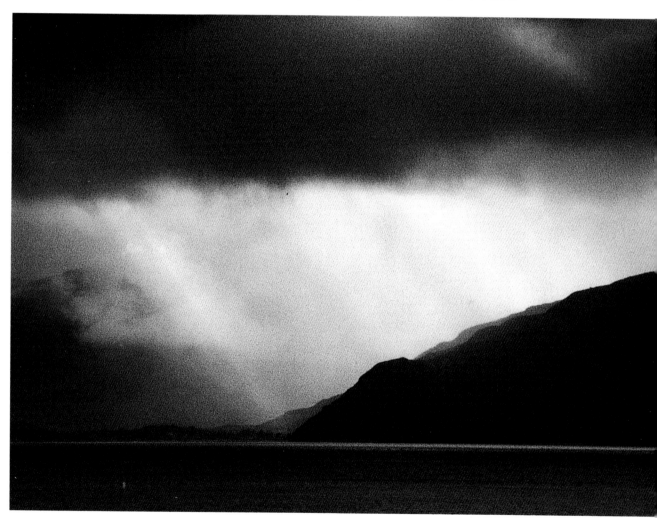

When the heart of a storm is some distance away, use a telephoto lens to magnify the most dramatic part of the scene. This picture was taken in such conditions; the scenery around the photographer was relatively uninteresting, but on the far shore of the lake rays of sunlight were spilling from the dark sky. To emphasise the darkness of the shadowy hills, the photographer left the exposure to his camera's integral metering system, knowing that the bright patch of light would cause underexposure – which is exactly what he wanted.
EQUIPMENT: *Olympus OM2n, 300mm telephoto lens* ***FILM:*** *Fujichrome P800/3200 rated at ISO1600* ***EXPOSURE:*** *¹/₂₅₀ second at f/8*

Sunsets

There are few sights more breathtaking than the sun's golden orb sinking towards the horizon, filling the sky with vibrant colours and creating beautiful reflections in lakes and rivers. In the northern hemisphere the sun sets slightly north of west during summer and slightly south of west during winter. In the southern hemisphere it sets slightly south of west in summer and north of west in winter. The time at which sunset

The photographer discovered this scene during late afternoon, and knew that at sunset the warm glow in the sky would be reflected in the meandering river. Returning just before sunset, he composed the picture and waited until the light was perfect. The exposure was determined using his camera's integral metering system, and no adjustment was made to the reading obtained.
EQUIPMENT: Pentax 67, 165mm lens, 81C warm-up filter, tripod, cable release **FILM:** *Fujichrome Velvia ISO50* **EXPOSURE:** *1/30 second at f/16*

occurs depends on the season of the year. In western Europe and the northern USA, use the following times as a guide:

• Summer	8–9pm
• Spring and autumn	6–7pm
• Winter	4–5pm

The type of location you're in will also influence the time at which the sun actually disappears from view. In relatively flat areas and by the sea, for example, you will be able to watch the sun sink all the way to the horizon, but if you're looking west towards hills, mountains or tall buildings in urban areas, the sun will disappear from view some time before it finally sets.

Equally important are prevailing weather conditions. The most dramatic sunsets tend to occur on days when there's broken cloud in the sky to pick up reflected light from the sun once it has disappeared beneath the horizon. However, when heavy cloud is present you may not see the sun at all, and as it sets, little or no trace is left behind to make photography worthwhile. Similarly, on clear, cloudless the days the sun is often very intense until it sinks beneath the horizon, making inclusion of the sun's orb in a photograph tricky due to the risk of flare. In such conditions, the setting sun also tends to have little effect on the sky, and results can appear rather bland.

WHAT YOU NEED

Camera: Any type can be used to take successful sunset pictures, though a 35mm SLR is more versatile because it gives you control over lens choice and exposure, the latter being particularly important for producing consistent results.

Lenses: The focal length you use will be determined by the type of picture you wish to take. For sweeping views, a moderate wide-angle lens around 28mm will be a good choice, but this will record the sun's orb as nothing more than a pin prick.

If you want to make more of a feature of the sun, a telephoto or telezoom lens should be used to isolate a small area of a scene and enlarge the size of the sun's orb to produce simple, dramatic images. The longer the focal length is, the bigger the sun will be – a 300mm or 400mm is ideal.

HOW IT'S DONE

The first step is to ensure that you reach your chosen location well before sunset occurs, allowing you time to seek out the best viewpoint, set up your equipment and compose the picture. If you are unsure about where to go, check a map of the area

or ask a local. If you watch the movement of the sun during the morning and early afternoon, it's usually quite simple to predict where sunset is likely to occur.

Locations containing water are always a good choice, especially in calm weather, as the colours in the sky will be reflected to give the whole scene a colourful glow. Trees, windmills, buildings, boats, statues, people and other subjects can also be included in the foreground as they will record as a strong silhouette with the sun setting behind.

When it comes to determining the correct exposure, sunsets are relatively straightforward. If you can look at the sun without squinting, your camera's integral meter should give an accurate exposure simply by taking a general TTL meter reading. However, if the sun is very bright, it's a good idea to take a meter reading from an area of sky with the sun excluded from the camera's viewfinder, otherwise its brightness may cause underexposure.

Alternatively, compose the shot, take a general meter reading, then increase the exposure set by one to two stops using your camera's exposure compensation facility. Either approach will give an exposure that's correct for the sky and sun, so any solid features between you and the sun will be underexposed and record as a silhouette.

If you don't want this to happen and instead wish to record detail in the foreground – which is usually the case when taking wide-angle sunset pictures – a meter reading should be taken by tilting your camera down so the sun and bright sky are excluded from the viewfinder (or by taking a spot reading from the

This picture shows the effect you can obtain using a long telephoto lens to photograph the setting sun.
EQUIPMENT: *Olympus OM2, 400mm lens, tripod.* **FILM:** *Fujichrome RDP ISO100.* **EXPOSURE:** *⅟₆₀ second at f/11.*

foreground if your camera has such a facility). The exposure reading obtained should then be used once you re-compose the final shot, either by setting it on your camera in manual mode or by using the exposure lock if it has one.

Doing this will cause the sky to overexpose, so you will need to fit a graduated filter to your lens to darken down the sky and ensure its warm colours record on film. A two-stop (0.6) graduate is usually dark enough, but in bright conditions you may need a three-stop graduate (0.9).

Most photographers use grey graduates, which don't affect the natural colour of the sky, but you could use a pink or orange graduate to enhance the sky colours when they are naturally a little weak.

TOP TIPS

• Never look at the sun through a telephoto lens if it is very bright because you can damage your eyesight.
• Always fit a lens hood to your lens when shooting a sunset, to prevent flare which will ruin the picture.
• Use an 81C or 81D filter so as to make your sunset pictures even warmer. In hazy or overcast weather when the sunset is weak, you could even use an orange 85-series filter, or a 'sunset' graduate.
• To ensure a perfect result, bracket exposures over and under the meter reading your camera sets. Do this using your camera's exposure compensation facility and bracket one stop over and under in half-stop increments.

In order to retain detail in the foreground of this Greek island scene, the photographer took a meter reading from the hillside, set it on his camera, then fitted a grey graduated filter to his lens so the sky was darkened sufficiently to ensure its beautiful colours didn't burn out.
EQUIPMENT: *Pentax 67, 55mm wide-angle lens, 2-stop grey graduated filter* **FILM:** *Fujichrome Velvia ISO50* **EXPOSURE:** *¼ second at f/16*

Toning Prints

Although the idea of black and white photography is primarily to produce black and white images, many photographers prefer to take the process a stage further and tone their prints. A wide variety of toners are used to produce all kinds of colours, including sepia, copper, blue and green, and the final result can be as subtle or as blatant as you like, depending on the type of effect you want to achieve and its suitability to the image. Toning also serves another important function in that it converts the remaining silver salts in the print to a more stable compound, thus making the image more archivally permanent and reducing the risk of the image fading over time.

If you own a darkroom and make your own prints, toning can become a natural extension of your photographic repertoire – it will certainly allow you to make the most of your black and white picture collection. However, as toning can be carried out in daylight you don't actually need a darkroom to do it, so it's perfectly feasible to experiment with toning using commercially made black and white prints.

Toning chemicals are readily available from most photographic dealers, and modern kits make the whole process quick and relatively straightforward, although if you become really involved you can make up your own toners from raw materials.

This pair of pictures shows how toning can transform a black and white print. Although the original image (above) is perfectly acceptable, the photographer felt that the addition of a warm tone would enhance the stillness and tranquillity of the stormy lake scene. To produce this, the print was bleached for 75 per cent of the recommended time, then immersed in sepia toner which had been diluted to produce a moderate tone.

WHAT YOU NEED

Black and white prints: Prints made on both fibre-based and resin-coated papers are suitable for toning, and print size is irrelevant. However, different brands and types of paper respond differently to toning, so if you make your own prints it's worth experimenting.

Print trays: A set of print-developing trays will be required to immerse the prints in the toning chemicals.

Print tongs: Use tongs to handle the prints and transfer them from one bath to another. This prevents you from contaminating them with your fingers, but also means the chemicals don't have to come into contact with your skin – some can be harmful.

Clean water: Required to soak the print before toning, and to wash it between toning baths.

A timer or clock: Although it's possible to monitor toning by eye, a timer will allow you to do this with greater accuracy.

Toning kits: There are many different types of toner available, all of which give different results. Here is a brief outline of the most popular types and shades:

Sepia toner (sulphide toner): Adds a brown tone to your prints, though the density of the colour can be varied from a very subtle hue to a deep, chocolate brown. It's probably the most popular type of toner used as it allows you to recreate the effects seen on old prints, and is ideal for all types of subjects.

The toning process involves two stages: first the print is immersed in a bleach bath which fades the image, starting with the highlights, then it is washed and transferred to the toning solution where the image reappears after a minute or so with the characteristic brown colour.

Blue toner: As you would expect, this type of toner adds a blue colour to your prints. It's a one-bath process, so all you have to do is place the print in the bath of toner, and when you're happy with the density of colour, remove the print and wash it to arrest the toner. Blue toning tends to make the shadow areas in an image more dense, so choose your print carefully, otherwise you may find that after toning the image appears dark and 'muddy'.

Selenium toner: This is probably the most widely used toner among professional photographers. The main advantage of selenium is that it makes prints archivally safe, but with some types of bromide printing paper, such as Ilford Multigrade, it does this without changing the colour of the image. This makes it an ideal choice where you don't want a noticeable colour cast adding to a picture but equally don't want the image to deteriorate. Selenium toner can also be used to enhance an

Although many photographers automatically assume that sepia-toning means adding a very obvious 'chocolate' brown colour to an image, it is possible to create much more subtle effects. Here, for example, the print was bleached as normal, then sepia-toned in a very dilute bath of toner. This has resulted in the whole image receiving a very weak, warm tone.

image as it will make the blacks deeper and purer while slightly increasing contrast.

The effect of selenium can be controlled by varying the dilution of the toner. When diluted in the proportion of 1 part toner to 20 parts water it is ideal for the purposes outlined above, and you can safely leave the print in the toner bath for 10–15 minutes.

Where you require the addition of a colour cast, increase the strength of the dilution to 1 part toner and 5 parts water. The actual colour you get will depend on the type of printing paper and the way it was developed. Bromide papers tend to show a slight blue or purple hue in the shadows, while warm-toned chlorobromide papers, such as Agfa Record Rapid and Agfa Multi-contrast Classic, give much warmer results, not unlike sepia in some cases.

The key with selenium is to experiment. Try different dilutions and different toning times. It also responds better to fibre-based printing paper than resin-coated.

Copper toner: This type of toner creates anything from a pink to a red colour, depending on the type of paper you use, the dilution of the toner and the amount of time the image is toned for. The longer you leave a print in the toner, the richer the colour will become. It's also worth noting that copper toner tends to lighten the image, so you should ideally begin with a print that's slightly darker than you would normally use.

be after toning. Prints that have already been partially b and sepia toned can also be gold toned to give a w peachy/copper colour.

The depth of that colour depends on the density of t tone on the print and the length of time you leave it in toner, but the changes occur slowly – anything up to 30 – so you can simply pull the print from the toner bath a it in water when you're happy with the result.

HOW IT'S DONE

Your approach to toning will depend on the type of toner you are using, but in each case the process is relatively simple.

Begin by organising a clean, flat work area that offers enough space so you can arrange your print trays and still have room to manoeuvre. Ideally, you will need a tray of water to wet the print, a tray for the bleach (if necessary), an empty tray or bucket in which you can transport the print for washing, another tray for the toner solution and a final tray of clean water in which to place the toned print. It's advisable to cover surfaces with newspaper, as some toners will stain, and to wear an apron in order to protect your clothes.

Once you have selected a few prints, mix up the toner chemicals according to the manufacturer's instructions, pour them into the trays, then soak the first print in water. This stage isn't essential, but many photographers prefer to wet their prints before toning.

Here's a step-by-step guide to sepia-toning a print:

1 Remove the print from the water, drain off excess water, then slide the print into the bleach bath so that it is completely immersed, and start the timer.

Blue toning produces a much more obvious effect, but with simple, graphic subjects the addition of a very cool blue cast can enhance the image and add plenty of impact.

Gold toner: Most brands of gold toner are expensive because they work by coating the silver in the print emulsion with gold, which is chemically inert and thus makes the image archivally safe. However, there are some cheaper alternatives which give similar results. If you use gold on un-toned bromide prints the print is made archivally permanent, but no real change of image colour occurs – if anything the print will seem slightly cooler after toning. With prints made on chlorobromide papers, however, you get a blue tone – the warmer the original image, the bluer it will

2 Agitate the print by rocking the tray back and forth to ensure that the bleach washes over the whole image. Do this until 20 seconds before the recommended bleaching period ends, or until you're happy with the level of fading that has occurred on the image. If you only require partial bleaching, make sure the bleach bath is very dilute so its action is slowed down.

3 Lift the print out of the bleach with a pair of tongs, drain excess bleach, then quickly transfer to a bucket or tray and wash the print under running water so that all traces of bleach are removed.

4 Slide the print into the tray of toner solution, start

the timer and begin agitating the print as before. If total sepia toning is required, do this until the recommended time has elapsed, but for partial toning, remove the print when you're happy with the effect.

5 Drain off excess toner, then place the print in a tray of clean water to arrest the toning process and transfer to a bath or sink where the print can be washed to remove all toner solution from it. Resin-coated prints only need a 5-minute wash, but fibre-based prints should be washed for at least 30 minutes as the chemicals soak into the paper.

6 Once the print has been thoroughly washed, remove excess water with a squeegee, then allow it to dry naturally.

This process is pretty much the same for all types of toner, the only difference being that with most you don't use a bleach bath. Once you've mastered the art of basic toning according to the manufacturer's instructions, you can then begin to experiment with other toning techniques.

Split-toning

This popular technique involves partially toning a print so that some parts are toned while others remain unaffected.

When a print is bleached prior to sepia-toning, for example, the highlights in the image are affected first, then the mid-tones and finally the shadows. So, if you remove the print from the bleach after a short time – perhaps half of the recommended time – only the highlights will have been attacked by the bleach while the rest of the image is still visible. This means that when the bleached print is placed in the toner solution, the highlights will be toned with a delicate hint of warmth while the mid-tones and shadows are unaffected. This effect can look wonderful.

As the bleach acts very quickly, it's a good idea to dilute it more with water so the action is slowed down. This means you can monitor the effect of the bleach on the print and remove it at just the right time.

Selenium toner works in the opposite way to sepia in that it affects the darkest areas of the image first, and the highlights last. With bromide printing papers such as Ilford Multigrade, split-toning in selenium won't actually show a colour change but will merely enrich the blacks in the print and perhaps add a very subtle blue-black tone. With warm-toned chlorobromide papers you're more likely to see a difference when split-toning in selenium, as it tends to make the shadow areas much warmer while leaving the mid-tones and highlights unaffected.

However, the main benefit of split-toning in selenium with any type of paper is that it stabilises the shadow areas so they are chemically inert, but leaves the highlights and mid-tones open to colour change by using a different toner. Which brings us on to another useful toning technique.

Multiple-toning

If you split-tone a print in sepia or selenium, the affected areas of the image won't be changed if the print is then re-toned in a different type of toner, but the un-toned areas will. This allows you to produce attractive multi-coloured effects.

If you look carefully at this picture you will notice that the highlights and mid-tones are warm while the shadows have a subtle blue colour. The effect was achieved by split-toning the print in sepia, thoroughly washing it, then placing it in a bath of blue toner just long enough for the shadows to be affected. Multiple- or dual-toning in this way can produce a wide range of attractive results, and is well worth experimenting with.

Split-toning in sepia affects the highlights but not the shadows so, for example, if you then partially tone the same print in blue toner – which affects the shadows first – you will end up with a print which exhibits warm highlights, cool blue shadows and unusual blue/green mid-tones.

Similarly, if you split-tone a print in selenium so the shadows are made stable, then partially bleach and sepia-tone the same print, you will get a duotone effect. Split selenium followed by blue toning gives blue highlights and brown shadows. Alternatively, use copper toner instead of blue.

The unusual tones in this picture were created by first split-toning the image in selenium, so that the shadows and darker tones took on a subtle blue/black colour, before partially bleaching and re-toning in sepia to warm up the highlights. The end result was totally unexpected but is nonetheless appealing, adding an ominous, slightly cold feel to the brooding seascape. The print was initially made on Ilford Multigrade FB paper, a standard bromide paper, so the selenium toner turned the shadows blue/black. Had the print been made on a chlorobromide paper, such as Agfa Record Rapid, the shadows would have been much warmer.

The same approach can be used with copper and blue toner – the copper affecting the highlights and the blue affecting the shadows. To make the effect as subtle as possible – almost to the point that the print doesn't appear to have been toned unless you compare it with an untoned print of the same image – do the following: place a test print in the toner bath and note how long it takes for the colour of the toner to begin to appear.

When you come to toning the final print you should remove it from the toner five seconds earlier than the test print. This will enhance the tonal range of the print and give a very subtle toned effect.

It's tempting to leave prints in the toner for longer, but the results tend to be more attractive when toning is kept very subtle.

TOP TIPS

• The techniques covered are just the tip of a very large iceberg – once you've mastered them, experiment and devise your own.

• If you overtone a print, you may find that the effect can be reversed by immersing it in a weak bath of print developer.

• Fully exposed and developed prints are the best for toning – overexposed prints 'snatched' from the developer to prevent them going too dark never tone very well.

• Always wash a print thoroughly after fixing, otherwise any fixing salts left in the print could cause uneven patches to appear on the toned print.

• If you are multiple-toning a print, make sure it is washed thoroughly between toners, otherwise contamination may occur and produce strange results. Fibre-based papers should be washed for at least 20 minutes between toners.

• Handle prints carefully after toning so that you don't mark the edge – this is particularly important with blue toner.

• Some toners have a better shelf life than others once they have been diluted, so check the manufacturer's instructions and don't use them beyond the recommended period. Within this period you may find that the toner becomes less effective once you have used the solution to tone a number of prints. If this happens, tone your prints for longer.

• Always make notes when toning prints, so that you can repeat the effect afterwards – things don't always turn out as you expect, but sometimes the unexpected can be even better – and how annoying if you didn't record the process.

Gold toner produces a more noticeable effect when it's used on prints that have already been toned. This picture of an avenue of trees, for example, was first split-toned in sepia to add a delicate warmth to the highlights, before being toned in gold toner for around 15 minutes to produce an overall pinky/red hue.

Traffic Trails

Traffic trail photography is one of the simplest 'special effect' techniques used by photographers, but when practised with a little care and imagination it can produce excellent and colourful results.

All you have to do to take pictures like those shown here is to use a long exposure time to photograph traffic moving along a busy road at night. By doing so, the bright head and tail lights of the passing cars, buses and lorries record as a series of colourful streaks tracing their way into the distance. The longer the exposure and the more traffic there is, the more streaks you get and the better the final picture. It's as simple as that.

WHAT YOU NEED

Camera: Any type of camera that has a B (bulb) setting so you can hold the shutter open for as long as you like. All 35mm SLRs, medium- and large-format cameras have this feature, but a growing number of compact cameras do as well.

Lenses: The focal length you use will depend on the type of shot you want to produce. Wide-angle lenses of 24mm and 28mm are ideal for broad views of busy roads, while telephoto lenses can be used to pick out small areas to create simple, abstract images.

Accessories: A sturdy tripod to keep your camera steady and a cable release to trip the camera's shutter.

Film: Use slow-speed film – ISO50–100. Not only will this give optimum image quality, but the low ISO rating will also enable you to use a long exposure.

HOW IT'S DONE

The best time to shoot traffic trails is during the period immediately after sunset when there is still a little colour in the sky – don't wait until it's completely black if you intend to include sky in your pictures.

It's also a good idea to plan your shoot during the winter months, when dusk roughly coincides with rush hour, as the roads will be at their busiest then. That said, if you live in a big city, the roads tend to be busy even late at night, so you can shoot traffic trails in summer as well.

In terms of location, bridges over major roads and motorways are ideal, because you can position yourself directly above the traffic flow so the road heads off into the distance. Driving up to the top floor of a multi-storey car park in a town or city centre will also give you a good view of the roads, roundabouts and houses below, and you can add interest to your pictures by including office blocks, shops and other buildings.

Have a wander around during the day to establish the best place to shoot from, then return around sunset so that you've got a little time to set up your equipment and get ready for action.

With your camera mounted on a tripod and the scene before you composed, set the lens aperture to f/16 or f/22 and the camera's shutter to B (bulb). All you have to do then is wait until the light levels have fallen sufficiently for the lights on passing traffic to stand out, and start shooting. To do this, trip your camera's shutter with the cable release and hold the shutter open

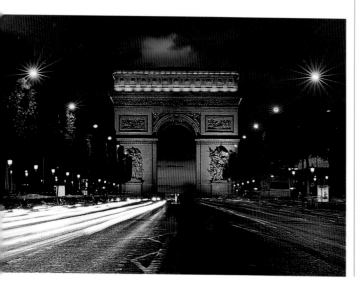

The Champs Élysées is probably Paris's busiest road, so what better place to take traffic trail pictures – especially with the stunning Arc de Triomphe looming on the horizon. This picture also shows that you needn't shoot from a high vantage point to get successful results – the photographer was actually standing in the middle of the road with traffic passing on either side. As a general rule, this approach should be avoided unless there is a recognised area in the road for pedestrians to stand. Even then, you must take great care and make sure that you are clearly visible to passing motorists.

EQUIPMENT: Nikon F90x Prof., 80–200mm zoom lens, tripod, cable release **FILM:** *Fujichrome Velvia ISO50* **EXPOSURE:** *30 seconds at f/16*

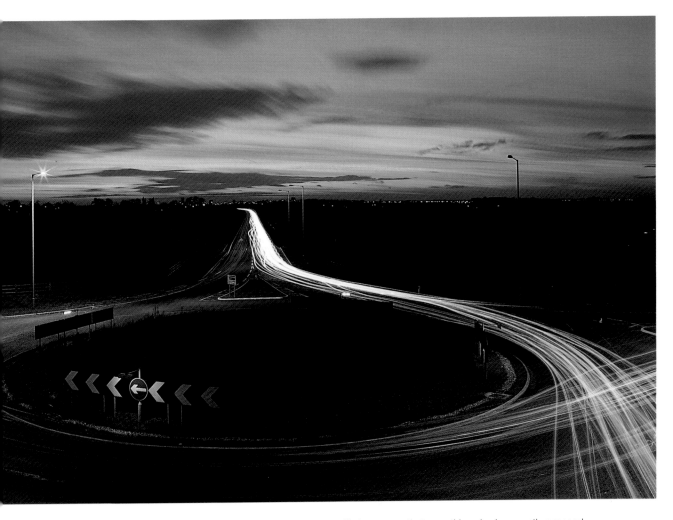

This colourful image shows the type of results you can expect by photographing traffic trails. Captured near the photographer's home, it was taken from a pedestrian bridge over a main road. The inclusion of a roundabout in the foreground adds extra interest, while the beautiful colours in the dusk sky provide the perfect backdrop to the red and yellow light trails from the moving traffic.

EQUIPMENT: *Pentax 67, 55mm wide-angle lens, tripod, cable release*
FILM: *Fujichrome Velvia ISO50* **EXPOSURE:** *2 minutes at f/16*

for at least 30 seconds so plenty of passing traffic will record – the more traffic passing while the shutter is open, the more light trails you'll get.

Alternatively, if you are shooting in a town or city centre and decide to include buildings in your pictures, instead of using the B setting to obtain a long exposure, set your camera to aperture priority mode. In this way, the integral metering system will automatically set the correct exposure required for the scene, which will be long enough to capture plenty of traffic trails, and

will also ensure that everything else is correctly exposed.

If there are lulls in the traffic, hold your hand just in front of the lens or shade it with a piece of black card to prevent light reaching the film. When more traffic comes along you can then move your hand away and record more light trails. When you do, take care not to knock your camera, otherwise your picture will be ruined.

TOP TIPS

• Roundabouts make good locations for traffic trail pictures as you can record moving and stationary traffic in the same picture.
• Bracket your exposures by using different exposure times to ensure that at least one picture is perfect. If your first exposure is 30 seconds at f/16, for example, take others at 45, 60 and 90 seconds.
• Remember that the best time to shoot traffic trails is during the period after sunset when there is still some colour in the sky to add an attractive backdrop.

Unusual Viewpoints

Of the millions of photographs produced each year, the vast majority are taken with the camera held at eye-level. This is a natural way to work, because the objective of most photographers is to capture a realistic view of the world. At the same time, however, shooting from eye-level all the time can produce rather obvious, uninteresting images, and by intentionally choosing a more unusual viewpoint, either very high or very low, it's possible to create pictures that are far more exciting to look at and which hold the viewer's attention for much longer because they present an aspect of people or scenes that we're not used to seeing.

WHAT YOU NEED

Camera: It's not the type of camera you use with this technique that counts but the way you use it, so anything from a simple compact to a sophisticated SLR is capable of producing successful results.

Lenses: Wide-angles are ideal when shooting from high and low viewpoints because they create dynamic compositions, and the distortion introduced by using the lens at an extreme angle will emphasise the effect even more. Telephoto lenses are also useful when shooting from high viewpoints as they allow you to isolate details at ground level – such as people rushing around like ants way below.

Accessories: A tripod can be invaluable when shooting from low viewpoints, as it will allow you to position and hold the camera almost at ground level.

HOW IT'S DONE

When you are wandering around a location, look for different viewpoints instead of choosing the most obvious.

In a town or city you'll get a bird's eye view from the local multi-storey car park, church tower, a bridge or balcony, or perhaps there's a hill nearby offering a panoramic view.

High viewpoints are particularly useful in busy built-up areas as they allow you to see much more than you can at ground level, and reveal details that you may not have seen before. Tables and chairs arranged outside a street café create a fascinating pattern when photographed from above, for example, as can unusual paving.

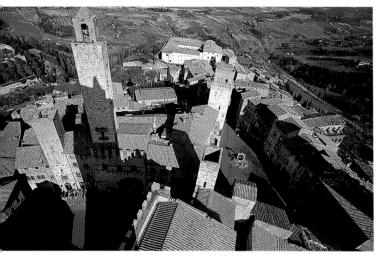

ABOVE **This bird's eye view of the old Tuscan town of San Gimignano in Italy was taken from the top of one of the town's many fourteenth-century stone towers. By shooting from such a high position, the photographer has captured a fascinating view of the town, and produced an image that is far more dramatic than any taken at ground level. An ultra wide-angle lens was required to record the whole town, and the distortion it has produced adds to the impact of the picture.**
EQUIPMENT: Olympus OM4-Ti, 20mm wide-angle lens
FILM: Fujichrome Velvia ISO50 **EXPOSURE:** *1/60 second at f/16*

RIGHT **This picture of the Louvre art gallery in Paris was made more interesting by shooting from inside the glass and steel pyramid that sits in the courtyard between the beautiful old buildings. As well as providing a dramatic contrast between old and new architecture, the shapes in the steel frame of the pyramid have also created an eye-catching pattern.**
EQUIPMENT: Nikon F90x Prof., 28mm wide-angle lens
FILM: Fujichrome Velvia ISO50 **EXPOSURE:** *1/30 second at f/16*

In late afternoon sunlight the long shadows cast by lamp posts, trees and people rushing around can also add interest and impact to a picture.

In these situations, use a telephoto or telezoom lens to pick out the more interesting areas, or switch to a wide-angle lens and capture a true bird's eye view. If you use an ultra-wide lens, such as a 17mm or 20mm, tall buildings will lean dramatically towards the edge of the page, making it appear that you really are soaring over them like a bird on the wing.

Low viewpoints can work well, too. If you move up close to a tall building or monument, then crouch down low and look up at it through a wide-angle lens, the dramatic perspective can produce truly amazing results, with the sides of the building tapering off towards the sky.

But don't just do this with buildings. Try it with people, so your subject's feet look much bigger than the rest of their body, and they tower over you like a giant. Children will enjoy being photographed in this way, and it will give you a glimpse of what it must be like being a tiny child in an adult's world. The same technique can be used with trees – if you shoot from ground level in the middle of a forest, the trees will appear to taper off towards the lush green canopy of foliage, and to be enormously tall.

If your camera has a removable pentaprism, you will be able to rest the camera on the ground and compose the picture by looking down on the focusing screen. This can open up all sorts of interesting opportunities. Why not fit a wide-angle lens, then place the camera in a flower bed, for example, to capture the blooms stretching up towards the sky? This 'worm's-eye' view is bound to produce stunning images as we're not used to looking at the world in such a way.

Another picture of Paris – this time the magnificent Eiffel Tower. As the tower is so tall most photographers capture it on film from some distance away. However, by moving in close and looking up at the enormous structure, it's possible to produce a more dynamic image, while including people adds scale and further emphasises the size of the monument.
EQUIPMENT: Nikon F90x Prof., 20mm ultra wide-angle lens, polarising filter
FILM: Fujichrome Velvia ISO50
EXPOSURE: 1/60 second at f/8

TOP TIPS

• Experimentation is the key to success. Instead of automatically holding your camera at eye-level to take a picture, try using it in ways you've never thought of before. You'll be surprised just how rewarding this can be.

• When shooting from ground level, set your lens to a small aperture so there's sufficient depth-of-field to record everything in sharp focus.

• Clamps, suckers and other accessories are available that will allow you to place your camera in the most unusual places – such as on the bonnet of your car, so you can take pictures while driving along.

• Remember to turn your camera onto its side too.

Waterfalls

Moving water, be it in a raging waterfall or a tumbling mountain stream, provides an irresistible subject for photographers. You may not have access to Niagara Falls or similar wonders of the world, but that doesn't matter because even the smallest trickle of water can, with care, be the source of pleasing images.

WHAT YOU NEED

Camera: A model that allows you to set slow shutter speeds of at least half a second, and preferably longer, or one which has a B (bulb) setting.

Lenses: Focal length will be governed by the location and size of the waterfall, but anything from a wide-angle to a moderate telephoto or telezoom will be suitable.

Accessories: A sturdy tripod to keep your camera steady, plus a cable release to trip the camera's shutter. It's also a good idea to carry a neutral density (ND) filter of 0.6 or 0.9 density.

Film: Stick to slow-speed film – ISO100 or less – so you can use slower shutter speeds.

HOW IT'S DONE

The most common method of photographing moving water is to use a slow shutter speed, so it records as a graceful, gaseous blur – the slower the shutter speed is, the smoother the effect becomes. As a starting point, set your camera to ½ second or so, but don't be afraid to use much longer exposure times of several seconds – 10 or 20 seconds isn't unusual.

The slowest shutter speed you can set will depend on light levels at your chosen location. If you are in a shady, wooded area you may find that with your lens set to its smallest aperture – usually f/16 or f/22 – an exposure of many seconds is required. However, out in the open in sunny weather the slowest speed you can use at minimum lens apertures could be as fast as ⅕ second, which is too fast to create sufficient blur in the water.

Slightly overcast weather provides ideal conditions for waterfall photography as light levels are much lower than in bright sunshine, making it easier to use long exposures to blur the water. Contrast is also low so there are no bright highlights on the water to contend with. For this shot, the photographer moved well away from the waterfall and used the stream to help lead the eye up through the scene. The inclusion of rocks and trees also helps to emphasise the blurred effect on the water.

EQUIPMENT: Pentax 67, 135mm lens, tripod, 81B warm-up filter **FILM:** *Fujichrome Velvia ISO50*
EXPOSURE: *4 seconds at f/22*

This waterfall was photographed after a period of heavy rain which meant that the amount of water tumbling over the edge was much greater than normal, resulting in a more interesting image. To make the most of it, the photographer climbed down to the base of the falls so he could shoot from close range.
EQUIPMENT: *Olympus OM4-Ti, 28mm wide-angle lens, tripod*
FILM: *Fujichrome RDP50 ISO50* **EXPOSURE:** *2 seconds at f/16*

To overcome this, use an ND filter on your lens to reduce the amount of light entering, and force an exposure increase. A 0.6 ND requires a two-stop increase, so instead of using ⅟₁₅ second you could set ¼, while a 0.9 ND requires a three-stop exposure increase and in this example would allow you to use a shutter speed of ½ second instead of ⅟₁₅.

If you don't have an ND filter, a polariser can be used instead as it reduces the light entering your lens by two stops and has the same effect as a 0.6 ND filter.

When taking an exposure reading of the scene you're about to photograph, remember that water is highly reflective and can fool your camera's metering system by bouncing a lot of light around – especially if the waterfall or river fills a large part of the viewfinder. To avoid exposure error, move the camera to one side and take a meter reading from an area that doesn't contain water but which is in the same light. A grassy bank or green trees would be ideal. When you've done that, set the exposure on your camera, and re-compose and take the picture, remembering to use a cable release so you don't have to press the camera's shutter button with your finger and risk causing vibrations.

TOP TIPS

• For the best results, include stationary features, such as rocks, in your picture so they will come out pin-sharp and help to emphasise the blurred effect of the water.
• Use a telephoto lens to home in on more interesting parts of a waterfall, rather than always trying to capture the whole thing with a wide-angle lens.
• Look out for interesting details to photograph in fast-flowing rivers and streams, such as a solitary leaf caught on a rock in the middle of the flow, or water flowing around a fallen tree. Anything that breaks up the regular flow of the water will produce more interesting images.
• If you are taking pictures close to a large waterfall or weir, protect your camera and lens from the flying spray by placing it in a polythene bag.
• Take care when walking alongside rivers and waterfalls – wet rocks are slippery and can easily cause you to fall.

Windowlit Portraits

nthusiast photographers have a tendency to over-estimate the amount of equipment required to produce successful pictures, and the complexity of the techniques involved. Nowhere is this more evident than with portraiture. It is taken for granted that banks of expensive studio lights are required, along with special backgrounds and fancy attachments to modify the light.

However, while many photographers do go to these lengths, all would confess that it isn't essential, and that a single window can be just as effective in providing flattering illumination for portraiture. In fact, many professional photographers use studio equipment to recreate the beautiful light a window can provide, and some of the best portraits ever taken have been shot using natural daylight flooding in through a window.

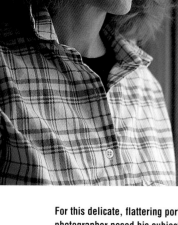

WHAT YOU NEED

Camera: Any camera can be used for windowlit portraits.

Lenses: A short telephoto lens with a focal length from 85 to 105mm is considered the best choice for head and shoulder sportraits, because the slight compression of perspective such lenses give is flattering to facial features. For half- or full-length portraits a 50mm standard lens is ideal.

Accessories: A white reflector will be handy for bouncing light into the shadows to give more evenly lit results. This need not be any more complicated than a sheet of white card.

For this delicate, flattering portrait of a young woman, the photographer posed his subject next to a large north-facing window on a dull day and asked her to look out of it so the light flooded across her face to give a soft, almost shadowless form of illumination. Note the dark background – this was actually a wall painted pale green, but the fall-off in illumination behind the subject was such that the wall received little light and was underexposed.

EQUIPMENT: *Mamiya C220 TLR, 80mm standard lens, tripod*
FILM: *Fujichrome RDP100, ISO100* **EXPOSURE:** *⅕ second at f/5.6*

Film: Any speed or type of film can be used. Light levels tend to be quite low when shooting portraits by a window, so if you use slow-speed film – ISO50–100 – a tripod will be required to keep your camera steady. Many photographers prefer fast film – ISO400+ – as it means a tripod isn't necessary and the coarse grain helps to add atmosphere to the images. Both colour and black and white film are suitable.

HOW IT'S DONE

The illumination that is present will depend mainly on three factors:

The size of the window

Generally, the larger the window is in relation to your subject, the softer and more even the illumination, and vice versa. Small windows such as skylights and portholes produce a small pool of light that can be used to create bold, spot-lit effects, whereas large windows and patio doors tend to flood the subject with light so that contrast is lower and shadows less harsh.

If you are working with a large window, you can control the quality of light using card to mask off areas, though little can be done with small windows. In most cases, an average-sized room window will be sufficient for head and shoulders portraits.

The direction the window faces

Where direction is concerned, windows facing south receive direct sunlight throughout much of the day, so the light tends to be harsh and contrasty, especially in bright, sunny weather. North-facing windows, on the other hand, only admit reflected light from the sky and surrounding buildings, which tends to give much softer and more flattering illumination.

Direct light flooding in through a window offers considerably more options, because its colour and intensity will vary depending on the time of day. During late afternoon, for instance, the light is much warmer and softer than it is at midday, and you can make good use of the golden glow and the long, raking shadows created by the low sun.

Weather conditions

The effects of changes in the weather are seen more in south-facing windows which receive direct sunlight – the brighter and sunnier the weather, the harsher and more intense the light. North-facing windows are less affected, though in bright weather light levels will obviously be much higher than during dull, rainy days, simply because there is much more light being admitted.

As a general rule, most photographers prefer a north-facing window and shoot in bright but slightly overcast weather conditions when the light is diffuse and very flattering. That said,

it is well worth experimenting with other options, because all can produce successful images.

Positioning the subject

Another factor that will affect the overall mood of your portraits is where you position your subject in relation to the window. If your subject is side-on to it, half of their face will be lit and the other half in shadow. This is the most popular approach, especially with men and older people, as the bold sidelighting reveals the texture of the skin, while the gradual fall-off in light and shade emphasises modelling to produce very moody results.

If you don't want dense shadows, position a large white reflector opposite the window so it bounces light back towards the shadow side of your subject. Alternatively, ask your subject to face the window a little more so that the light floods over their face. This can produce beautiful results in overcast weather, when the light is naturally soft and the shadows weak.

Alternatively, you could position your subject so the window is behind them. This obviously means that their face will be in shadow, but if you expose carefully for the shadows, the background (the window) will be overexposed and will burn out to create a moody, high-key effect.

When taking a meter reading, expose for highlights – the part of your subject that is lit – so their skin doesn't overexpose. The easiest way to do this is by using a handheld meter and taking an incident reading of the light falling onto their face.

Finally, keep the background plain and simple so it doesn't compete for attention with your subject. If the existing background in the room is unsuitable, hang a sheet of cotton or canvas from the wall. Often you will find that light levels behind your subject are much lower than next to the window, so the background will come out very dark anyway. However, it is wise to take precautions.

TOP TIPS

• To soften the light coming through a window, fix a sheet of white cotton muslin or tracing paper over it.
• In late afternoon, hang net curtains over the window to create dappled shadow patterns across your subject's face.
• You can control the amount of light coming through a window by simply pulling the curtains closer together so that the size of the window is reduced.

Bold sidelighting tends to emphasise the rugged features of the male face, and is widely used for portraiture. To produce this effect, the subject stood next to an average-sized room window so the light flooding in caught only one side of his face. The weather outside was bright but slightly overcast, with nearby trees reducing the amount of light entering the window. Fast black and white film was used so the photographer could handhold his camera, and the portrait was shot on the spur of the moment during a brief visit by the subject to the photographer's home. After printing, the image was partially sepia-toned to add a warm colour cast and emphasise the mood of the stark, grainy portrait.

EQUIPMENT: Olympus OM4-Ti, 85mm lens *FILM:* Ilford HP5 Plus (ISO400) rated at ISO1600 and push-processed by two stops
EXPOSURE: 1/60 second at f/5.6

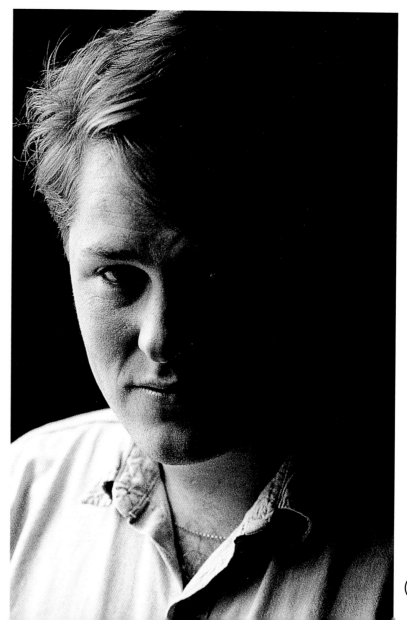

Winter Wonderland

Winter may not be the general public's favourite season of the year, but for photographers it can be the source of many beautiful pictures. Freshly fallen snow crunching under foot, icicles hanging from gutters and drainpipes, valleys filled with mist and fog, frost-covered landscapes – all these aspects of winter have the ability to transform a scene overnight, while eye-catching photographs can be taken of subjects that wouldn't even command a second glance at any other time of year.

WHAT YOU NEED

Camera: A 35mm SLR is the easiest type of camera to use – ideally with large controls that you can operate while wearing gloves. Compacts are also ideal for the winter photographer, as you can carry one in a pocket while out walking and use it to capture any interesting scenes you encounter.

Lenses: Focal lengths from 28mm wide-angle to 200mm telephoto should cover all your needs, especially if one of them has a close-focusing facility so you can shoot small details such as frozen leaves or icicles.

On cold, frosty mornings, go for a stroll down your garden and look for interesting details like these frozen leaves on the ground. You could even place objects, such as a bunch of flowers, outdoors overnight so that they freeze, or arrange natural subject matter into a pleasing composition so it will make an interesting picture on a frosty morning.
EQUIPMENT: Pentax 67, 135mm macro lens, tripod, cable release
FILM: Fujichrome Velvia ISO50 **EXPOSURE:** ⅛ second at f/16

Accessories: A polarising filter is handy in sunny weather for maximising colour saturation, while an 81B or 81C warm-up filter will help to balance the blue cast in the light on dull days or when taking pictures in the shade. It's also a good idea to carry a tripod

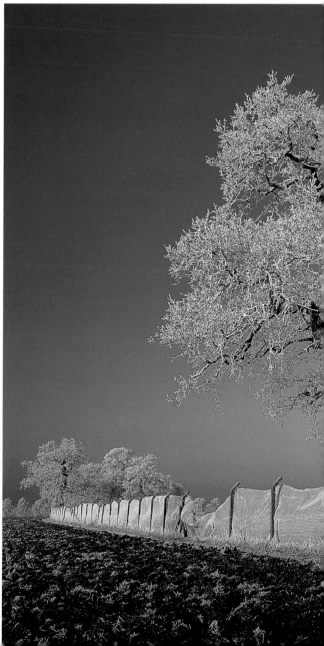

RIGHT **By mid-afternoon during winter the sun is already low in the sky, adding a delicate warmth to snowy scenes and casting long weak shadows across the landscape that reveal texture. For this picture taken into the light, careful exposure calculation was necessary because of the brightness of the snow and sky. To prevent underexposure, the photographer took a general meter reading with his camera set to aperture priority mode, then increased the exposure set by two stops using the exposure compensation facility. Shortly after the picture was taken, the batteries in the photographer's camera drained due to the cold weather and he didn't have a spare set!**
EQUIPMENT: Nikon F90x Prof., 28mm wide-angle lens, 81B warm-up filter *FILM:* Fujichrome Velvia ISO50 *EXPOSURE:* ⅟₃₀ second at f/8

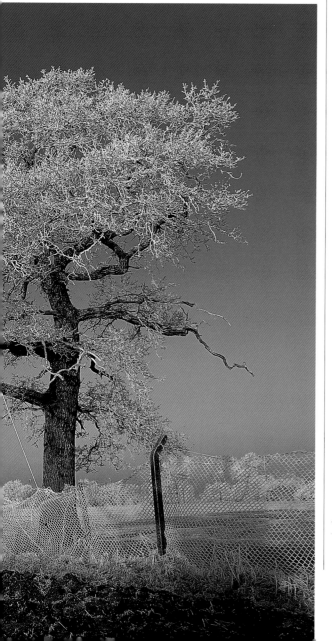

LEFT **After a night of freezing weather, beautiful scenes like this are not uncommon during winter. Clear blue sky, bright sunshine and crisp white frost make an irresistible combination, though you must be out during early morning as a sudden rise in temperature will quickly melt the frost and spoil the overall effect. This picture was taken just a few hundred metres from the photographer's home, so he didn't have to travel very far to take it. To determine the exposure a handheld meter was used to measure the light falling onto the scene.**
EQUIPMENT: Pentax 67, 55mm wide-angle lens, polarising and 81B warm-up filters, tripod, Minolta Autometer IVF handheld meter
FILM: Fujichrome Velvia ISO50 *EXPOSURE:* ⅟₃₀ second at f/16

On a cold but clear winter's morning, the sky is often tinged with pastel shades of purple, pink and blue, and this makes for attractive images. Here the colours were reflected in the still water of a lake, and the photographer moved close to a snow-covered jetty, using it as foreground interest to help lead the eye into the scene. In situations like this, where the brightness range isn't excessive, your camera's metering system should be able to give a relatively accurate exposure with little or no adjustment.

EQUIPMENT: Olympus OM4-Ti, 28mm wide-angle lens
FILM: Kodachrome 64 ISO64 **EXPOSURE:** ⅟₁₅ second at f/16

because light levels tend to be quite low during the winter.

Film: Slow-speed film – ISO50–100 – is the best choice for general use, but faster films with coarse grain are also ideal for shots of misty scenes.

HOW IT'S DONE

To capture snow at its best you need to be on location as soon as possible after the fall ceases, so that it's in pristine condition and devoid of footprints or slushy grey patches. Ideally, the weather should also be clear and the sun shining. Crisp snow against a deep blue sky looks wonderful, but snow against a dull, grey sky looks far less inspiring.

Early morning and mid-afternoon are generally the best times to shoot. This is because the sun is low in the sky so it casts long, cool shadows which add interest to your pictures – acres of unblemished white snow can easily get monotonous. The warmth in the light also keeps the snow looking pure and white. Around midday or in dull weather there's a tendency for snow to record with a slight blue cast because the light is cooler.

When shooting in sunny weather, use a polarising filter to deepen the blue sky and remove unwanted glare from the snow. This can create a blue cast, however, so it's advisable to use an 81B or 81C warm-up filter to balance it. A Skylight 1B or UV filter is also handy in winter as it reduces the blueness in the light and cuts through haze to give pictures with improved clarity, especially when shooting at high altitudes where the light has a much stronger ultraviolet content and haze tends to be more pronounced.

You also need to take care when calculating the exposure. The meter in your camera is designed to expose correctly 'average' subjects comprising a mixture of light and dark tones, but snow scenes contain few or no dark tones, so the overall brightness causes underexposure and the snow records as a muddy grey colour. To avoid this, take a general meter reading, then, using your camera's exposure compensation facility, increase it by 1½ stops (set +1.5) for photographs taken in weak sunshine or that contain darker areas such as buildings or trees, and two stops (set +2) for shots taken in bright, sunny

weather, or if snow fills most of the picture area (see page 10).

When shooting wide views it's also a good idea to include something in the foreground to break up the snow and give the composition depth. A drystone wall, fence or gate with snow at its base, or a road or river snaking into the distance is ideal.

Smaller details can also make interesting pictures after a fall of snow. Look out for milk bottles half-buried on a snow-covered doorstep, or snowy trees against the blue sky. Children building a snowman, having a snowball fight or tobogganing down a hill make good subjects, too.

In the countryside, ice often transforms day-to-day objects into beautiful natural sculptures: leaves trapped in a frozen puddle, twigs enclosed in a glassy coat, icicles created by the constant dripping of water, or waterfalls that have been completely frozen by the cold temperatures – you may even find a waterfall that still has a trickle emerging from the frozen surrounds. To capture it, mount your camera on a tripod and set an exposure of a second or more so that the water blurs.

If you rise early on a cold winter's morning you'll often find mist swirling around trees, hanging over rivers and streams like a shroud and reducing the world to pastel colours and simple, two-dimensional shapes devoid of fine detail. Mist also tends to settle in valleys, and when viewed from a high position can look very evocative, with treetops and church spires just visible, or plumes of smoke from wood fires drifting into the air. Scenes like this tend to look their best after a very cold night, when the mist has frozen and lingers for longer. If you descend into it you will also find trees covered in a thick coat of ice due to the moisture in the air settling on them before freezing.

Use a 28mm or 35mm wide-angle lens to capture sweeping views, but remember to include something in the foreground to lend depth, scale and perspective to your shots. Again, a stream or river, especially if it's enveloped in mist, or the frost-encrusted furrows of a ploughed field, are ideal. An 81B or 81C warm-up filter can be used to enhance the light. A grey grad may be necessary in some situations, in order to tone down the sky so that it doesn't burn out when you set an exposure that's correct for the foreground.

Winter is an ideal time to shoot the sunrise and sunset, which are much closer together than at any other time of year. As the sun doesn't climb very high in the sky before beginning its descent again, the quality of light is also very good all day, with long, raking shadows revealing texture in a scene, while the

warmth of the light itself makes even the most mundane surroundings come to life.

Finally, if you keep your eyes peeled as you're wandering around on a winter's morning you'll find all sorts of interesting details worth recording, such as a line of washing frozen solid, or gravestones encrusted in beads of ice.

For the best results, fill the frame so that all attention is focused on the patterns and textures created by the frost. A standard or short telephoto lens are usually sufficient to get you close enough. You may also need a tripod to keep the camera steady, especially if you're using slow film for optimum image quality.

TOP TIPS

• Cold weather can cause the batteries in your camera to drain, so keep a spare set in your pocket where they will stay warm, and swap them over if necessary.

• After taking pictures outdoors for a while you may find that your camera and lenses develop a coat of condensation when you take them back inside where the temperature is much higher. To prevent this, place your equipment inside a large polythene bag with a few sachets of silica gel before going indoors, so any condensation will form on the bag and be absorbed by the silica gel. When all traces of condensation have gone, you can take your equipment out of the polythene bag.

• Remember to keep yourself warm when venturing outdoors in cold weather. Walkers and mountaineers wear lots of thin layers of clothing rather than two or three thick layers. A hat is also essential as 40 per cent of body heat is lost through the head.

Dramatic, stormy weather is common during winter and always makes for exciting pictures like this Welsh lake scene. To produce correctly exposed results in such conditions you should think carefully about your approach. After composing the scene, the photographer took a spot meter reading from the large boulder in the foreground as he wanted to ensure this recorded as it appeared. However, by doing so he knew that the much brighter sky would be badly overexposed, so to ensure that detail and colour were retained, a three-stop (0.9) density grey graduated filter was positioned over the lens to darken the sky down so its brightness was similar to the rest of the scene.
EQUIPMENT: *Olympus OM4-Ti, 28mm wide-angle lens, 0.9 grey graduated filter, tripod* ***FILM:*** *Fujichrome RFP50 ISO50*
EXPOSURE: *$\frac{1}{15}$ second at f/16*

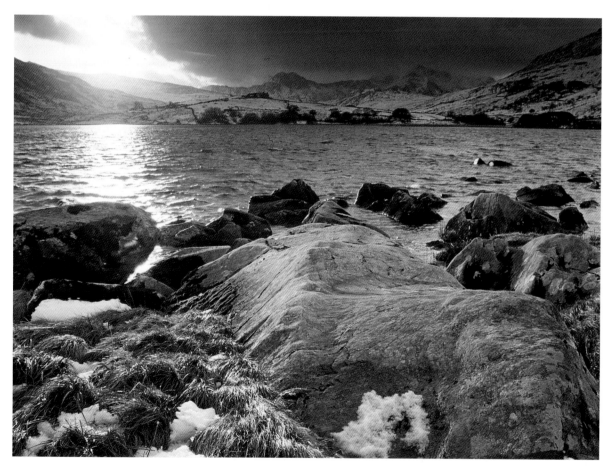

Zooming

The variable focal length offered by zoom lenses is not only a useful aid to precise composition – it can also be used to create interesting special effects on all manner of subjects, as you'll soon discover.

WHAT YOU NEED

Any type of zoom lens is suitable for the 'zooming' technique. Those with a 'two-touch' design are perhaps easier to operate as they have separate focusing and zooming actions, which means you can't accidentally adjust the focus while zooming the lens. However, those with the more popular 'one-touch' design which focuses by rotating the focusing ring, and zooms by pushing or pulling it, are just as useful when handled with care; you simply need to ensure that you don't turn the focusing action while

This stained glass window was captured inside a church, and because light levels were so low the photographer decided to take a few zoomed shots as well. The camera was mounted on a tripod to prevent shake and a long exposure time was used.
EQUIPMENT: Olympus OM4-Ti, 70–210mm zoom lens, tripod
FILM: Fujichrome RFP50 ISO50 EXPOSURE: 3 seconds at f/16

zooming the lens, otherwise your subject will be thrown out of focus while the picture is being taken.

HOW IT'S DONE

The basic idea behind this technique is that you zoom your lens from one extreme of the focal length range to the other while the camera's shutter is open and a picture is being taken. By doing so, your subject will record as an eye-catching 'explosion' of colourful streaks, and when you get it right the effect can look amazing, adding drama and impact to even the simplest subject or scene.

The best results tend to be produced by photographing static or relatively slow-moving subjects such as people, vehicles, bicycles, flowers and statues. Neon signs and floodlit buildings at night also work well. Ideally, your subject should be relatively simple so that the final zoomed image doesn't look too confusing, and should be as colourful as possible to enhance the effect.

The key to success is setting your camera to a shutter speed that's long enough for you to zoom the lens through its focal length range – ideally at least $1/15$ or $1/8$ second – and zooming at an even pace to ensure you get a smooth effect. Initially this may prove rather tricky, but if you practise with no film in your camera at different shutter speeds you will soon get to know how quickly or slowly you need to zoom to get the effect just right.

Here's a step-by-step guide to producing zoomed images like those you see here:

1 Choose your subject and compose the picture with your zoom lens set to one extreme of its focal length range. This can be the smallest or the biggest focal length; the choice is yours.
2 Before taking a picture, quickly zoom your lens to the other end of the focal length range to check what your subject looks like. You may then decide to move closer or further away.
3 Once you're happy with the composition of the picture, take a meter reading and set the exposure on your camera. If you stop your lens down to its smallest aperture – f/16 or f/22 – you should be able to use a relatively slow shutter speed of $1/15$ second or slower.

A simple bed of spring tulips turned into a striking image using the zooming technique. If you look closely, it appears that the flowers are literally exploding due to the way they have been transformed into colourful streaks.

EQUIPMENT: *Olympus OM2n, 35–70mm zoom lens* **FILM:** *Fujichrome RFP50 ISO50* **EXPOSURE:** *⅛ second at f/16*

4 Focus on your subject, and as you press the camera's shutter release to take the picture, immediately begin to zoom the lens through its focal length range.

The slower the shutter speed is, the longer you will have to do this, and vice versa. If you have timed it correctly, the camera's shutter should close to end the exposure just before you reach the end of the zoom's focal length range.

5 When the exposure has ended, continue zooming through to the end of the focal length range to be sure of obtaining a smooth, even effect.

TOP TIPS

• Practice is the key to success, so don't expect perfect results on your first attempt.

• Use zooming to turn ordinary subjects into interesting images.

• Initially you may find it helpful to mount your camera on a tripod, so you can concentrate on zooming without worrying about moving the camera to create blurred pictures.

• For even better effects, try panning the camera (see page 98) and zooming the lens at the same time so that you get blurred streaks in two directions.

Index